FEARLESS
PHOTOGRAPHER
Weddings

Joseph Salvatore Prezioso

with Cathleen D. Small

Course Technology PTR
A part of Cengage Learning

COURSE TECHNOLOGY
CENGAGE Learning™

Australia, Brazil, Japan, Korea, Mexico, Singapore, Spain, United Kingdom, United States

COURSE TECHNOLOGY
CENGAGE Learning

Fearless Photographer: Weddings
Joseph Salvatore Prezioso with
Cathleen D. Small

**Publisher and General Manager,
Course Technology PTR:**
Stacy L. Hiquet

Associate Director of Marketing:
Sarah Panella

Manager of Editorial Services:
Heather Talbot

Marketing Manager:
Jordan Castellani

Acquisitions Editor:
Megan Belanger

Technical Reviewer:
Neil van Niekerk

Interior Layout:
Jill Flores

Cover Designer:
Mike Tanamachi

Indexer:
Kelly Talbot Editing Services

Proofreader:
Kelly Talbot Editing Services

For product information and technology assistance, contact us at
Cengage Learning Customer & Sales Support, 1-800-354-9706

For permission to use material from this text or product,
submit all requests online at **cengage.com/permissions**.
Further permissions questions can be e-mailed to
permissionrequest@cengage.com.

All trademarks are the property of their respective owners.

All images © Joseph Salvatore Prezioso unless otherwise noted.

Library of Congress Control Number: 2010931915

ISBN-13: 978-1-4354-5724-9

ISBN-10: 1-4354-5724-2

Course Technology, a part of Cengage Learning
20 Channel Center Street
Boston, MA 02210
USA

Cengage Learning is a leading provider of customized learning solutions
with office locations around the globe, including Singapore, the United
Kingdom, Australia, Mexico, Brazil, and Japan. Locate your local office at:
international.cengage.com/region.

Cengage Learning products are represented in Canada by Nelson
Education, Ltd.

For your lifelong learning solutions, visit **courseptr.com**.

Visit our corporate Web site at **cengage.com**.

Printed in the United States of America
1 2 3 4 5 6 7 12 11 10

This book is dedicated to
Vincenzo Prezioso and Joseph Vasapolli
My friends and family

Acknowledgments

I'd like to thank those who have let me learn and have inspired and taught me:

- The Independent Newspaper Group
- The Digital Wedding Forum
- Rich Bailey
- Barry S. Kaplan
- David Pratt
- Doug and Chenin Boutwell
- Neil van Niekerk
- Neil Cowley
- Jerry Ghionis
- Al Terminiello
- Canon and Nikon for making awesome cameras
- Kodak and Fuji for film

About the Authors

Joseph Salvatore Prezioso is a first-generation Italian American currently living in Boston, Massachusetts. He attended Salem State College and has a degree in communications.

Photography has always been a way for Joseph to tell stories. He started his career while in high school as a stringer for a few local-town weekly newspapers. That job quickly turned into a staff-photographer gig, and he was soon covering news stories, features, politics, and sporting events. It was a great time, but Joseph wanted more. His next adventure brought him into filmmaking, and he produced and directed a feature film. It was a great experience for Joseph, but in the end Hollywood chewed him up and spit him out.

The whole time while shooting at the newspaper and making movies, Joseph was shooting weddings, so it was only natural for him to open a studio and shoot weddings full time. He loves people, stories, and life.

Cathleen D. Small has been a freelance editor for the past 10 years, taking on writing projects here and there to keep things interesting. Cathleen also taught college-level writing for several years before making the move to full-time editing. She holds a bachelor's degree in English from Arizona State University and a master's degree in English from California State University Sacramento. When she is not busy editing or writing, Cathleen enjoys developing her photography skills. She has completed a number of classes and workshops in different areas of photography and has won local awards two years in a row for her photography work. Her favorite subjects are her young son, Theo, and her energetic pug, Luna. Occasionally, her quiet husband, Chris, sneaks into a frame or two as well.

Contents

Introduction

First off, thanks for buying my book! I hope it inspires you to be a better photographer.

My goal with this book is to inspire you to push yourself and to better yourself as a more creative wedding photographer. If you're reading this book, you have most likely shot many weddings—or maybe just a few. Either way, the chapters in this book are designed to refresh your skills and question the way you approach booking and shooting weddings.

I have been shooting weddings for almost 10 years. The first wedding I shot on my own was all film, and the client was my high-school vice-principal's son. Since then I have shot hundreds of weddings, and my style and skills evolve and change constantly as I strive to push and better myself.

Please read the chapters ahead and understand that everything I say and do is what I've found to work for me. You certainly don't have to do things the way I do them. Think of this book as an op-ed on wedding photography. I strongly believe there is no one way to do something. There are endless methods, styles, and techniques. I hope you enjoy mine!

About the Series

Get inspired, go on an adventure, and step—no, leap—out of your comfort zone. You may just end up with your best photos yet.

The *Fearless Photographer* series tackles popular photography topics and genres, but with new twists and blends. Wedding photography meets fashion photography. Nature and surreal meet up to form something fresh and dazzling.

Don't be afraid to use what inspires you in your daily life and infuse your photography with new vitality. But it doesn't stop there. Learn to see the world and your subjects in a new light, and learn to photograph them in any light. Learn to choose the right clients for *you*, and don't be afraid to say no to someone who is not a good fit. Be fearless in how you shoot (hang from the rafters, lie down in the mud, stand a little too close to the fire!), fearless in how you market yourself, fearless in how you edit your images. Command your craft with confidence, and dare to challenge yourself each time you pick up your camera.

1

Philosophy:
Are You Ready to

I've been shooting weddings since 2000, and even after more than a decade of being in this business, I need to stay fresh, continually tap into my creativity, and constantly set goals and challenges for myself. Weddings are not for everyone, and every wedding is not for you. Let's talk about how to find weddings that *are* for you, so that you can be happy shooting and have happy clients.

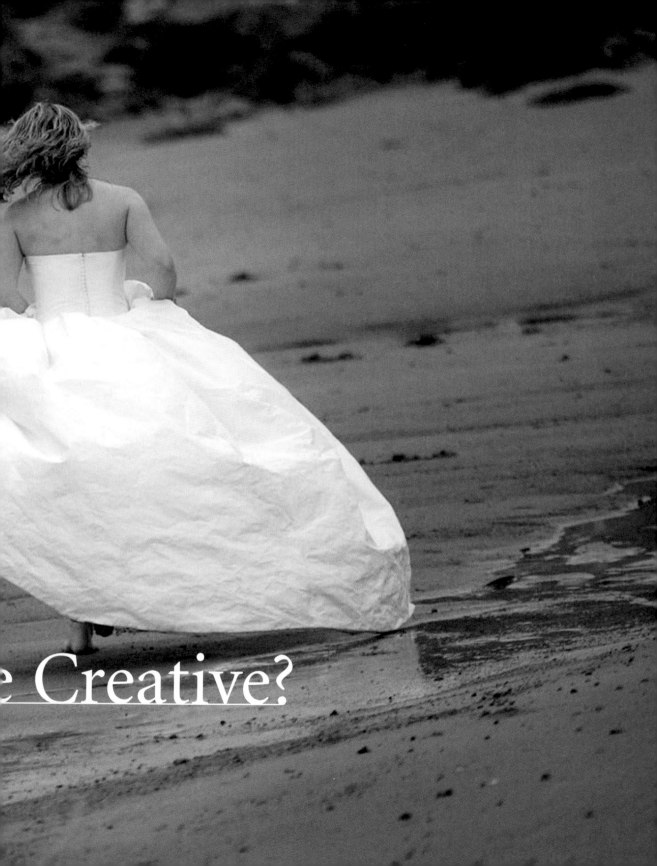

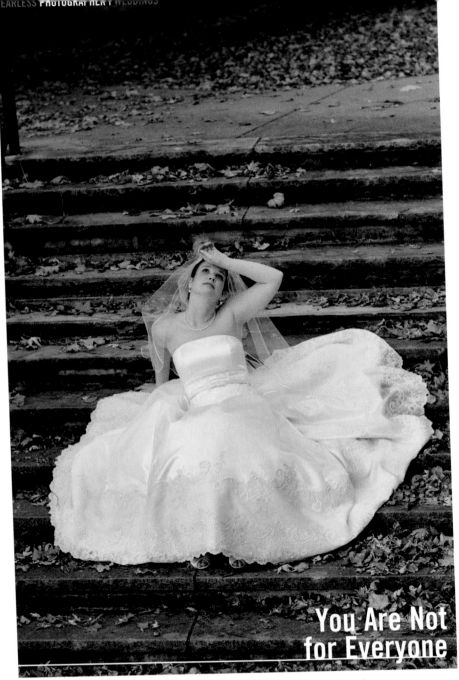

You Are Not for Everyone

Ever been to an art gallery or a museum? If you have, you know that there are many styles of painting—modern, Renaissance, oil, fresco—and then many more stylistic differences between painters themselves. Do you like Picasso, or are you more of a Monet fan? Regardless of your tastes, the style of painting you like may be completely different from what the person standing next to you prefers.

And just as each person has his or her own tastes in painting styles, so does each person have particular tastes in photography styles. As a photographer with your own style and way of creating images, don't try to make your photos—your art—please everyone, or you're setting yourself up for failure. I know that when I'm in a museum of fine art, I like oil paintings from 18th- and 19th-century Europe and the U.S., but I don't really care for a lot of modern art. Similarly, I know that someone who likes the photography of, say, Dorothea Lange may not be a fan of the work of, say, Robert Mapplethorpe. The photographers' styles are very different, so it would be unrealistic to expect that every person who loves photography would like the images of both.

NO FEAR

Don't try to please everyone with your style, or you'll end up pleasing no one. Shoot in the style you love, and people with similar tastes will be drawn to your work.

Knowing, therefore, that you can't please everyone, you must develop your own style that you like and enjoy, and you'll find people out there who will love it. Art is supposed to come from your heart, and photography is no exception. To create images that are empty of style and to aim to please the masses is no different than preparing a fast-food burger when what you really should strive for is an elegant sit-down dinner.

Developing your own style isn't something that will happen overnight. Style is something that takes years to develop. As you shoot and learn and frame and adjust to shooting in a certain manner, you'll develop your own style. Your style will be influenced by everything you know, like, and hate; but in the end, your style reflects you and your soul.

It took me many, many years to have a clear style, and there was never a time when I picked up my camera and said, "Oh, I have a style." It was more that when I put my work together, I could start to see commonalities between my shots, or when someone would look at one of my shots and say, "That's such a Joey shot."

When I'm shooting, I'm not thinking about style, either. I'm just shooting and concentrating on getting my shots. Color, contrast, framing, lighting, your use of your gear, and how you look at the world will all mix to form your style.

I also want to be clear that when I'm talking about style, I don't count style as, "Well, I'm a photojournalist," or "I'm a portrait photographer." Style is not something that can be grouped under a giant umbrella like that. Read your newspaper, and you can clearly see that many photojournalists shoot in different ways.

Your style is how your images interpret the way you see the world, whether you're a portrait photographer, a wedding photographer, a photojournalist, or a landscape photographer.

Pay Attention to the Moments, Not the Technical Bits

Don't pay so much attention to your gear and settings that you miss the striking, unposed moments.

One thing to keep in mind is that your camera gear has nothing to do with your style or how well you shoot. The camera is just a tool for you to use to capture light. You do need to be fully competent on how to expose, but it should be something you do quickly and then move on to shoot without worrying about it. Exposure and technical abilities should be second nature, and you should be concentrating on your composition, direction, and, of course, the moments.

When you are free from having to worry about finding that perfect exposure and you just get it and shoot, you can watch for the moments that are happening around you. If you're too busy adjusting your flash or changing the ISO or another camera function, you're liable to miss the moments that are happening all around you. Let go a little. Trust yourself.

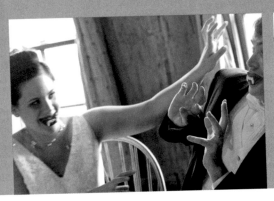

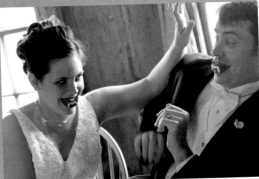

Get Clients Who Like You

We've established that not everyone is going to be a fan of your work; it's a fact. However, if your work is a reflection of your passion and soul, there *will* be people who love your work.

Brand Yourself

The first step is to advertise with photos that portray the kind of photography you love and want to develop. It's useless to show a photo that is not aligned with your style and expect to get hired by clients who'll truly appreciate your work. If you advertise with a photo that's not indicative of your style, clients will be sorely disappointed when they realize that your work isn't quite what they were expecting.

Your portfolio, slideshows, book work, and website should be fluid examples of the kind of photos you want to take. In marketing-speak, this is called *branding*—everything that relates to you and your company should reflect your style and work. If your style is happy, giddy color, and flair, that's what you should show if you want to earn clients who like that type of work. If your work is darker and more couture, show it. Display work that reflects your overall style and not just some average images, and you'll get clients who know what they want and like. You wouldn't want to get clients who hire you based on one photo in your portfolio that does not represent your overall style—they won't be happy or appreciative, and neither will you.

www.JosephPrezioso.com

This ad helped me weed out potential clients whose desired style wouldn't be a good fit with what I have to offer.

Create Ads That Reflect Your Style

The ad I ran in a local Boston magazine was not aimed at attracting every bride under the sun. I don't want that. It was aimed at getting brides who were a bit more edgy and fun. Hence the bride on the General Lee—I knew this image would scare away any bride who was not into what I had to offer, and it would save me the time and pain of meeting with brides and couples only to find out that we were not compatible. The brides who saw this ad and contacted me knew that I was different, and they were in love with my style—or at least intrigued enough to explore more of my work.

It's very important that your style and marketing be fully thought out and connected. All my branding and my company image reflect my style and the types of images I produce. When I do a bridal show—and yes, I do them—even my table or section has to reflect me. I want brides and couples to immediately know what I am all about, before they even say hello to me.

NOFEAR

Don't be afraid to step outside the box with your branding and company image. It can help you attract the kinds of clients who value something a little different in their wedding photographer's style.

At bridal shows, I distinguish myself from other wedding photographers by setting up a mini studio instead of using a plain, rectangular table.

One of the ways I do this at bridal shows is by setting up a living room or mini studio setup, in contrast to just using an eight-foot table. Being different and trying to create my studio at the bridal show brings out my style much more than just a plain table could ever do. I'm not saying there's necessarily anything wrong with using a table; I have before and will in the future—it all depends on the show and what I am aiming to get out of it.

Dress the Part

How you dress when meeting with your clients or dealing with inquiries reflects your style. It's one thing to be professional and well groomed, but it's another thing to be yourself and show your style. Anyone can wear a suit and tie, but if that's not your style and not how you would want to dress when shooting, you shouldn't dress like that when meeting with your clients. You need to reflect everything you do and want to do.

Obviously, don't show up dressed in ripped jeans and an unkempt shirt to meet a client. You should always be clean and well groomed, but if you are comfortable shooting and meeting clients in khakis and a polo shirt, then that's how you should dress. If you wear a suit and tie just to impress your potential clients, you may find yourself feeling very uncomfortable and stiff—and that may affect how you present yourself.

The bottom line is that your total branding, image, portrayal, advertising, and way of thought need to be in sync so that your clients know exactly what they are looking at when they see you, and they know what to expect and fall in love with.

My new marketing kit is much more me.

Your Marketing Kit Is a Reflection of You

This is my old marketing kit showing some fun and giddiness. It's a good shot and a great ad, but it didn't market me the way I wanted. Fast-forward two years with a new company logo and branding—my new marketing kit shows off my style and look. At the same time, I went from wearing a suit to new meetings to wearing jeans and a cool dress shirt, with styled hair.

My old marketing kit was certainly presentable, but it didn't really reflect my style the way I wanted it to.

Your Niche Wedding

When I first started shooting weddings, I shot for a wedding agency for two years. Prior to that I was a newspaper photographer. Shooting for the agency allowed me to experience many different weddings, from lavish and large to small and just plain trashy, as they say.

After a few years, I became aware of wedding styles—not my shooting style, but the wedding as an entity itself. I learned that I didn't want to be the American Legion Hall photographer. I wanted to photograph fun and intimate weddings with interesting locations and splendor—that's my niche. Does this mean that I wouldn't photograph a function hall wedding if that's where my clients were having it? No. It just means that I don't show that type of wedding in my portfolio. I want to attract brides who have weddings with a much larger story to tell. I like weddings where there is a story and a background for the couple's love, not just a rushed gathering of people and a Justice of the Peace.

So how do I secure these weddings? With my price and my style. Read on…

Let's say you're offering weddings at $500 (yes, super low). Then you're not likely to attract a couple spending $75,000 on their wedding. They're going to be looking for higher-priced vendors that are in their price range. This isn't always the case, of course, but I usually find it to be true.

I find that most couples having average weddings want to spend about $2,500 for a photographer. Then you have the next range of $3,000 to $6,000 and then finally the $6,000 and up range. Prices can vary a bit depending on where you are in the country, but I find these ranges to be pretty standard.

You can charge whatever you want, of course. I find myself in that $3,000 to $6,000 range, because that's what most couples in my area are willing to spend on a wedding photographer. Do I lose out on a lot of weddings for couples who want to spend less? Yes, I do, but I'm okay with that. I don't want to shoot 70 weddings a year at $2,000 or so per wedding; I would rather shoot fewer weddings and make more money.

Price Yourself Appropriately

Price yourself in the wedding market that you want. Your pricing should reflect your work and your style. If you have low prices and quality work, there's a good chance that the client hiring you will not really appreciate your work for what it is, other than a good deal. This isn't always the case, but often it is—some clients are notoriously price-driven. And so, your fees should reflect the budget of the weddings you want to shoot and the market you live in or want to shoot in.

Another photographer once told me that shopping for a wedding photographer can be compared to buying a car. If you had the budget to buy a high-end car, would you even go to the budget lot? No. It's the same with weddings. The wedding couple you want is going to look at the range they want to spend and the style they want. If you price yourself too low, you'll miss out on your target market, and the same is true if you go too high.

NOFEAR

Don't be afraid to set your price high enough to put yourself in the market for the types of weddings you want to shoot. If you price yourself too low, you may find you'll only attract people in search of a good deal.

The point here is not to be greedy, but to gain the client market that's right for you and to create a niche for yourself. You need your own market to survive and be happy. If you were like every other photographer, you wouldn't stand out—you'd just blend in. That's all fine and good if you want to hide, but I prefer to stand out.

Continue to Develop Your Niche

Once you have your niche, develop and work it. You should never rest or be satisfied. Every wedding should allow you to hone your skills as a photographer. Your style will evolve, and your clients will love the work you produce.

There are plenty of ways to develop your niche and stay fresh. There are classes and conventions, such as the DWF or WPPI, that I try to attend myself every year to see and hear what everyone is doing and to toss around ideas and tips.

Some photographers develop their niche market as a "trash the dress" shooter, a pure photojournalist, or a destination-wedding photographer. There's fashion, fun, retro, and super-stylized. There is really no end to the niches that are out there.

It's important to remember that not every wedding and couple will be your ideal situation. And you know what? It's totally cool, because they love your work, and that's why they hired you. Your job is to treat them the same as any other wedding couple and shoot your style, use your creativity, and make art. Not everyone is a Kate Moss or a Frank Sinatra, but everyone has character and image and can be photographed with style.

Catch the Eyes of Wedding Planners

Once you start producing work that has its own look and is consistent, you can be sure that you'll catch the eyes of people looking at it—not just brides, but wedding planners and coordinators. If your work stands out, and you're generating happy clients, planners will be sure to know. Planners are great assets for attracting new couples, because they can help find couples that fit you and your style.

"Not everyone is a Kate Moss or a Frank Sinatra, but everyone has character and can be photographed with style."

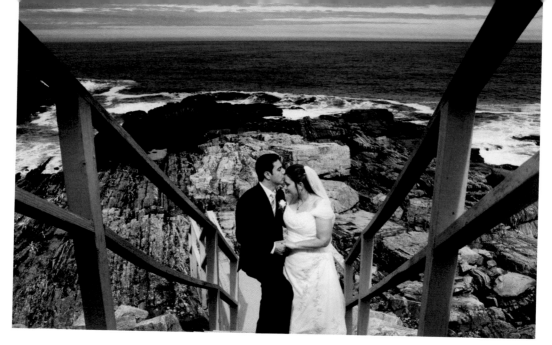

I work with a few Boston wedding planners, and they know when they have a couple that might be a good fit. When they do, they send the couple my way or contact me on the couple's behalf. This only works, though, if you have a consistent style and you end up with satisfied clients. If you shoot one low-end wedding that looks lousy, and the next one is high-end society and looks like gold, you've accomplished nothing. You need to shoot every wedding the same, whether it's at a regal mansion or a local hall. Your greatest challenge is nothing short of being able to create amazing images anywhere you go. If you can do this and be consistent with your work and style, you're sure to be added to a wedding planner's address book.

Don't Shoot to Get Paid

Don't shoot to get paid—shoot because you love it, and you will get paid. That is the honest truth.

I'm an artist and a businessman. I can't just be an artist, nor can I just be a businessman. I need both. Having a lifestyle and material things costs money, so I have no desire to be a starving artist, and neither should you. You need a good balance of business smarts and art to succeed. If you're doing good business, then you'll have no problems getting work and being free to express your style to others. If you're just an artist with no clients, then you might have style, but no one will see it or appreciate it, and you won't be able to live.

"I can't just be an artist, nor can I just be a businessman. I need both. I have no desire to be a starving artist, and neither should you."

Shooting weddings is a passion of mine. I love people, emotions, ceremonies, intimacy, fashion, and most of all, my clients. I can honestly say that if there were no such thing as money, I'd still want to shoot weddings.

Part of shooting weddings has to come from your desire to *want* to shoot weddings. If you don't really enjoy people, groups, parties, and intimacy, you might want to put this book down now and change careers.

If you are in love with weddings and people, you'll succeed, but not if you're just shooting for a paycheck. You need to want to challenge yourself, break boundaries, and push your work.

Build a Relationship with Your Clients

Just being a good photographer and having a cool style and image is not enough. You need to build real and healthy relationships with your clients to be successful. Your clients should love you, and you should love them. When they love you, everyone will love you. If they hate you, many people will hate you. You have to love your clients and find out who they are, what they do, and what type of people they are.

Orchestrate the Initial Meeting

The first meeting with your couple, before they're even technically your clients, is the most important meeting you'll ever have with them. Presenting yourself to them, introducing your work, and letting them get to know you is how they'll determine whether you are the photographer for them.

I recently had a three-hour meeting with a newly engaged couple. We'd been emailing back and forth for a few days, and the bride and her fiancé finally found time to meet with me at my studio. I greeted them at the door as I do all my clients, and then I gave them some bottled water and took them up to my studio.

My studio was already in what I call "client mode" by the time they walked in. All the lights were set to a moody, romantic look, and I had set the right music and a giant slideshow on my studio screen. I want my couples to walk into another world when they enter my studio and say "wow".

NOFEAR

Pull out all the stops for your first meeting with your potential clients. Remember what they say about first impressions....

My studio is decorated with my work and furniture that represents me and carries out my branding and image to the couple. When they see my studio, they see an extension of me, just like on my website and in my images.

When the couple sits down and we start to talk or look at my work, they're already in my world. The answer to whether they want to be in my world on their wedding day is something I'll know at the end of the meeting or in a few days. Either way, I'm showing them me and not someone else or any mismatched styles. Everything I do is done in my style. I am consistent, and that portrays confidence.

Think of it this way if it helps: If you went to a high-end car dealership, and the salesman was dressed like a clown, would you buy the car? If you were at a high-end steakhouse, and the waiter came over in shorts and a tank top, would you want to eat there?

Image is everything, and your clients are not just buying your photos; they are buying an experience. Your time is your most valuable asset, so make sure your couples know what they're paying for. Anyone can take a photo in perfect conditions at a perfect scene, but only you can make a photo that has style and can look good no matter what the situation is.

Making Friends with Your Clients

I try—and I mean *really try*—to become a friend of the bride and groom. I want to know all about them, and I want them to know about me. If my clients see me as a friend and not as just a photographer, then I'll be able to get more intimate shots with them. Better shots for them translate into a better portfolio for me, as well as happier clients. Win-win.

NOFEAR

Don't be afraid to make friends with your clients. Be professional, of course, but also make a real attempt to get to know them. If you do, you'll get better shots of them on their big day—they'll thank you for it, and your portfolio will, too!

You are spending one of the most important days of the couple's lives with them. You see every moment and capture the tears, smiles, kisses, and many other emotions of the day. Knowing my clients gives me a better handle on how they're going to react to events of the day and lets me better capture their images at those events.

I've had couples who become super close to me at their wedding and tell me things that most of their family members and friends probably don't even know. This might be how they feel, things going on in their lives, or really naughty personal info that's just not appropriate! Whatever they choose to share, knowing these things helps me when I'm shooting them, because I know how they feel and can form a better idea of how they might react to things I might say or what others may say or do.

Knowing my clients helps me better capture their intimate moments.

I've had brides who were super-emotional and would cry at almost anything, and I've had others who were not emotional at all. Knowing the differences in how people react will let you better capture them. Some people laugh and others cry their eyes out. The criers may want very dramatic emotional shots, whereas some fun jumping-in-the-air shots might appeal to the more giggly couples.

The first step after booking clients and talking to them via phone or email is the engagement shoot. I get to spend a few hours with the couple; we can joke, talk, and share stories. It's a time for me to

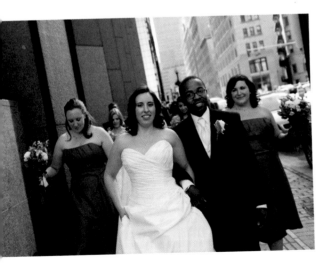

connect with the couple and them with me. Many times engagement shoots end with me having drinks or dinner with the couple. This is really special to me, because I feel I've just made new friends, and my clients now see me as a friend and not just a guy with a cool camera.

Before the shoot, I always try to find out as much as I can about the couple. This helps me plan out the engagement shoot so that it's something special for them and not just a photo for the newspaper. I like to ask where they met, where they hang out, and what's an important or special place for them. Knowing the importance of the location where you are shooting them and treating it as a third subject in your shoot will enhance the engagement shoot.

For example, if I'm shooting in the city, then the city becomes a subject I must take into account when shooting my couple there. The buildings, lights, and bustling people are all elements that I have to mix with my couple as we shoot. It's like that 500-pound gorilla in the room—you can't ignore it.

You can't ignore the city, so you might as well embrace it.

Stay Open to Ideas

Be receptive to ideas with your clients. They may have picked you for all the cool shots you do, but they may have some shots in their head that are not your style but that you can capture. Any time a couple asks me to take a shot, I do. You can't be egotistical about it. If it pleases your client who already loves you, do it—and add some of your style to what they want.

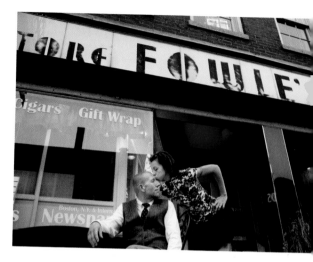

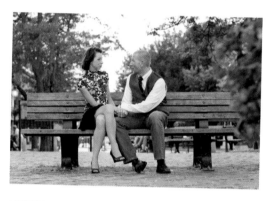

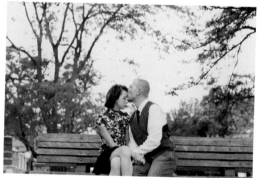

This is something the couple wanted to start with—them on a bench. It's not my favorite place, but we started there, and from that I was able to get them to open up and have fun, and we eventually got the next two shots.

Now that we've covered how to establish your style and branding and how to find clients who'll love your work and then build a relationship with them, it's time to move on to the ever-exciting (but necessary) discussion of your gear. Turn the page to learn more....

2 Gear:
It Does Make a D

We all have tons of gear, some of it useful and some of it just a gimmick. Good gear can make the difference between getting a shot and not, but in the end it still comes down to knowing how to use your gear. You may have the newest top-of-the-line equipment, but do you know how to use it? If you don't, you might as well be using an inexpensive point-and-shoot.

Being creative isn't solely based upon your mind and your ideas; it's also very much based on what your gear can physically do. You don't need every new-fangled invention or tool to be able to capture great moments and create beautiful shots. What you do need are reliable, professional products that won't break down or fail when you need them.

Good gear is what works for you, not what works for everyone else. I wouldn't want to shoot a wedding with a point-and-shoot, but hey, if you can, great. And if you want to use a rangefinder, do it—as long as you know it, trust it, and can work it.

fference

Lenses

Cheap lenses from camera kits won't cut it. Lenses should be fast—focus-wise, but primarily aperture-wise. Most weddings receptions are mood-lit or in low light indoors, so every stop of light you can gain with a lens is a major help.

Lenses should also be sharp and lightweight. I prefer prime lenses (lenses that are just one focal length and do not zoom) because they're faster and sharper. I prefer to move around and work on my composition that way, rather than use a slower zoom lens. I do use zooms for some things, but generally, I like to bring a good number of prime lenses with me to every wedding.

Today, there are zoom lenses that are faster and sharper than many prime lenses, and many photographers use them to get incredible images. Nikon and Canon make incredibly fast and accurate image stabilizer lenses that let you obtain a sharp image at a lower shutter speed and capture an amazing shot.

So why don't I use these new-and-improved zoom lenses? Quite simply, I like the lenses I already have. I know how they work and what they can do for my clients and me. I know that I can capture superior images of a couple's big day with the quality lenses I have, so I haven't yet been inclined to replace them. That doesn't mean I won't in the future, though….

There are so many reviews of lenses online today that it's easy to find a good lens and know what it can do and what it can't do. In the following pages, I'll talk about the lenses in my camera bag and how I use them. I realize that much of my gear may be old, but as I said, I love it. I purchased high-quality lenses when I started my collection of gear, and they haven't ever let me down.

When I'm shooting, I carry two bodies and several lenses: a telephoto lens (whether my 85mm f/1.2 or my 80–200mm f/2.8) to cover things far away from me, my standard/wide 35mm f/1.4, my 20mm f/2.8 to cover large scenes or when I am close to everyone, and my 50mm f/1.4. That's it. With two bodies and these lenses, you can cover an entire wedding and be light and free to move and shoot. I like to be able to shoot things that are happening all around me, so I can use my 85mm or my 80–200mm zoom to capture things that I am not close to, or I can use them to isolate subjects. If something is happening close to me or I want to get a wider view, I have my 35mm or 20mm to use.

As a photographer, you should have lenses in your bag that can help you capture light in whatever the situation calls for. Whether you have two zoom lenses or eight primes, you should have a few lenses. I use my primes, but you could easily use two zooms—it's just preference.

Know What Your Lenses Can Do

Every lens has a different look. The perspective of a 50mm is completely different from that of a 20mm, an 85mm, or a 200mm. For example, I would never use a 35mm for a headshot, because it wouldn't flatter the subject's face—it would exaggerate it and stretch it out. I'd use an 85mm or a 200mm because it would compress features and create a more flattering look.

Telephoto lenses compress the scene and bring the background closer into frame, whereas wide-angle lenses exaggerate the scene and give the impression that the background is farther away. Normal lenses, such as a 35mm or a 50mm, tend to be more realistic and like what we see. If you take just one lens, such as a 28–80mm zoom, you're missing out on so many looks that lenses can provide. An f/2.8 will never be an f/1.2; they're two different looks altogether. The depth of field—that is, the area in apparent focus—at f/1.2 is a lot less than on the same 85mm on a zoom at f/2.8, so even though you're at the same focal length, the two lenses could give different looks. Lenses also have their own distinct bokeh, which can add to your images' look.

Bokeh is the quality of the out-of-focus areas in your image; they can be foreground or background. Every lens's bokeh is different and based on the lens elements and aperture blades within the lens. Some lenses have harsh bokeh, and others have more pleasing or milky bokeh. It has nothing to do with a lens being a prime or zoom or what f-stop you're shooting at. Bokeh is usually more noticeable on out-of-focus highlights, which can appear as circles. So take a look at the out-of-focus areas of your images and see what you like and don't like.

You might be wondering why this is important. It's important because if you are to create dynamic images and create your own style, you'll need to know what your lenses can do and how they affect what you're photographing. Aiming for dramatic shots that wow your clients will determine how you shoot.

For example, if you were on a hill with mountains in the distance, and you had the bride and groom in the foreground, would you shoot with a wide-angle lens, a telephoto lens, or a normal lens? What would each do, and how would they affect the shot? You need to know these things!

When the time comes and your bride and groom are having their moment, you need to know what lens to shoot it with. You can't say, "Let's try this," look at your LCD screen to review every shot to see whether you like the look, and then shoot. If you're reviewing shots on your LCD (also called *chimping*), and you're not ready for the moment with your gear, you're going to miss the moment and the shot.

My Canon 1D MKIII with an 85mm f/1.2 lens.

A wide-angle lens will make the mountains in the distance look far away, exaggerating and expanding the distance between objects, whereas a telephoto lens will bring them in and compress everything so that everything seems very close, as if the mountains are right behind the bride and groom. Which shot is better? Neither, really—it depends on what you want. But if you don't know what you want, then you're not ready, and you'll miss some amazing shots.

Lens Specifics

So now that you know what to look for in a lens and what general types you'll likely want in your bag of gear, let me go through a few lenses of mine that I've found serve me well as a wedding photographer.

"Take multiple shots. You don't want to take one shot and then later realize you have to Photoshop eyes on a person that blinked."

The 85mm f/1.2

An f/1.2 lens is very versatile at weddings. You can use it to shoot in very low light and maintain a fast shutter speed to freeze action and get a very sharp shot even at f/1.2.

This lens lets you shoot without flash in places where you need to be invisible or prefer to be unseen or noticed. (And during the intimate atmosphere of a wedding, the last thing you want to do is stand out!) Anytime I want to get close shots of my clients and not be in their face, if there is low light, this is the lens I use.

"During the intimacy of a wedding ceremony, the last thing you want to do is stand out."

An 85mm f/1.2 lens.

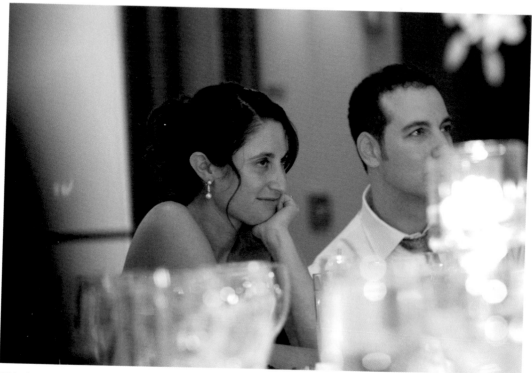

This image was taken in low light with my f/1.2 lens.

Dark reception? No problem—this lens rocks the darkness. Just find a little light, and you're all set. You don't want to be popping flash every second and having to wait for it to cycle or carry a battery belt for it. This lens frees you to just be there and shoot. At f/1.2, you won't have to worry about waiting for your flash to cycle. Just keep shooting.

The 80–200mm f/2.8

The 80–200mm f/2.8 (which is now a 70–200mm; mine is rather old) was one of my favorite lenses until I purchased the 85mm f/1.2, but this lens still comes to every wedding with me. This is the lens that I use to get shots that I can't get near enough to shoot with the 85mm.

The lens is a fast f/2.8, so it's limited to fairly well-lit locations without flash or image stabilization. With flash, you can shoot in any light with it, and I've used it to cover entire receptions. New versions of this lens from both Canon and Nikon include image stabilization that even allows you to shoot without flash in low-light situations and capture shots at shutter speeds that otherwise wouldn't be possible without flash. I haven't used one of these image-stabilized lenses yet, but that's because, as I mentioned earlier, I'm quite attached to my old gear. However, I do see a new 70-200mm stabilized lens on my wish list. I always want to push myself to learn more about my craft, and trying out some new gear is a goal of mine…no matter how much I love my tried-and-true lenses.

But back to my trusty 80–200mm f/2.8… This lens excels at large outdoor daytime weddings, where everything is very spread out, and you don't want to miss out on any of the action. If you see something happening across the tent or vineyard, for example, you can just zoom to 200mm and get a great shot.

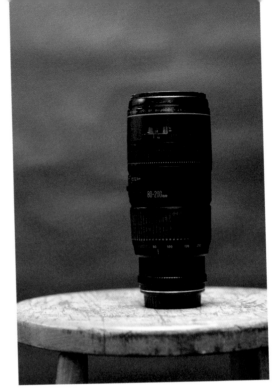
An 80–200mm f/2.8 lens.

This lens also excels at giving your bride and groom space so that even when you *can* get close, you don't have to. You can let your couple be intimate without you breathing down their necks. Distance is a great tool for letting people open up to each other, which will result in better, more natural images of the couple.

NOFEAR

A versatile lens like my 80–200mm will let you get close, intimate shots of a couple without hovering right next to them. A great compliment of a wedding photographer is, "I didn't even notice he was there!" A lens like this lets you get the close shots the couple wants without you being intrusive.

The shallow depth of field blurs the background trees beautifully so that the couple is sharp and bold in the foreground.

The other useful feature of this lens is its effect on the image. The 200mm can compress everything as opposed to stretching it out, like a wide-angle lens would. It also brings the background closer and allows for a shallower depth of field. You can utilize this for portraits by totally blurring the background and giving a flattering look to your clients, making them look very bold or isolated against the soft background.

This is very important, too, if you're at a location where the background is very busy, and you want to get an isolated shot of your clients. This lens can blur out the busy background and procure a sharp portrait of your couple. The downside to this? You might have to yell at the couple, because you'll have to be fairly far away to fit them into frame at 200mm. In a case like this, I suggest you first go over with the couple what you want them to do and then back off until you are in position—then give them the go-ahead. Trust me, it's better than yelling.

The 35mm f/1.4

The 35mm f/1.4 is my favorite lens and the one I would choose if I were only allowed to use one lens. At 35mm, it's not super wide, but it's very much what our eyes see. And at f/1.4, you can shoot in any light. Because it's fairly wide, even at f/1.4 there's a good depth of field. This lens allows you to get really close and shoot your clients without flash, so you can capture them in very intimate moments. Not having to zoom and pretty much having the field of view of your vision, you know that what you see with your eyes you can capture, and you don't have to worry about zooming for backing off or getting close.

I don't recommend doing close-up portraits with this lens, because the wide-angle tendency of it will distort your clients for a not-so-pretty look. It can be used perfectly for what I like to call "environmental portraits" of your clients—portraits that include location and a subject, such as a bride on a sofa or in a field, where you want the field to be in focus and prominent. The lens can also open up wide and has great background blur at f/1.4, which can make your subject really pop, if you want it to.

I used my 35mm f/1.4 lens to capture this low-light shot without a flash.

I find this lens on my camera from the moment I meet up with the bride and groom while they're getting ready to when they're dancing. I don't use it for shots of everyone boogying on a packed dance floor, because it's not wide enough for being in the mix of everyone right on top of me dancing (I get right onto the dance floor); but other than that, I use it for all the family formals and all the moments of the day, which I'll go over in later chapters. For now, just know that this lens is fast and ready for anything.

The 20mm f/2.8

A 20mm f/2.8 lens.

I love super-wide shots, as you will learn, and this lens gets them without a hiccup. Although it's not as fast as an f/1.4 lens, like the 35mm f/1.4, this lens is ready to take on the day or night or whatever light your wedding throws at it. (I usually shoot around f/2.2 to f/2.8 anyway.) If you're in a small space but you need to get a wide shot or you want to capture a really cool vista, this is the lens to use. It can be used in low light with high enough ISO and flash, and this is the lens I use to photograph groups of people dancing at weddings. It allows me to move around the dance floor with the crowd; I can dance a bit here and there and just hold the camera out and shoot.

NOFEAR

Use a 20mm lens with a wide aperture to get those fun dance-floor reception shots. You can be right in the middle of the action, capturing the images, with a lens like this.

"The couple's big day only happens once, and you don't want to miss capturing their memories because you forgot to pack your backup lenses!"

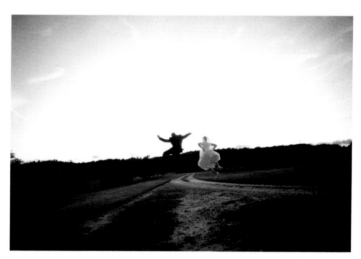

An outdoor shot taken with the 20mm f/2.8.

An indoor shot taken with the same lens.

Twenty millimeters is wide enough that the lens has a huge depth of field even at f/2.8. You can hold it however you want, not even looking, and shoot paparazzi-style, or you can frame for something cool. However, I find that if I'm in the middle of a packed dance floor, and everyone is jumping and moving all about, it's generally easier to just hold the camera up in the air and point it where I want to shoot.

I do use this lens for portraits once in a while, when I want to show the couple with a huge vista, but otherwise I am not a fan of this lens's look for portraits.

Perhaps you're saying to yourself, "Is that all I need to bring?" The answer is no, but that's what I primarily use. I do bring a 50mm f/1.4 lens and a 28mm f/2.8 for backup. I am all about backup! If one of your lenses fails, is stolen, or gets dropped, you need to be able to keep shooting. The couple's big day only happens once, and you don't want to miss capturing their memories because you forgot to pack your backup lenses.

Bodies

So aside from all those lenses, what bodies do I bring? Just as with lenses, I believe in speed, durability, and utility. I use Canon 1 series bodies, and at the time of this writing, I have the 1Ds Mark II and a 1D Mark III. I also have a 1Ds as a backup for that just-in-case scenario.

When digital first became available at the less-than-$10,000 range, wedding photographers everywhere (well, almost everywhere) went out and bought these new devices and implemented them into their wedding shoots. The biggest mistake many photographers made is that they took for granted that these new cameras could do a lot

of the thinking for them and could make all the decisions. They gave up using their light meters and manual flashes, and they put everything on Auto or Program.

Many photographers were also used to having the high exposure latitude of color negative film, so that if they overexposed with flash or underexposed their shots, they knew that the negative would still be okay, and their labs could save or still get a usable image out of the negative. Shooting digital used to be much like shooting slide film—there was not a huge exposure latitude like that of negative film back in 2001, maybe 5 to 7 stops compared to 8 to 10 of negative film. (Today's digital cameras have a 10 to 15 latitude range, depending on the camera and the Raw or JPEG processing you use.)

So when these photographers went out and started shooting digital, there was no lab or negative to save their shots, and they got stuck letting the camera make the decisions for them, and the Program mode became their lab. Today, the lab is your computer, and you can post-process and pull tons of details from highlights and shadows…to a point. In the end, though, if you're letting your lab or your computer save all your shots, then you're not getting your exposure right in the first place, and you're not being the best photographer you can be. Granted, I often use Photoshop to burn or dodge elements in a photo, but I try to get my shots 95-percent accurate in frame. In post-production, I usually just add saturation or contrast, because I shoot my images with my digital camera set to neutral.

The point I'm trying to make is that you need to get your exposure correct in the first place. If you don't, you're really not doing much more than a guest with a point-and-shoot camera using all auto modes on his camera.

"You're the expert! Remember that ultimately, you know more than anyone else about how to get a great shot."

In my mind, letting the camera do the work for you kills creativity and is a mistake. Even though these new cameras have a million features and state-of-the-art functions, you need to tell the camera what to do, and not the other way around. Don't just have your lab or computer save you—remember that you're an expert here. No matter how good your camera is, you ultimately know more than anyone (or anything!) else about how to get a great shot.

Shoot with a Pro Body

It doesn't matter whether you shoot Canon, Nikon, Pentax, or whatever, as long as it's a pro body with pro features. I don't like the cropped sensors or slow auto-focus that so many prosumer bodies have, nor do I like their lack of seals to save you if you're shooting on the beach. You can use any particular brand of camera you like, as long as you know what it can do and you understand its limitations. I learned on the Canon 1 series, and I've just stuck with it because holding one is second nature to me.

Of the utmost importance with any body you choose is understanding how it works. Reading the manual is very important if it's a brand-new camera to you. Today's cameras come with countless custom functions that you can modify, from setting the flash sync to the rear curtain, all the way to adjusting how the auto-focus works. The goal of all these features is to make the camera do what you want it to do. You're not forced to only focus here and click there; you have the ability to make the camera do things the way you want it to.

What most photographers want in a body—film or digital—is great metering (spot and matrix) and fast and accurate auto-focus. All the other features are just extra—aside from, of course, expected features, such as a fast flash sync speed, a fast frame speed, and maybe some weatherproofing to save you if you have to shoot in the rain.

I prefer full frame bodies for my 35mm and 20mm lenses, and I use the 1.3 cropped sensor body for my 85mm and 80–200mm lenses. One key thing to remember when using a cropped sensor body is that you are not magnifying your lens; you are simply cropping the image via the camera, as the sensor sees less of the lens's full circle of coverage. I use mostly prime lenses, and I like getting the full frame of my lens, so I prefer full frame bodies.

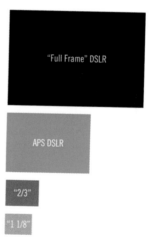

This graphic shows the different sensor sizes available today compared to that of 35mm negative film, which encompasses the full circle of coverage of a 35mm camera lens.

A must-have for pro bodies is a double memory card slot so that you can back up photos as you shoot. Cards can go corrupt, and having them backed up while you shoot can save you if your main card ever fails, breaks, or just crashes.

NOFEAR

No matter what, be sure you have a double memory card slot in your camera. It will prove invaluable in case of card failure.

This Canon has two memory card slots so you can back up your images as you shoot. The Nikon D3 series also has this, and it's a great feature.

Understanding Sensors

All digital cameras record their images via a sensor that is either a CCD or CMOS and is rated in pixel count. The more pixels the sensor has, the larger the file size and the bigger the image. It's commonly misunderstood that you always need a huge sensor to make great images. That is not true. Color and dynamic range have increased with newer sensors, but you still don't need to go overboard if the biggest photos your clients are ordering are 11×14. I shot for years on a four-megapixel camera and made many 12×18 albums with it, and the images were always fantastic. Today I shoot at 11 and 17 megapixels, and to me that is more than enough. I can blow up to 40×60 and retain high levels of detail (sometimes even the pores on people's skin) so that the image does not fall apart when you look at it up close.

What the new sensors are providing along with the greater megapixel count is higher ISO sensitivity. Just a few years ago, I would never shoot wedding formals over ISO 400 or reception moments over 1600—and that was grainy, or *noisy*, as it's referred to in the digital world. Today, I can shoot at 3200 or 6400 and get images that look like they were shot on the ISO 800 or 1600 of just a few years ago.

These new sensors allow you to shoot in so many situations where flash would have been a must-have in the past. You can now get shots that you never could have captured in the past. The darkness is opening up to photography and higher ISO, and clean and clear images are letting us capture these dark moments that would otherwise be hidden.

There was no moon when I shot this image—just two outdoor lights. I shot this at 3200 ISO handheld, at 1/13 second. Look at how the grain is— it's not golf-ball sized, like it would have been in the past.

There was no moon when I shot this image—just two outdoor lights. I shot this at 3200 ISO handheld, at 1/13 second. Look at how the grain is—it's not golf-ball sized, like it would have been in the past.

Shooting Film

Another important fact that I want to mention is that you don't *have* to shoot digital. I learned photography on film and, like many other photographers, I shot weddings on film, too. To me, film is cool, classic, and has a look of its own. You can do all the post-production work you'd like to digital files; but to me, 3200 ISO B/W film still rocks, as do some Fuji and Kodak stock films.

Film is costly today, as it has always been, so it's not really economical to shoot weddings on film in a digital era. Film is more of an artistic choice—something I do because I like it. That said, it can be fun and can get you different looks. Plus negatives, if cared for properly, will last much longer than a non–archive quality burned CD or hard drive.

I take a panoramic film camera to my weddings. Although I just started using it this season, I'm already achieving so much more with it than I would by taking a digital shot and cropping and manipulating it. I'm using film as a side or second body for unique moments that would look great on my panoramic camera and the film I have loaded. Would I shoot the entire wedding with this camera? No, but with another body and tons of film I could.

There are many excellent film cameras out there today, and it would be wrong to think film is a total waste of time. It's another creative outlet. Most feature films are still shot on film, scanned, and then edited. Shooting film at a wedding can be the same.

"Film is an artistic choice—something I do because I like it."

A panoramic shot taken with my film camera.

A Nikon N90 film camera.

So grab a 645, a 35mm, or any old film camera and shoot a few rolls to see what you get. You may be surprised at what you see. Using a film camera will also make you shoot a bit differently, knowing that you need to make all your shots count because you don't have an endless roll of film.

NOFEAR

Shooting film is a scary thought to some, an intriguing challenge to others. What do you have to lose? Grab a film camera and a few rolls and give it a shot (pun intended). You might be pleasantly surprised by the results.

Filmstrips make awesome contact sheets!

My Crazy Russian Panoramic Film Camera

My Horizon panoramic camera has a swing lens that rotates with the shutter and takes wide-angle 28mm shots on 35mm negative. The resulting image is 24×58mm as opposed to the 24×36mm of a normal 35mm shot. The camera is great for vistas and wide shots with a lot going on.

With no meter or battery, the camera is totally manual, so I need to think fast and make sure my settings for exposure are correct if I want to get a good shot.

Focus

Probably one of the greatest inventions for personal cameras and professional cameras alike was the introduction of auto-focus in the late 1980s. The first auto-focus cameras were slow, and the lenses whined as the primitive elements moved around to align the lens elements. They were slow, noisy, and pretty much a pain in the you-know-what.

Today's lenses are super fast, quiet, and a pleasure to use. That said, I still use manual focus. Ha! I feel like the anti-technology camera guy sometimes. Lest you think I fear technology, let's get into why and when I use auto-focus and when I don't, as well as how auto-focus works.

Auto-focus works with an auto-focus sensor inside the camera that looks for contrast and sharpness at predetermined spots (focus selection points). Some cameras also use infrared beams to measure the distance to the subject and point selected and turn the lens to the exact focus point. Focus modes can be one-shot—which is when you focus and then can take a shot, and then you have to focus again—or servo, where you can keep shooting, and the camera's sensor will track the subject as it moves.

I like to use a combination of auto and manual focus, and I find it's a pretty 50/50 split. Sometimes I'm just supercritical, and if I'm shooting at a really open or wide aperture, such as f/1.4 or f/1.2, I know I have to be on the spot or my shot will be blurry, and there's no room for error. For this reason, I switch to manual and focus dead-set on the eyes and then recompose. I sometimes use the infrared assist from my flash to focus in low light, but I often find that by the time the beam has gone out and come back and the camera focuses, the shot or moment is over.

Some of my lenses offer full-time manual focus, so even in AF mode I can turn them and adjust my focus to where I want it to be. In situations where it's sunny and bright out, and I have good depth of field, I am auto-focus all the way. The same is true when I am shooting moving subjects, such as the bride coming down the aisle with her father. At times when things are perfect or too fast for me to control, I let the camera do the work. When I have the time to focus myself or the lighting conditions dictate the need to do so, I switch to manual.

As with everything else, not all cameras' auto-focus systems are the same. Generally (but not always), the more you pay for a newer body, the better you get. However, some cheaper new bodies may have much better AF systems than a body from the year before that was at a much higher price. It's the same as with any technology—the price can come down and the quality can go up as new models are created and released. But often, it all boils down to getting what you pay for. A high-quality camera with a good AF system will probably not come cheap.

Reconfigure Your Shutter Button

Some cameras today allow you to rearrange some of their functions by changing the function of certain buttons. You can set your shutter button to just trigger the shutter and not control any focusing, and by doing that you allow another button to be pressed for focusing. This way, your shutter button is no longer linked to your auto-focus button, which is useful if you just want to set your focus and know it won't change when you go to click the shutter; it will only change when you hit the AF button you assigned.

I always use manual focus for detail shots like this one.

My bodies have 45 auto-focus points, which allows me to select almost anywhere in the frame to focus and shoot. Some cameras' auto-focus systems have five or seven or even three points. I like to have more points so I can be more selective about where my focus is, such as on a subject's eye or someone's finger. It may sound strange to think about someone's finger as a focal point, but remember, we're stepping outside of the box here. Think about a portrait shot with the bride's ring as the focus point. The image of the bride may be slightly softened, but the ring will be clear and sharp and will really pop. That's a beauty of having many auto-focus points—you can think beyond the standard "eyes as focal point" portrait and come up with something more unique and creative.

However, it's important to remember that more points doesn't mean more accurate. Many new five- or even three-point systems can lock onto a subject in lower and less-contrast light better than one of my older bodies could. The key is to find out how your AF system works and find one you like that suits the way you shoot.

Many times I'll auto-focus, lock my focus (by clicking AF off), and then shoot. I just don't trust auto-focus if my subject is not moving. I keep auto-focus on for all the formal dances, speeches, and crazy party dancing. I pretty much use manual focus in dark churches, portrait photos, and open-aperture shooting that needs to be super exact.

When I'm shooting a detail shot of a ring, and I have a lens in macro mode or really close up, I use manual to focus on the diamond exactly as I want it to, so that it's perfect and the way I want it to look. Auto-focus may or may not be able to get that shot, and I don't want to waste time trying when I know I can get it with manual focus.

There is no wrong or right way; it's just what will work best for you and what you're doing. Now let's move on to talking about how to use your gear. The next chapter will cover exposure, and then we'll deal with light.

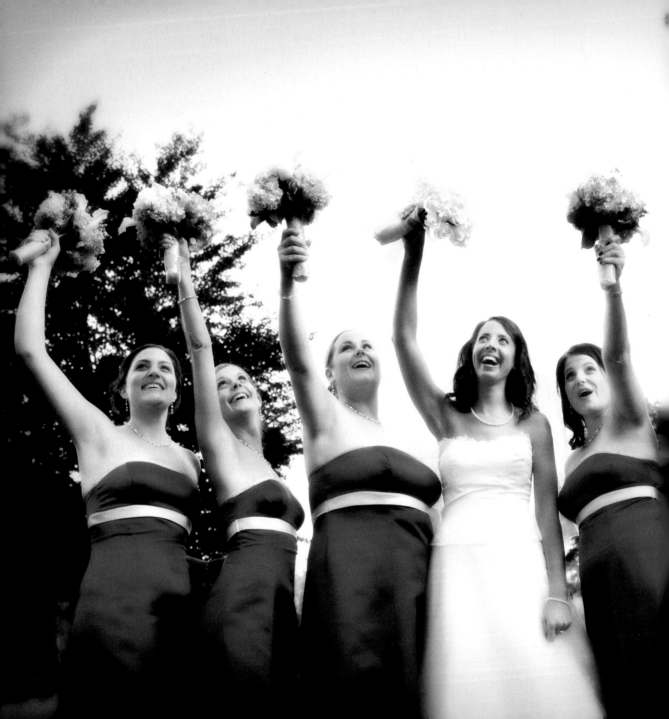

Exposure

If you're reading this book, chances are you know what exposure is. But regardless of what you know, I'm going to go over exposure in depth so that by the time you're finished with this chapter, you can look at a sunny day, take photos of a scene, and know that the exposure is 1/125 at f/16 at ISO 100.

I believe that digital and modern technology has given photographers too much of a comfort zone, allowing them to just let the camera do all the metering and exposing. If you do this, you're not being as creative as you can, because you're not calling the shots—the camera is. You need to know how to meter, what to meter for when you're shooting, and what modes to use for different scenarios.

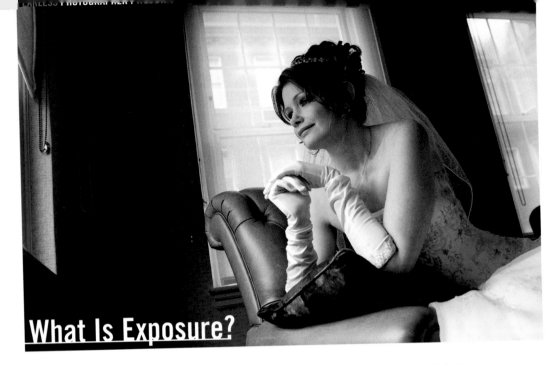

What Is Exposure?

Exposure is the combination of shutter speed and aperture setting that allows for an amount of light to, in essence, "see" your film or digital sensor. Every object reflects light and has its own exposure based on how it reflects light back to your camera. A person in the shade will require a different exposure than a person in full sun. Once you find an exposure for a given scene, you can lock it in, shoot freely, and keep composing different shots as long as the lighting does not change.

If you just have your camera in Program or one of the priority modes, such as Aperture Priority or Shutter Priority, and the camera is set to matrix metering, the camera is making all the calls, and you pretty much have no say.

This is not to say that the camera won't create some good images or get the right exposure—it very well can. What I'm saying is that in these auto modes, you lose the ability to control the shot. If the camera were set to Program and matrix metering, and you were shooting the bridal party getting ready, with people in different outfits—let's say black and white, moving in and out of the frame—the camera's exposure would keep changing even though the room's exposure for your subjects' faces would be the same. The reason for this is that the camera doesn't know what you're photographing; all it knows is light is measured off of everything in the room. So as people walk by and light is reflected from them, your camera's meter is reading the scene and changing the exposure as

"If you let the camera do all the metering and exposing, you're not being as creative as you can, because you're not calling the shots—the camera is."

light is reflected by people or objects coming into and out of its view. If it sees more dark-toned outfits, it will want to let in more light than if it sees lighter outfits.

This is not to say that Program or the priority modes are useless modes. They can save you in a pinch. If something is happening so fast that you're totally unprepared, and you don't have time to meter for it, then one of these modes will get you a shot. The shot may not be what you wanted, and it may not be perfect, but you'll have a shot, and any shot is better than no shot when it comes to weddings.

If you want to use modes such as Aperture Priority, Program, or Shutter Priority, that's cool—but you'll need to learn to ride the exposure compensation wheel or dial. Many incredible photographers use these modes to great success, but that is only because they know how to read the image they're seeing. If an image has lots of bright white areas, they'll tell the camera to overexpose; and if the scene is overly dark, they'll tell the camera to underexpose. The camera wants to make everything 18% gray, and you can't let it do that, or your shots will be poorly exposed.

18% gray is a tone that reflects 18% of visible light and is a universal reference for metering. Companies such as Kodak make kits with color boards and gray cards. These 18% gray cards are a neutral grey and reflect the same amount of light in any lighting condition, so they provide a great reference.

NOFEAR

If you want to use the Program or priority modes, just learn how to use the exposure compensation wheel. There's no shame in starting with a priority mode, as long as you know how to override its exposure setting when the situation calls for it.

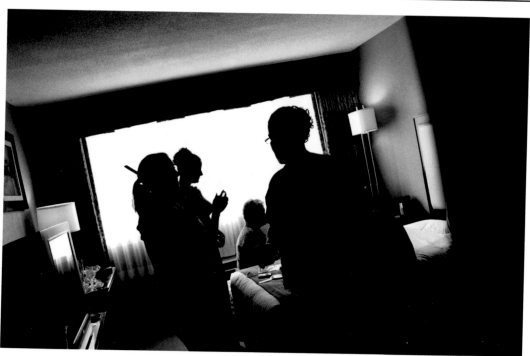

Matrix metering ruined what could have been a good shot.

Shutter Speed and Exposure

Shutter speed is the duration for which the camera lets in light. This can range from several minutes to 1/8000 of a second or faster. The faster your shutter speed, the less light the camera lets in. To stop motion and avoid motion blur, you need a fast shutter speed.

The shutter speed is not always relevant only to freezing action. Sometimes you need to use a lower shutter speed to let ambient light register and then use flash to freeze your subject. Because flash is high speed—only a fraction of a second—you can use it to freeze your subject, yet have a very slow shutter speed and a background that is streaming full of motion blur or camera shake. For this to work properly, the ambient exposure has to be darker than your flash exposure, and you may still have some motion blur in your subject, but it looks cool to me!

"Remember that you're not a tripod!"

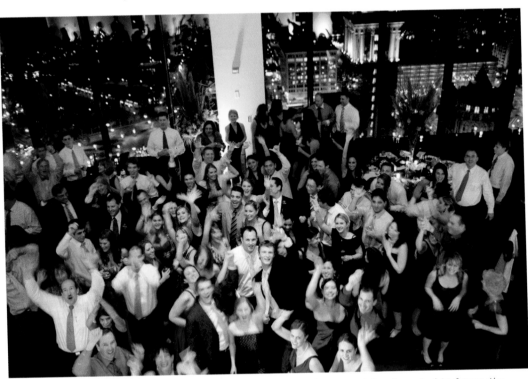

This image was taken at a slower shutter speed to allow motion to register. I wanted to freeze the group but also show that they were dancing and having a good time.

A general rule of thumb is to try to keep your shutter speed to at least the focal length of your lens or faster. So with a 50mm, you'd want a shutter speed no slower than 1/60. With a 300mm, you'd want a shutter speed no slower than 1/300 or 1/250. This is just a guideline to help keep your hands from shaking the camera and causing blur. The longer your lens, the more easily it is affected by your motion. As you magnify a small area of view, your slight movement can really shake the image, and if you're rocking a cropped sensor camera, such as cameras with the 1.6 crop or so, then you're really seeing less than the lens's full circle of coverage was intended for; motion will be more apparent, and a faster shutter speed will be needed than the lens itself. A 35mm lens would be 56mm, so 1/30 of a second might not cut it; you might need 1/60 to compensate for your hands shaking.

Think of it like holding a pair of binoculars up to your eyes. It's hard to hold them super-steady on a faraway subject, right? The same is true with a camera, so you need to compensate for your motion with a fast enough shutter speed to cancel out your motion blur.

I break this rule all the time, but it's a good rule to have in the back of your mind if you keep getting blurry shots at 200mm with a shutter speed of 1/60. You need to remember that you're not a tripod!

Aperture and Exposure

A camera's aperture is like an iris that opens and closes to let more or less light in to pass through your camera's shutter. Aperture is rated in what we call *f-stops*. The wider the aperture, the smaller the f-stop number and the more light allowed in. Aperture stops also control the amount of depth of field with a lens. For example, a lens at f/2.0 will let in lots of light but will create a shallow depth of field, whereas f/16 will let in a small amount of light but create a large depth of field.

This lens is wide open at f/1.4.

The opening on this lens is much narrower, at f/16.

What Is Depth of Field?

Depth of field determines what portion of your image appears sharp. It is based from your focus point or focal plane—the apparent focus or location you have focused with your lens. With a large depth of field— say your camera was set to f/22 and you had a 50mm lens—objects in front of your focus point and on the same focal plane and behind would appear to be sharp and in focus, even though you only focused on one point. With a shallow depth of field—say you were shooting at f/1.4—your focal point and everything across that plane of focus would be sharp, but the areas in the foreground and background would be out of focus. The depth of field describes the areas outside of your focal plane that appear to be in focus.

Depth of field determines what will appear to be in focus outside of the apparent focus point of your lens and what is not within that focal plane. Most lenses have a depth of field chart on their focus ring that is very helpful for determining what will be in focus in a shot. If you're taking group shots and need to get a few rows of people in focus, the depth of field chart on the lens lets you know what f-stop you need to have set to get the desired focus.

NOFEAR

Use aperture and depth of field to tell the story in your image. Softening a distracting background can help draw attention to the main subject of your photograph.

Depth of field is the most important part of my photos. It's how I communicate to the viewer what the subject of my image is. Gone are the days of "f/8 and be there" (an old newspaper photographer saying)—having everything from far away to up close in focus. I want my shots to have feeling, emotion, and presence. If everything was sharp, what does that say about the image? What does that convey to the viewer? Everything in the shot is important, right? But then think about if only a bride's eyes were in focus or only her ring. You would be drawn to her eyes or her ring, and you would know what the image was all about. Use aperture to control what your image is all about.

Working with Aperture and Shutter Speed Together

Now we come to finding the correct combination of aperture, shutter speed, and ISO to capture your desired photo. If you put your camera in Program mode, it will meter overall for a correct exposure. It won't let you decide the depth of field you want or the amount of motion you want.

The right exposure is what works for you to get the desired image. If you want to shoot at a certain f-stop, then you can change your ISO and shutter speed to do so (or vice versa). With digital, you are free to change ISO on the spot, whereas in the old days of film, ISO was set. Digital has allowed more flexibility in that respect.

We need to start somewhere, so let's start with the Sunny 16 rule. If you have ISO 100 film or your digital camera is set to ISO 100, then on a bright, sunny day, with the sun behind you, the correct overall exposure is 1/125 at f/16 or 1/250 at f/11 or 1/500 at f/5.6, and so on. Once you know the overall exposure for a scene, you can dial up or down your aperture and shutter in conjunction—one up and one down or one down and one up—until you get the desired outcome.

It's a matter of ratio. As your shutter speed increases or decreases, you have to open up or stop down on your aperture correspondingly so that the given amount of light needed can be allowed in.

Understanding Metering Modes

Finding the exposure for your subject or scene is critical, and to do that, we need to go over your camera's different metering modes. Your camera can meter the scene in different ways, but they all function on the same principle: They look to measure the reflection of light off the objects in view.

Depending on how your camera meters the scene, you can meter light in a few ways. Most modern cameras can meter in modes such as matrix or overall averaging, center-weighted, and spot. Each mode changes the area from which the meter measures light or takes in all the measurements and determines a suitable exposure. Some cameras have more metering points than others, and some can be more or less accurate than others as well. Some cameras come with a metering memory and have been programmed to know that if you're shooting the sunset, they must meter the entire scene and not just expose for the sun. Meters are no longer just center-weighted or a matchstick in the viewfinder.

Different metering modes will help you in different situations, so read your camera's manual to find out how each works for your camera so that you can use the right mode for the right scene. Unfortunately, this book lacks the space for me to go into all the different metering modes for the major cameras on the market today. But your camera's manual is a good resource to help you understand how your particular camera uses metering modes.

Evaluative/Matrix and Average Metering

In matrix/evalutive mode, the camera is measuring light from zones or points on its metering system and weighting the information together, sometimes in conjunction with your focus point (depending on your camera). It's running calculations based on a pre-programmed number of exposures based on thousands of images to find an exposure that's suitable for your scene. If you're shooting someone in strong backlight and the focus point is set to the person in the foreground zone, then the camera's matrix will put more weight on that zone's exposure so the person is not silhouetted against the strong backlight source.

Evaluative

We also have average metering, which is great for scenes that have the same overall tone. It's also useful when you're shooting landscapes and huge vistas where you have lots of sky and/or land that you want to expose for. This mode is not good for exposing for individual elements or scenes such as white on black or black on white; matrix is better suited for that.

If you had a bride in her white dress against a black wall, the average setting would see mostly the black and compensate for it by creating an exposure where your bride would be heavily over-exposed or blown out. Using matrix or metering off of a gray card would be better suited to get a correct exposure here. Every scene is different, based on the size and location and what tones are dominant in zones your camera is metering.

On the other end of the spectrum, suppose you had a bride and groom on a snowscape scene with bright tones from light being reflected from the sun. The average mode would measure all the white and then give you an exposure where your subjects would be underexposed. If you were using matrix, then the camera would weigh in your bride and groom as subjects and give you an exposure more suitable to adding them into the shot.

The problem is that the camera is trying to measure for 18% gray, and by underexposing a high-tone snow scene, it turns the snow gray. White snow reflects about 90% or more of light in bright sunlight, so the camera's meter will want to make that snow gray, so as not to overexpose it. The camera doesn't know that it's snow; it's just reading the light being reflected toward its meter. As I mentioned earlier, 18% gray is what the sensor bases its calculations off of for determining a correct exposure, because it is a neutral tone.

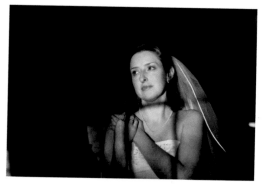

A white bride on a black background would throw off the sensor in average mode.

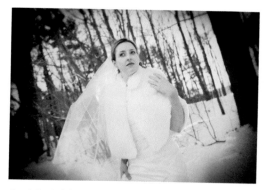

A white bride on a white background would result in underexposure.

Spot Metering

Spot metering is the mode on your camera where the light is measured from the central spot or metering point of the camera—usually about 5% of the entire image. When it's in this mode, the camera ignores all the information from the light being reflected and only pays attention to that central spot.

Spot 〔▪〕

This is the mode I use 90% of the time. I find a neutral-toned object—sometimes something close to 18% gray, sometimes someone's face, but something that will get me close to a suitable exposure. I take a few shots and find an exposure I like, and then I lock it in and shoot. Once my exposure is locked, I'm all set.

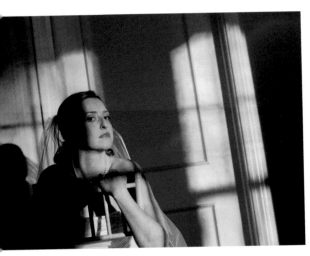

Here I spot metered off the bride's face to let the background go dark, so that she would be a highlight against the shadow background.

When you move the camera around, the meter will say that your exposure is wrong, because the central point is no longer at the exact point you metered for. You just have to ignore this and keep shooting, knowing you have exposed for what you wanted to expose for.

So if you had that bride in the white dress on a black wall, you could just meter off of her face and then shoot, and she would be exposed almost perfectly, depending on her skin tone. I always take a test shot and sometimes need to open up more or stop down, but I do this very quickly or meter off of something neutral. Or, I just use my handheld light meter.

It's important to note that spot metering is not always super quick and easy, and it's not always the best way to shoot. I use it because I've learned to compensate for scenes and different tones and how my camera's meter reads them. You can't just simply spot meter anyone's face and have a good exposure—not everyone's face is a neutral tone like that of 18% gray. Finding the right tone in the light you want to meter off of is important. Doing this could take time if you're not used to it, so you could potentially miss shots if you're fooling around with your settings. If you're not comfortable with spot metering, you may be better off using matrix mode. As usual, it comes down to what you know and how you like to shoot.

As a general rule, though, anytime you have a lot going on in a scene, it works well to just expose for the bride or groom's face, because they're your subjects, and then lock in that exposure and keep shooting. If you see the lighting change, you can compensate by increasing or decreasing your shutter, aperture, or even ISO.

Center-Weighted/Partial Metering

Partial

In center-weighted/partial metering mode, the camera measures everything it sees but puts more weight or importance on the light reflected from the center of the camera—usually about 25% or more. I don't really ever use this mode. I find it easier just to use spot or matrix metering.

Using a Handheld Meter

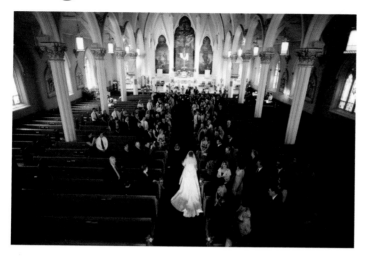

This church had window light, stained-glass light, and incandescent lights all mixed together.

A tool that I think every photographer should have is a light meter. This lets you find exposure perfectly and accurately, and it's not tricked by the camera's reflective metering system. You can simply bring the meter to your shoot, hold it up, dial in some settings, press a button, and get the scene's or subject's exposure.

A light meter comes in very handy for finding exposure before you even start shooting. If you get to a large church that has some dimly lit areas and then floodlights and spots in other areas, you can simply walk around with your meter and find out the different exposures for these different spots in the church. That way, when you start shooting when the ceremony begins, you're not searching for the exposure during those moments that only happen once. Of course, lighting can change, so it's important to still pay attention to your camera's meter and to check your LCD on your digital camera every once in a while.

The meter will also come in very handy if you're setting up strobes to do family shots, setting up a photo booth, or even just taking some fashion poses. It will save you the trouble of taking a number of shots with your camera until the image looks right.

The camera's meter is pretty much useless when you start to add non-TTL strobes to your shot. The light meter, which can be set to trigger and read studio strobes, can tell you your exposure and measure both the ambient room light and your strobe, so that you can properly dial in both the camera's exposure and the power level of your strobes to achieve your desired effect.

Whew! Finished with our discussion of exposure, although it will come up here and there throughout the book. Ready to start reading about shooting the wedding? Not so fast! We've got one more tech-heavy chapter to go before we get to that. Turn the page, and let's talk about light....

"Every photographer should have a light meter."

4

Light

"There's such a thing as bad light, but there are always ways you can add light or change it to work for you."

What is light? Well, for one thing, it's the most important element in photography. Without it, we would have no image or vision. Light is electromagnetic radiation emitted from an object. It is part of the same set of radiation that includes radio waves and gamma rays. The visible light that we harness to see with our eyes and capture with our cameras is nothing more than radiation. Fun stuff, right?

Enough with the techno mumbo-jumbo. This is not a scientific paper! Light is everywhere—sometimes in large amounts and other times in tiny amounts. Light can be from the sun, a light bulb in a room, or even a camera flash. The point is that light is everywhere, and to really be able to photograph with your own style, you must know how light reacts and how to use it in any given situation.

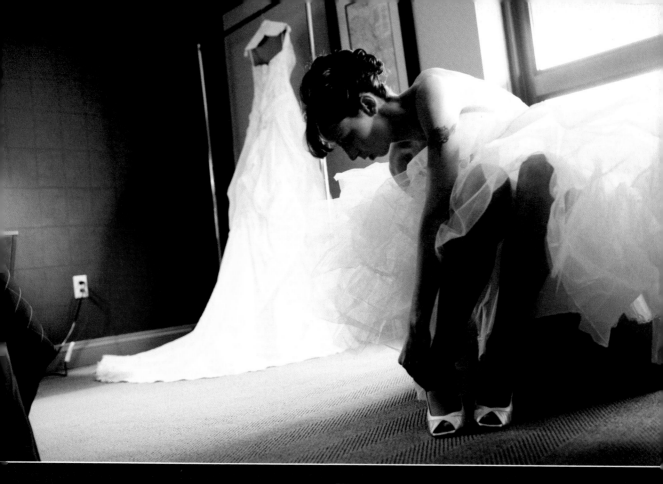

I want you to be able to go into any room or location and know how to use the available light to work for you. I'm really tired of hearing people say, "There was no good light" or "The lighting was horrible." If you don't like the light, you have to add or subtract light to make it work for you. There's such a thing as bad light, but there are always ways you can add light or change it to work for you.

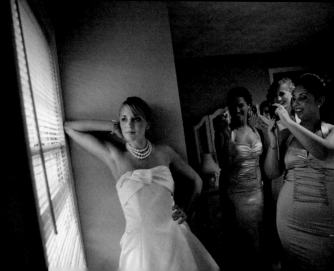

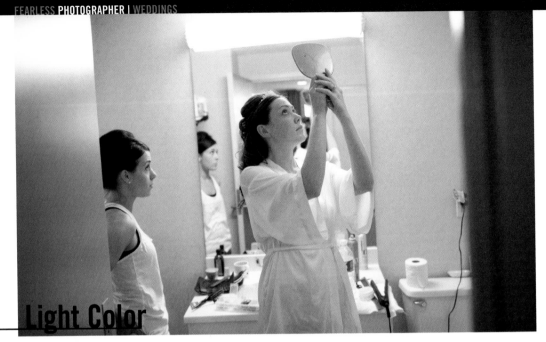

Light Color

As I said before, light is nothing more then radiation—the visible waves emitted from an object are what we call *visible light*. Light is measured in kelvins, and objects at different temperatures emit different colors of light. What we see as light from the sun is generally blue—and I say *generally* because depending on the time of day, color temperature can change. Incandescent bulbs, which burn much cooler than the sun, show up as orange, and fluorescent can be daylight balances, tungsten, or even green.

Light color is important to understand so that when you see light, you know how your camera will react to it. That's why cameras have settings for white balance. It's all good to just use the auto white balance feature, and I use it about 90 percent of the time. The other 10 percent of the time, when I have lights mixing from different sources or I start adding flash or video light, it becomes very important to know how the light looks so that my subjects don't turn out discolored in the images.

The following table shows common temperatures, in kelvins, for light that you can set your camera's white balance to.

1,850K	Candlelight
2,700–3,300K	Incandescent light/video light. This is the light bulb tungsten setting on most cameras' white balance control.
5,000K	Daylight/the sun. This is the sun setting on your camera, usually depicted by a picture of the sun.
5,500–6,000K	Camera flash/speedlight. This is the flash setting on your white balance control, usually depicted as a lighting bolt with an arrow end. I use this when shooting in my studio under my studio lights.
6,500K	Cloudy day. This is usually an image of a cloud or a sun partly obscured by a cloud

Sun: Morning

Waking up at dawn and seeing the sky light up and the horizon glow is a magical thing. The first moments of dawn are warm and clear. This light is great for photography because there are no harsh shadows, and everything is pretty much lit directionally from the sun, and then from the side as the sun's rays hit the sky and bounce back down. It's gorgeous. This light is hardly ever used for weddings, though, because almost everyone is still sleeping.

Late-morning light is also great and clear. It's perfect for getting group shots or for ceremonies where the light is coming through church windows and lighting up the room from one side. However, depending on how your subjects are placed, the light can be harsh, as it is strong light coming from pretty high in the sky. I like to use this light as it is bounced from buildings or into buildings. You just need to be mindful of where and how you place your subjects or the direction from which you're shooting them.

NOFEAR

For late-morning light, which can sometimes be quite strong and harsh, try capturing the light as it's bounced from or into buildings.

For this light, I tend to utilize fill flash to balance out shadows on subjects' faces. I also recommend using the lowest ISO you can to get the best color and image possible.

Morning light image. This was a very early wedding for me—all before 10 a.m. in Boston.

Sun: Noon

Noontime light has long been thought of as the absolute worst light to work with, and many have never considered it a good time to shoot. Before I argue this, let's look at the light. The sun is (almost) directly overhead, creating tiny shadows below us and resulting in what we sometimes refer to as *raccoon eyes*. (Your forehead creates a shadow over your eyes, so you look like a raccoon.) Light is pretty much everywhere, hitting everything it can evenly and directly from above. No wonder why no one likes it.

So what are your options? You could run for shade or use the light you have. Work your subjects by angling them to best use the light. I'm not saying it will be an incredible shot, but it could be more interesting than the shade. I've used both methods when shooting, and I find that each has its place. Sometimes I like the refraction of the overhead light through the trees; other times I like the direct light and the contrast it can create with my subjects.

NOFEAR

Instead of running from noontime light, try positioning your subjects at different angles for some creative use of the light. Or, try positioning yourself at a different angle to best use the light. No one ever said you always have to stand on the ground, facing the couple, to get the best shots.

So just look at the noontime light, know that it's very powerful light, and use it. Don't fear it. It's all about working it with your subjects so that you control the way the light hits them and your camera. Don't just hold your camera as you normally stand; move around, get on the ground, and find the shot that works.

Adding fill flash can help. Shooting for your flash and letting the background underexpose works, too. I sometimes like to lie on the ground and place my subjects with their bodies almost over me to have the sun right behind them and backlighting them. Finding places such as alleys, where you're between two large buildings and there's shade filled with reflected light from the buildings, can work well when shooting in this light.

If I'm working with just a bride and a groom, then I can have harsh shadows and be okay with it as long as they're looking at each other and not me, so that I don't see the harshness but rather I see their bodies and their pose as the subject.

"Move around, get on the ground, and find the shot that works."

The glare on the ocean is terrible in the noonday sun.

You can always go into the shade and work with dappled lighting, too. That can be pretty, depending on how spotty the light shining through is, or it can be messy, with hot spots all over your image.

Many people consider shooting in the shade to be the safe shot. Well, guess what? It is. But there's nothing wrong with getting a safe shot, especially if you're doing a family formal. I don't think the bride's grandmother wants to look super high-contrast in the sun anyway. But if you're working with the bridal party or just the bride and groom, and this is the only time you have, then just the safe shot may not cut it. Be creative! Get the safe shot and then move into the sun's light.

If you're in a city at this time of day, you might get interesting reflections of light from all the buildings. All those windows being hit by sunlight could create a cool look. If you're out in the country,

The image on the left was taken in open light. The shot on the right was captured in the shade, using a flash.

then maybe try doing some wide shots where the subjects aren't close up, and you can't see them trying to keep from squinting. The landscape can look pretty dramatic when it's lit from above, so have fun with it.

I will say that you should be very careful around the ocean at this time of day, because it can be totally glared, depending on where you're shooting from.

Look at these two group shots, taken a few minutes apart. One is in the open noonday sun, and the other was taken in the shade with a flash. Which one do you like better? Which is more interesting?

Sun: Afternoon

Now the light is getting better. To me, afternoon light is like morning light—except I'm awake for it, as are my subjects! The sun is at an angle and lighting everything from the side—what we refer to as *directional lighting*.

This time of day is perfect for outdoor photography, shooting formals, portraits, or anything. It's hard to get a bad shot in this light. Could this be boring light? Well, it's less of a challenge to work with, but it's great because your subjects aren't squinting at you.

"Be creative! Get the safe shot and then move into the sun's light."

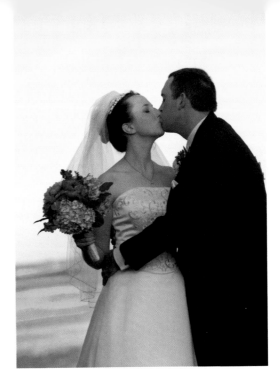

Afternoon fun.

My suggestions for this light is to just get out there and shoot it. Put the sun behind your subjects and have them be backlit. You don't always have to have the sun behind you. Backlighting is a very cool effect and really makes your subjects pop as it highlights/backlights their hair and body.

NOFEAR

Have fun with backlighting when you're working in afternoon sun. Notice the highlights you get in people's hair when you use this method of lighting. As an added bonus, your subjects won't be squinting at you if they're backlit.

You can use flash at this time of day to wash out any shadows and balance a person's face so that she has even tones, or you can use flash to create a catch light in your subject's eye. However, I find it easier to just get the exposure for the direction I am shooting in, sometimes move my subjects to how I want them to be lit in relationship to the lighting from the sun, and try to avoid shadows on them altogether and obtain an even exposure to shoot.

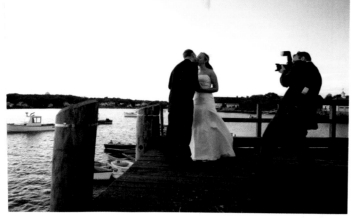

The light doesn't get any better than at sunset.

Sun: Sunset, the Über Hour!

This is my absolute favorite time of the day. The sun is almost completely (if not totally) set, and all you have left are the rays bouncing up from beyond the horizon to light the sky. This creates awesome colors, annihilates shadows, and produces perfect soft lighting all around. Then the sky slowly gets darker and turns from pink and light blue to darker and darker blue to eventually black and lit with stars.

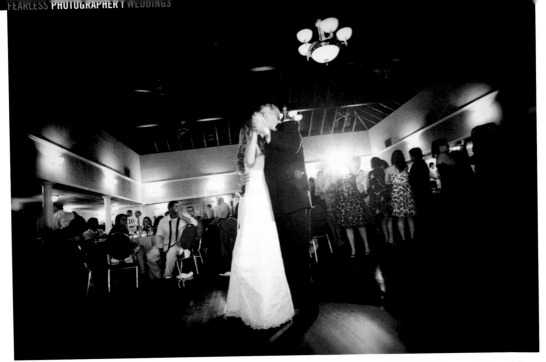

For this image, I had my assistant holding the video light behind me to light the father and daughter as they danced.

I use video light when I'm doing my portraits of the bride and groom because it lets me create a spot light or highlight area on them without having to use flash. When I do shoot with video light, for the most part I'm shooting wide open with my lens and paying close attention to my meter. Video light falls off very quickly to the background and edges of the light, and the farther you are from the source, the less powerful it becomes. If my subjects are moving or my assistant who is holding the light is moving, then my exposure could change drastically and ruin shots. So pay attention to your meter when you're using video light.

Having my assistant hold the light lets me keep it off-camera and almost as a window light coming in from the side of the frame to sidelight or backlight my subjects. I do use it over my shoulder, but I find it much more dramatic from the side.

"Video light is not anything like flash—it is its own entity."

I should also mention the new LED lights on the market that run cool and don't burn your hands. These new lights are very promising, but at the moment I find that very few can do for me what a normal tungsten light can. I do believe that in time they'll be more powerful and will likely replace tungsten lights, but not just yet.

For video light, I use these little Sunpak lights because they fit in my jacket pocket, and I can bring one out any time without having to carry a big battery.

The light doesn't get any better than at sunset.

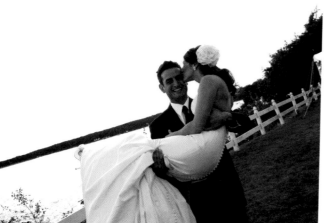

Sun: Sunset, the Über Hour!

This is my absolute favorite time of the day. The sun is almost completely (if not totally) set, and all you have left are the rays bouncing up from beyond the horizon to light the sky. This creates awesome colors, annihilates shadows, and produces perfect soft lighting all around. Then the sky slowly gets darker and turns from pink and light blue to darker and darker blue to eventually black and lit with stars.

Sunset is the best time of day to shoot so many different types of light to work with! But you have to be quick, because the exposure can change from minute to minute. Be aware of that as you capture the gorgeous pinks and blues the sunset provides.

You have an hour of shooting with so many different colors and styles of light to work with that you just have to be creative. When shooting in this light, you have to be very aware of the speed at which the light is leaving you. Very often, you can set your exposure, and a moment later it will have changed. This light moves very quickly, and if you stop to look around, it could blow right by you.

Be prepared for this. Know where you want to shoot and what you want to shoot. Have your flash or video light ready if you are going to use them. I tend to like to mix in video light at this hour and let the sky go dark blue with the camera balanced for the tungsten video light. This creates a dramatic sky and a well-lit subject. You can also use your flash to light your subjects. Or, you can even just expose for them—if your lens is fast enough and your ISO is light enough—and just let the sky be. I find that flash or video light is necessary most of the time to make the subject pop, because there is usually very little light from the sun available. Where you're standing could be dark, but the sky could be beautiful, so have your lights ready to add to the shot.

Night: No Sun

So the sun is gone, the stars and moon are above, and you're outside. What are you going to do? More shooting!

Now that the sun is gone, you can have total control over the light on your subjects. There's no need to balance in with the sun or try to work your subject and camera to get the best angle at which the sun's rays hit. Now you can just set your lights to where you want and expose for the image how you want.

If you're in a city, then the city will come alive once all the streetlights and store lights are turned on. You'll be in an electric jungle, with tungsten and fluorescent lights all around. For times like these, I recommend high ISO and a very fast lens. Shooting into light like this is very dramatic and powerful. Use video light and flash to light your subjects. Don't overpower your subjects with your lights and let the background go black, though. Instead, try adding light with your flashes or video light, but play with the power settings to the point where you can expose your subject and still expose for the surrounding area as well. You don't want to have a flash or video exposure that is too high so that your background goes dark or is way underexposed. You want to set your lights so that they look natural and blend in with the surrounding lights.

NOFEAR

If you're shooting at night without a tripod, you can try using a slow enough shutter speed that you can hand-hold the camera. Or, you can create a makeshift tripod by balancing your camera on something solid, if you're faced with shaky hands creating blurry shots.

If you're not in a city, try using an everyday streetlight on a highway or outside a venue. Or put your camera on a tripod, set it for a long exposure, and hit your subjects with flash to freeze them.

"When you walk out into the night, don't be frustrated. Be overjoyed. Look for color and contrast, and you'll find the light."

Whew! I got the shot even without my tripod.

Room Lights

So you're inside. Yahoo! Indoor lighting is super easy to work with because you can shoot with it or ignore it altogether. I tend to work with it, but that's just my style. Indoor lighting can include (but is not limited to) tungsten bulbs, fluorescent bulbs, chandeliers, recessed lighting, candlelight, window light, LED up-lights, spot lights, mixed lights, and just about anything that can glow or shine.

The first thing to do when you walk into a room is to look at the main light source, figure out its color temperature, and make a decision about whether you're going to shoot with it or compensate for it with flash. If you're going to shoot with it, then make sure to set your white balance to the color temperature of the main light source. If you're going to ignore it and use flash, which I hardly ever do, then make sure to set your exposure for your flash and your white balance for daylight.

In the case of fireworks at night, a tripod would be best. But if you don't have one, try a slow enough shutter speed that you can still hand-hold the camera and use some flash to freeze the foreground. The last wedding I shot that had fireworks…well, I was not ready for them, to say the least. I was told they weren't going to happen, so I put my tripod away. Then I heard the *swoosh, bang, pop!* I turned up my ISO, put on a flash, and set the camera to 1/15 at f/2 so that I could get the fireworks balanced with the people on the ground. I really didn't have time to get perfect focus, but I did get the shot, and that's what counts. So, as always, just be ready and know how your gear will work.

So when you walk out into the night, don't be frustrated. Be overjoyed. Look around. Look for city lights, look for streetlights, look for that little neon sign across the street. Just look for color and contrast, and you'll find the light.

I love warm indoor lighting and beautiful rooms lit with dim candles and chandeliers. This lets you use your lenses wide open and at high ISOs so that you can shoot the room pretty close to how your eye sees it. If the room is really dark—or just the foreground where my subject is—then I will use flash, but I gel my flash to match the color of the ambient light in the room. You don't want to throw blue daylight–balanced flash on an orange tungsten–lit room—that would just look wrong.

Many times when I get to a room where the bride is getting ready—or even when I get to the ceremony or reception venue—I find a window spilling daylight into a tungsten- or fluorescent-lit room. This is not the end of the world, and you don't have to shoot black and white. (I do that a lot, though.) Try auto white balance and seeing how that looks by checking your LCD. If you must use flash, balance it to whatever light is stronger in the room and just realize that it's not going to be

perfect in every shot. If a bride is standing in a pool of light from purple stained glass in a church, then don't try to make her white. She is supposed to be purple.

NO FEAR

If you have to use flash to light an indoor shoot, you can gel your flash to match the color of the ambient light in the room. This will help retain the correct color in the image and avoid that washed-out flash look.

If you have only been shooting with flash and have never actually shot with just the ambient light, you will be totally amazed by how great ambient light can look. Just be aware of the

This detail shot of the table was captured with ambient light and sunset light mixing. The bride and groom were captured with only the available light in the room.

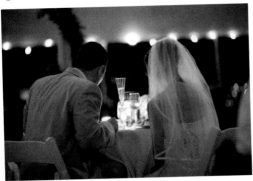

shallow depth of field you will have when shooting wide open. If you're at a high ISO on your camera, there will be noise, but I personally don't care. I'm looking more for the moment than for a clean, noise-free exposure. I want to capture the event as my eyes see it. That's just me, of course— in the end, it's a matter of personal taste and style.

If a room is lit to look bright, with many colors, or dark, with red walls and fancy-colored lights around, then just go with it. You're not supposed to adjust your white balance for every light. If your eyes see a room full of crazy mixed light, then that's what the bride wants. Most likely, she picked the colors for the room, so just go with it and try to match it to what your eyes see.

If there's no light to work with, or you just don't want to go with the ambient look, or you want to add to the ambient look of the room, then it's time to add flash and light the room. Sometimes lighting the room can add to the lights already in the room, so that your shots don't scream, "He used flash!" but more, "How did he do that?!"

It will really help you to carry a kit of gels for your flashes so that you're ready for whatever the room lighting is. I carry a green gel for fluorescent, a tungsten gel for tungsten, and a blue gel if I need to make a tungsten light daylight. I even carry a red gel for fun shots when I want to add a bit of extra color or just be different.

I simply place the gel over my flash, sometimes taped on and other times under my STO-FEN diffuser, but I also turn my white balance to that gel's temperature so that my shots have the white balance I want and don't have a mix of colored light. When my flash fires, its light temperature will match or be very close to the ambient light I'm shooting to. Just make sure you remember to take off your gel if you go into different-temperature light—say from indoors to outside—and to change your white balance setting accordingly.

Flash: On-Camera

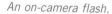

An on-camera flash.

On-camera flash is probably the second most valuable tool in photography, next to your camera. It lets you add light where there is none or not enough. It allows you to shoot day for night (to use enough flash power so that your exposure for your flash is higher than that of the ambient daylight, so that the ambient day turns underexposed and looks dark), to light up a room, or to merely add some catch lights in a person's eyes. It's a very powerful tool. But, like any powerful tool, you must be careful not to overuse it!

When I use flash, I want my pictures to look like I didn't use it…unless I want them to look like flash. Does that make sense? Let me explain. If I'm shooting a bride getting ready or important moments of the day, then I don't want my shots to look like I was there. I want the subjects to tell the story. If there's a big blast of flash hitting them, then you know I was there. By the same token, if I want to go for that paparazzi-runway-direct-flash look, then I want you to know I used flash. Otherwise, the shot is not the way I wanted it.

Let's start with the basics. On-camera flash, sometimes called a *speedlight*, operates for the most part in two modes—TTL and manual. With TTL (through the lens metering), the flash reads the image your lens sees and, using the camera's meter and its own processing, determines the amount of flash needed to light the shot. The flash metering works the same way as your camera's meter does and is looking for that 18-percent gray. So you'll have to add and subtract exposure with your exposure compensation wheel to achieve the correct flash exposure with your camera. More or less, the flash is going to look at the exposure you've dialed in and then determine how much light is needed to achieve 18-percent gray.

You can also add or subtract the flash power, so that even though you're telling it to underexpose on the meter, you can tell the flash to +1 on power. But as with all metering, as things move in the frame, the meter will read them differently, and the exposure and flash output will change from shot to shot. For this reason I use my flash in manual mode. In manual mode, you can set it from as low as 1/128 power

"I want the subjects to tell the story."

to full 1/1 power. This lets you add the amount of flash you want to a shot and not have to worry about it looking different from one shot to the next. This is not to say that TTL is bad. I use TTL whenever things are moving way too fast for me to manually expose, such as when a bride is walking down the aisle toward me. Aside from that, I use manual flash mode whenever I have the flash turned on.

NO FEAR

Play with TTL and manual flash modes to get the effect you want. TTL is great for situations when you don't have time to manually expose, and manual mode can help you capture darker, moodier lights that your flash might normally light up.

Most flashes and cameras sync at 1/125 or 1/250 of a second. That's the maximum speed at which you can use flash with your camera and get maximum output from it. Your camera's flash sync speed is totally dependent on the camera's design. My Pentax 6x7 syncs with flash at 1/30 of a second, and my old Canon Rebel G was 1/125 of a second. Make sure you know your camera's sync speed.

The flash can also be synced to either first curtain sync or rear curtain sync of the shutter. This means that the flash will fire either at the beginning of the ambient light exposure or at the end of it. So if you're taking a photo of, say, people standing on a balcony in the evening, and you're using a slower shutter speed to bring in the ambient exposure of the scene, then when your flash fires at the rear of the curtain or the end of the ambient exposure, the people who the flash hits will be exposed for again, but their flash exposure will be different than that of your ambient exposure, and your subjects will look frozen. (However, there could be visible movement or blurriness due to the length of the ambient exposure and how much they were moving.)

You are, in essence, combining two images or exposures, like a double exposure. Your ambient exposure is being composited with that of your flash exposure to create your image.

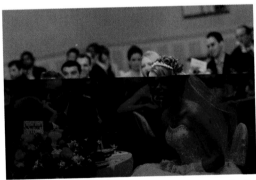

The image on the left was taken in TTL mode, with the flash bounced behind me onto a wall. This lit up the room very nicely. In reality the room was much darker, so later I put the flash back in manual mode to shoot the room with the darker mood that I saw, as in the image on the right.

This is only visible when you're shooting at a slow shutter speed and you want to freeze your subject's movements with flash in relation to the ambient exposure. The flash firing at the rear curtain will freeze the subject where her motion ended and not where it started. This way, the subject will look like she has moved and not ghosted.

On-camera flashes have come a long way since the days when they were just a flashbulb that was good for only one shot. Today's flashes are powerful, long-lasting, and most of all, movable. You can rotate and aim the flash head almost any way you like, so that you don't have to fire straight on.

When I do use flash, I like to bounce it over my shoulder so that I can make the wall behind me the light source. Bouncing flash is nothing new. The idea behind it is that softer light looks more natural, and the larger your light source, the softer your light. So, if you were to shoot straight on with your flash, it would look rather hard and with deep shadows. But if you bounce your light to a wall that is huge, then the wall becomes your light, and the light coming from it will softly light in front of you.

NOFEAR

Just because a technique is old doesn't mean it's out of date. The age-old trick of bouncing your flash to create softer light is still an excellent way to create gentle, even light for your scene.

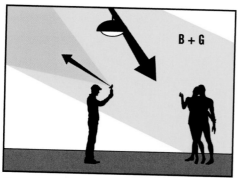
Bouncing your flash creates softer light.

An image taken with rear curtain sync.

There are also many add-ons you can use to modify the light coming from your flash, and they all mostly try to soften it or distribute it. I use nothing more then a STO-FEN on my flash. That way, when I bounce light over my shoulder, I can still send some light forward. It gives more of a giant softbox look than directional window light from behind me, but that's just part of how I like my shots to look.

Direct Flash

Shooting flash directly can look downright ugly. It's harsh, annoying, and blinding, and it just doesn't look natural. Almost every point-and-shoot camera has a direct flash built in, and you can see the look it creates in pictures taken with the camera. However, as I said before, I do use direct flash, and it does have its usages—it can help create some beautiful photos if used correctly.

One part of the wedding when I will use direct flash is for the ceremony—not during the actual ceremony, but only as the bride is walking down the aisle. I usually prefer to shoot at a large f-stop

and at high ISO, but some ceremony venues are just too dark to get a good shot, so flash is needed. I could bounce the flash off the church ceiling, but that would take a lot of power and eat my batteries quickly, so I put my flash on a bracket and shoot it directly at the bridal party as they enter the church. Almost everyone is taking pictures at that point, and flashes are going off everywhere, so I know I'm not a distraction.

I'll usually shoot this in manual on my camera and TTL on my flash, just because the subjects are moving pretty quickly toward me, and I don't want to have to worry about adjusting my exposure as they get closer to me.

Another great use of direct flash is for portraits and outdoor shooting. If you're outside and want to fill in any shadows on your subjects, just dial in the amount of power you want and shoot. There is nothing to bounce your flash off of outside, unless you bring a reflector or whiteboard. Direct flash outside is pretty much the norm for me when I find myself wanting to get rid of shadows. The flash will let your subjects pop and stand out with clean skin tones. Of course, that has to be the look you want—otherwise, do something different.

I used direct flash to take this shot of a bridesmaid coming down the aisle.

NO FEAR

Direct flash is often reviled, but don't discount its ability to help you capture even lighting for outdoor portraits or sexy lighting for an edgy shot.

Direct flash can also help make things look sexy. Harsh, hard light directly on a subject with the right matching expression and background can create a formidable portrait. I sometimes use this with the bride and her bridesmaids if I think they might like it. For this I usually use manual mode because I'm not looking to get a perfect exposure. I want to use the flash to overexpose the subject and the highlights to give her skin a really clean look.

I never use direct flash for the formal dances or formalities of the reception. I may use it for party dance shots from off camera, but that's about it. For every other time I need flash, I bounce it.

Direct flash on a bridesmaid to make her look sexy, in the vein of 1970s and 1980s party photos.

Bounce Flash

Ninety percent of the time, when I do want to use flash, I want it to look as if I was not using flash, and there is just a window to my side letting in the light. For this reason, I will bounce flash over my head and/or shoulders to get the desired effect.

Bounce flash has a much softer look and is more flattering to most people than direct flash. By bouncing your flash onto a large wall, you're creating a new light source—and a larger one at that. Wherever you bounce your flash, you're creating a window of light that will illuminate your room. How much light you need to bounce is relative to the room size, the distance to the wall or ceiling, and the ISO you're at.

The higher your ISO, the less flash power is needed to expose for the same image at a lower ISO. For me, finding my balance of ISO, exposure, and flash power comes from experience. Once you start shooting in both manual mode on your camera and manual flash (non-TTL), you'll start to learn or be able to guess very close the exposure settings you need for a given situation. You can also shoot all TTL flash in conjunction with your camera in manual exposure mode and just dial the exposure compensation wheel to add or subtract if you don't want to shoot manual flash.

If you're inside, you can pretty much bounce flash off of any surface. I've been known to bounce off people or tables if needed. I'll use any surface I can to mold my light to the way I need it.

"I'll use any surface I can to mold my light to the way I need it."

I took this image by bouncing the flash over my left shoulder. There was a window to my left, so I wanted the flash to look like the window light, and I aimed it accordingly.

Flash: Off-Camera

You can also take your speedlight off-camera and trigger it to fire via infrared or a radio trigger so that you can have your light fire from off-camera and bounce it to create directional lighting. With the flash on-camera, you can pretty much only bounce over your head, to your left, to your right, or over either of your shoulders. Taking the flash off-camera lets you place it wherever you want so that you can have your light coming from one direction and be shooting from a different area altogether. By doing this, you can create light when and where you want it.

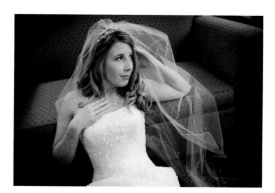

In this image, the flash was off to the right of the subject to make it look as if there was window light hitting her, even though it was cloudy and no light was coming in through the window.

Direct flash also looks awesome when being fired off-camera. You can set your shot and then create a spot or directional light from wherever you want. Whenever I'm shooting outdoors at night and I need flash, I love to fire it off-camera so that I can make it look as if the light is coming from somewhere else. I can also use the flash being fired off-camera to backlight a subject or even to light part of the location. Taking the flash off-camera will open up your ability to make magic with your camera and not limit you to just using flash from one place.

Multiple Lights

Another cool feature of today's on-camera flashes is their ability to work in tandem with other flashes. Basically, you can set one flash, usually on-camera, to be the master flash in TTL or manual mode and then set it to control other flashes near you. As long as the other flashes are set to slave mode, they will do whatever you program them to do via the master flash.

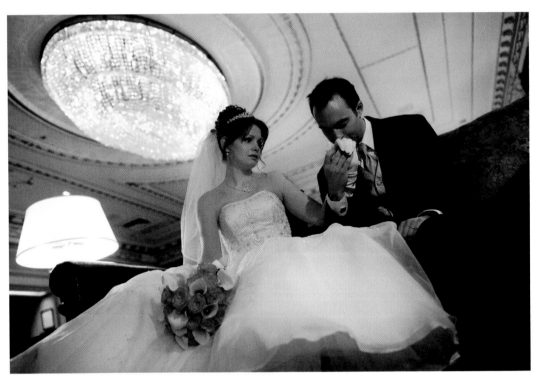

This image was taken with three speedlights going off—one on-camera over my head and one on each side of the couple.

I've found that this system doesn't always work perfectly, and sometimes it needs some tweaking as to where the flashes are, but it can help in lighting a subject (or a room, for that matter). I typically have my assistant hold one flash near me if I need some more light or want to add a more directional light. Flashes can be set to different power output levels, so that your master flash might only be the fill light, and the main light source could be off-camera.

If you don't want to use the built-in speedlight control system, you can also use radio-triggered devices, such as pocket wizards, to activate multiple flashes that you set up. Radio works almost anywhere and doesn't need to rely on line of sight. Some radio devices can only trigger your flashes, and some newer ones transmit full TTL control as well. Just read the specs on the system you have or are looking at.

In the end, these on-camera flashes are fast, reliable, and most of all, lightweight. Now let's talk about real strobes!

Studio Strobes

So you need more power. If your on-camera flash is not cutting it, or you need to light a larger area, then it's time to look into using studio strobes. These bad boys come in every make and model. There are powerful little lights and super heavy-duty lights with enough power to light up a stadium.

Lights of this kind come in two forms, for the most part: lights with a ballast or power pack and lights that are just AC (plug them in, and they work). Typically, lights with a power pack or ballast are more powerful and faster, and sometimes more portable if their power pack can double as a battery for location shooting. However, I won't say they're better. Every job needs a different light, and I've used AC-powered strobes for many years without an issue.

A studio strobe.

These lights work only in manual mode, and you have to either have a light meter to find the exposure for your shot or guess and check your LCD or histogram by looking for the shadow and highlight levels until you get it right.

These lights are great for family formals, lighting a room, lighting portraits, doing fashion and glamour work, and anything where you need lots of light. These lights are also very heavy. They are sometimes a hassle to set up, and they can be time consuming. I bring them to every wedding, but I keep them in the car unless I need them.

Video Light

Another tool in your gear bag that can be a total game-changer for photography and weddings is video light. Using video light at weddings is nothing new—photographers have been shooting with video guys for years. Now more than ever, though, photographers are using video light to create and mold light to their own ends. Video light can be your own modeling light, spot light, or even focusing light. It can give you that extra boost of light on a couple dancing in a dark venue. It can spot light a bride if it's held over her or at her, and then with barn doors (lighting flags you can move to adjust the light being projected) it can be focused and narrowed like old movie lights and made to shoot only a sliver of light.

Video light is not flash or anything like flash—it is its own entity. It's tungsten-based, hot, and bright.

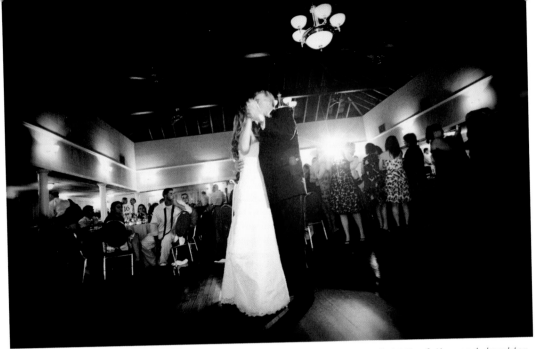

For this image, I had my assistant holding the video light behind me to light the father and daughter as they danced.

I use video light when I'm doing my portraits of the bride and groom because it lets me create a spot light or highlight area on them without having to use flash. When I do shoot with video light, for the most part I'm shooting wide open with my lens and paying close attention to my meter. Video light falls off very quickly to the background and edges of the light, and the farther you are from the source, the less powerful it becomes. If my subjects are moving or my assistant who is holding the light is moving, then my exposure could change drastically and ruin shots. So pay attention to your meter when you're using video light.

Having my assistant hold the light lets me keep it off-camera and almost as a window light coming in from the side of the frame to sidelight or backlight my subjects. I do use it over my shoulder, but I find it much more dramatic from the side.

"Video light is not anything like flash—it is its own entity."

I should also mention the new LED lights on the market that run cool and don't burn your hands. These new lights are very promising, but at the moment I find that very few can do for me what a normal tungsten light can. I do believe that in time they'll be more powerful and will likely replace tungsten lights, but not just yet.

For video light, I use these little Sunpak lights because they fit in my jacket pocket, and I can bring one out any time without having to carry a big battery.

Lighting a Venue

The time will come when your venue's lighting is just plain flat, boring, and lifeless—or even nonexistent. This is where studio strobes come in very handy. Using studio strobes to light a venue is not hard, but it's not for every venue, and it does take some knowledge of light bouncing and exposure to make it work well.

Venues with high ceilings and/or tents work best with this lighting method. The idea behind it is that you're setting up your strobes to bounce onto the ceiling and light the room. You can use one light for directional lighting or two or more to create even lighting across the room.

It's very helpful if you have a floor plan or layout of the room before you get to it, so that you can plan where to place your lights. I typically place one light in each of the two corners of the room on the far side, away from the head table and the dance floor. This allows me to shoot in one direction with the two lights bouncing light over me and onto the room in front of me. I can be anywhere in the room and not have to worry about on-camera flash.

Finding the exposure is very simple. Right after we set up the lights, I have my assistant run around with my light meter and read the f-stops to me. We then turn the power up or down to achieve the look I want. I'm not looking to shoot at f/8 across the room, but rather f/2.8 and faster. The lights are just giving that extra boost of light to create depth and contrast and hopefully a faster shutter speed than that of just the room lights.

Another great use of studio strobes is to balance the light in the room to that of the outside world. If you have your bride and groom's table or even the dance floor right next to a giant window during the day, you may have a huge exposure difference. If you expose for the room lights, the window and everything outside will be overexposed or blown out; and if you expose for the window, then everything inside will be silhouetted against it, really underexposed. To compensate for this, you can adjust your strobes to add just enough light to the room so that it comes close to the exposure in the window, therefore giving an even exposure. I won't say that this is better than shooting for just the room or even for the silhouetted shot, but it's another option. I've done all three methods, and I use whatever best suits the room and the wedding.

NOFEAR

Strobes can help to even out lighting and exposure differences in a room, but remember that with most strobes, you can't rapid-fire shoot. Be sure to take a few seconds between shots to let your strobes refresh, so you don't end up burning out your equipment.

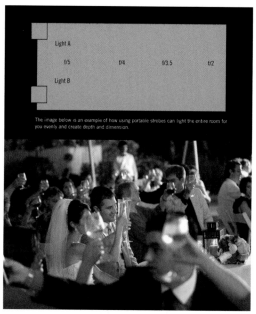

My lighting method for this wedding.

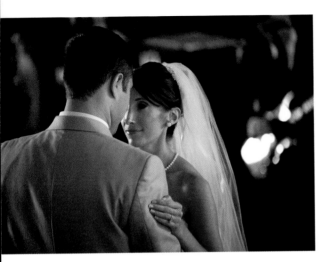

I shot this tent wedding using the lighting method shown in the previous graphic.

A key thing to remember when using studio strobes to light the venue is that you can't rapid-fire shoot. You need to wait for the strobe to cycle and refresh. This usually takes about one to three seconds, so be patient and plan your shots. There is no "aim and spray" with this method. You could easily burn out a strobe if you pop it too fast, or you could just miss moments and get underexposed frames. I like to take my shot and then count in my head, "One one-thousand, two one-thousand, three one-thousand," and click.

Some new studio strobes can cycle very fast and can allow you to fairly rapidly fire. I haven't used these yet, but I want to. For now, I just know the limits of my flash gear so I don't break anything.

I've used this strobe-lighting method to light both venues and ceremonies. I won't use it in a church, but I'll use it anywhere else. I don't use flash in church, but this method could easily light a really dark church should you need to.

If you don't have studio strobes, but you still want to light a room, you can use your speedlights. Speedlights with radio triggers attached or with a line of sight connection to your camera can light many rooms the same way a studio strobe can. They will drain batteries quickly if you're using a lot of power, and they might not cycle as fast as studio strobes, but in a pinch they're better than no lights if you need lights.

Gels: Are You Gelling?

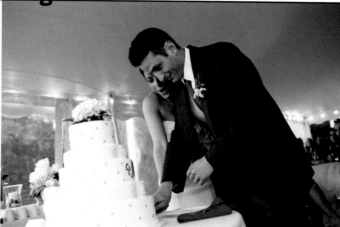

I have the wrong color balance in this shot with flash.

So now that you know what color temperature is, how it works, and how your strobes work, make sure you're getting the color right when you shoot so you don't have to change everything in post-production.

As I said before, I use gels on my strobes and on-camera flashes to balance for the lighting I'm shooting in. These gels are nothing more than plastic sheets that are colored and translucent. They are cheap—you can buy them at almost any camera store or lighting company.

To use gels, you simply attach them to your flash head with tape, Velcro, or even underneath a STO-FEN or other lighting attachment. Just make sure to change your white balance when you use them, and be very careful if you're shooting a daytime wedding and going inside and outside often. If you have everything balanced for the inside light and then you step outside, you must remove the gel and change the white balance, or you'll get an orange couple and a blue tint to the image. However, if you accidentally forget to remove the gel, there is a fix. I've done this many times, and the simple correction for me is to make the image black and white.

I carry all these gels with me.

If you're going to gel your studio strobes, be sure to make sure their modeling light is off too, because modeling lights can get very hot and can burn right through a gel. I know—I've done it, and burnt, smelly gels are not fun to deal with at a wedding!

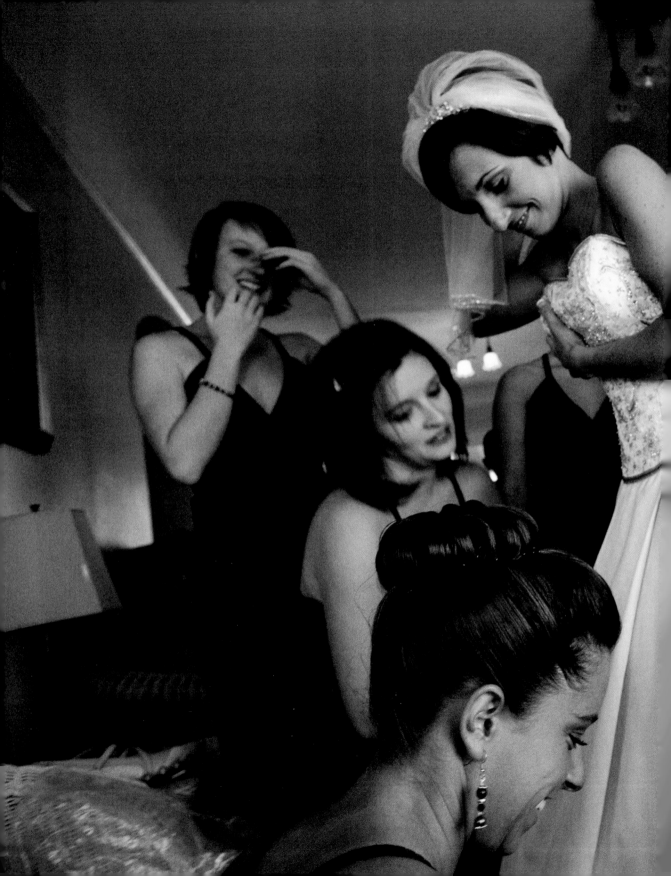

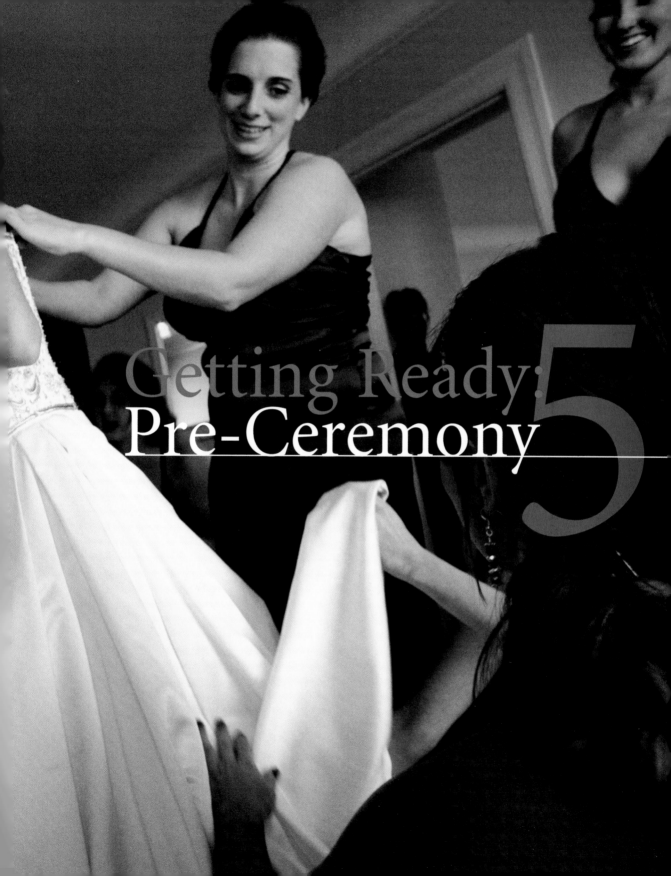

Getting Ready:
Pre-Ceremony

5

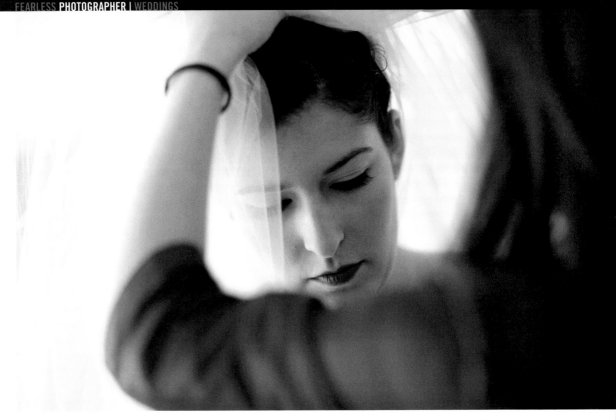

The wedding day starts early for most couples—more so for the bride and her bridesmaids. Hair, makeup, and getting dressed to the nines takes time and effort. These are also the last moments a bride and groom have as individuals before they're married. Some of my best work is documenting couples getting ready. There's just a cool feeling of joy that builds up to the wedding, and I love to shoot it.

Bride and Groom Prep

The hours before a ceremony are usually spent with the bride and her bridesmaids at a salon, in a hotel room, or even at a home, with the bridal party getting their hair and makeup done. Parents are busy getting dressed, dresses are being hung and steamed, and people are occasionally a bit nervous.

This is also a time full of jokes, friends and family at ease together, and placing the final touches on the details of day, with maybe a flower here or a birdcage there. For the groom, these moments are usually spent at ease—men tend to get ready more quickly, and I usually find the groom and his groomsmen out for some final adventure, getting back just in the nick of time to get suited up. Or, I find them watching TV and asking me whether they should get dressed yet.

"Photographing the prep moments in a photojournalistic style is the best way to capture them."

These are the last hours of the bride and groom as individuals and not as a married couple. I find that photographing these prep moments in an entirely photojournalistic style is the best way to capture them. In these moments, you see joy, fear, pride, elegance, and people without their shields on. At a wedding reception, the bride and groom sometimes have a shield on, so that their guests see them in a certain way; but in the time prior to the ceremony, when it's just you, them, and some friends and family, their guard is down, and you can photograph them as they are, how they feel, and how they live.

These aren't moments when you want to say, "Hey, look over here!" These are the moments when you just want to be in the room, doing your thing, and getting the shots. If possible, don't even use flash; instead, shoot at a really high ISO and wide open so that you can capture these moments as they happen, without affecting the people in the room. You don't want to distract people with a flash in their face; it's better to be on the other side of the room or on the floor in a corner, shooting the moments as they happen.

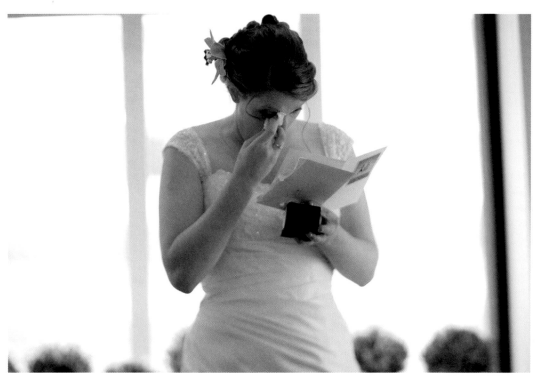

This bride was crying a bit over a card she read shortly before the ceremony. Emotions are typically close to the surface in the moments before the wedding, making it a perfect time to capture beautiful, raw, unposed images.

If you make the bride nervous, or if your presence changes the overall feel of the people in the room, you need to reevaluate what you're doing and how you're acting. You don't want to be the focus of attention, and you're not there to take posed snapshots. You're there to record the emotion of the day—of a mother and her daughter or her son, of a father and his little girl, all grown up now. These are the little moments that make the story of the day tie together at the ceremony. These moments are the story of who your clients are as individuals, as people, and as a family.

NOFEAR

To get the best candid, photojournalistic-type shots, shoot wide open and at a high ISO so you can avoid using flash. Nothing says, "Hey, I'm intruding on your private moment!" like a bright flash in the eyes....

The Bride and Her Bridesmaids

"Your goal is to make sure veryone is totally at ease before you get click-happy."

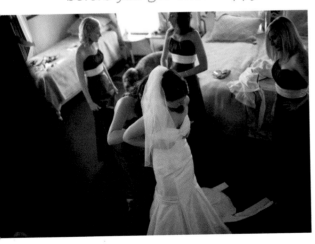

When you walk into a location, the first thing you should do is say hello to everyone, introduce yourself to the friends and family, and ask how everything's going or whether there's anything you can do for them. Make small talk, try to get a feel for how the bride is doing, and maybe sneak in a shot here and there.

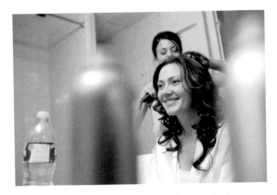

Whether the bridal party is getting ready in a fancy hotel room or a house, it's up to you to capture great shots no matter what you have to work with.

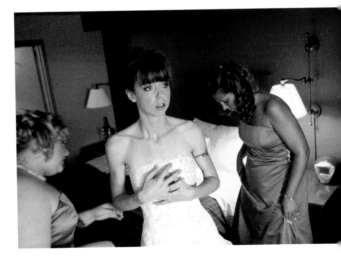

I set up these father/daughter moments by making a subtle suggestion to the fathers, but because the brides were unaware, I was still able to capture pure, unposed moments of emotion. This isn't pure photojournalism, but I sometimes find it necessary to get the shots the clients are dreaming of. I'm not the first photographer to do something like this, and I undoubtedly won't be the last.

Your goal is to make sure everyone in the room is totally at ease before you get click-happy. You can make your way from introduction to slowly disappearing into the action of the room. As I've said, I like to shoot wide open and fast; I don't want to be in the bride's face every second. Of course, sometimes a bride wants a few group shots of her and her friends, and I'm always happy to oblige them.

You want to get photos of your client being transformed from a woman to a bride, from no makeup and jogging pants to all dolled up. I like to get nice makeup shots and awesome shots of getting dressed.

Sometimes the locations you'll be shooting at are just plain awful—the light is bad, or the décor is distasteful. Your job is to shoot through it. Use your camera and your lenses; shoot tighter and control your depth of field and perspective. Shoot from up high or get on the floor and shoot up from there. You shouldn't have any excuses.

If I see a better location, I always politely tell my bride, "You know, the light is just so much better here. Would you mind doing your makeup and hair over here? Or maybe when you start getting dressed, you can do it over there with that nice window?" Never be afraid to ask. Even though you're being a photojournalist, you can still be a director and help design better shots without scripting it.

Again, another rule I will break: I'll create a moment if I have to. I'm a director, but I want to shoot these moments as a photojournalist. However, sometimes the moments just aren't happening, so what can you do? You can help create some moments. On occasion, I'll ask the father of the bride to go see his daughter and maybe tell her how he feels right now or how beautiful she looks and perhaps give her a kiss. I give the father these ideas without telling the bride. I don't tell him how or when to do them; rather, I encourage him to go be a father. Then the moment happens—the dad goes over to see his daughter, who's standing alone waiting for the limo, and he tells her how he feels. They laugh, they cry, all the bridesmaids start taking photos, and I take my photo.

NOFEAR

If the moment you want isn't happening, create it. You don't have to pose the people involved; rather, use the power of suggestion to help encourage the moments you want to shoot.

I didn't create the emotion; rather, I inspired people to show emotion. Some families are very open, and others are more emotionally shielded; but they all have emotion, and you want to find it, even if you have to provoke it a bit.

The Dress

"Treat the dress like a model and find the best light for it. "

Out of all the important parts of a wedding, the dress is high on the list for me. Many brides go from shop to shop trying on dresses until they find the one they fall in love with—*the* dress. If someone is spending that much time and money on one element of the day, it must be extremely important. So, I want to photograph it.

Ask to have the dress taken out of its bag or the closet, and then ask permission to place the dress where you want to photograph it. Naturally, you should assure the bride that it will be safe with you. (Brides can get very nervous about their dresses! It's the one thing that *can't* go wrong, in the eyes of many brides. This is their chance to look like a princess, after all.)

With the dress you can be a bit more creative—but not too much. I like to place the dress within the elements of the location I'm at to best see its detail. You should treat the dress like a model and find the best light for it. Sometimes that means creating the best light if it doesn't already exist. So get your strobes and video light out and get ready to experiment.

I sometimes hang the dress from the ceiling, place it near a window or on a bed, or even hang it from a lantern on the wall or on a bookshelf. I don't tie myself down to any cookie-cutter dress shot. I like to make each dress be unique in my photographs, just as every wedding is unique.

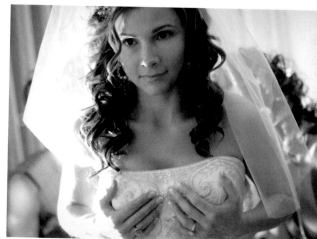

Some of your best shots may be of the bride getting dressed. Her dress is a huge part of the day for her, and her face will likely radiate emotion as she puts it on.

By the time you're finished photographing the dress, it's usually about time for the bride to get into it. Sometimes the bride will ask you to leave the room for a bit; other times, brides will drop everything and start changing. Either way, you should only take decent shots—you need to be a total professional. What you're looking for is the bride's face—the glow and the happiness she shows as she puts on the dress, or sometimes that scared look of last-minute jitters. Either way, you want to capture it. You want to capture the shared moments with her bridal party helping her get into the dress, lacing up her back, putting on her shoes, or pulling the dress down over her without damaging her hair and makeup.

Sometimes for these moments, I'll step out of the room and shoot through a doorway, framing the shot within the door. Other times, I'll shoot to show more negative space and frame the bride getting dressed against a wall or ceiling. I'll even shoot her backlit.

The point is that you don't want a boring shot. Look at the room when you first enter and talk to the bride. Look at the light and the décor and plan how to shoot it. If there's a second floor or a balcony, you can shoot from there. It's best not to have any preconceived ideas of how you'll shoot the bride getting ready. This is her most intimate moment of the day, and you want to make sure that your photos show that without you being distracting or in the way.

If that means you need to stand on a bed, a couch, or some other furniture in the room to get the shot, then do it. Get the shot, capture the moment—if you stand around and wait for the moment to happen or wait for that perfect view to appear, you're going to miss a lot. Search for moments, search for the views and angles you need, and shoot!

Tying the Ties: The Guys

If the groom is getting ready in the same building or really near the bride, you can go back and forth between the two groups to get the story of both getting ready. However, I personally won't photograph the men if they're more than a few minutes' walk from the bride or on a different hotel floor, because in my view the images of the bride getting ready are more important to the day than the shots of the guys. The bride is central to the wedding day, and her dress and details overpower the shots of the men getting ready.

However, when I'm able, I do take a lot of pride in photographing the groom and his groomsmen and family getting ready, and I always try to persuade my clients to get ready near each other so that I can tell each of their stories. I do believe that the groom getting ready is a vital part of the story of their day, but I can't always shoot it.

Shooting the men getting ready is no different from shooting the bride and her bridesmaids getting ready. The only difference is that you usually want the guys to look powerful, strong, and prepared—although a touch of vulnerability can make for a great shot, too. I also like to isolate the groom in whatever way I can, either with negative space or with a small depth of field, to show him as a key subject in the day. I want to see the groom as who he is at his most vulnerable moment, getting his suit or tux on, having his mother fix his cufflinks or tie his tie. These moments are key to the story, and although they may not involve an elaborate dress or makeup and hair session, these moments still say a lot about people and who they are.

I like to shoot the men toasting, pouring a drink in salute, or maybe exchanging gifts. I don't want them to look over here and hold up their glasses to me—I want them to do their own thing. When they're doing their thing and I can just shoot it, it's magical.

Sometimes nothing happens. I've walked into a room and found the guys just sitting there and doing nothing. All dressed up and bored… You can shoot them doing this and then improvise. "Hey guys, why don't you toast to each other or make a salute?" Ask them whether they want to look cool, and of course they'll say yes.

When guys are getting ready and you can walk into a room where they are busy brushing their teeth, showering, and getting dressed, then you can have a field day shooting. Turn up your ISO, open your lens, take a metering of the room, and shoot. I try to shoot wide shots of the room with my panoramic camera and then shoot tight details, such as hands, ties, shoes, and cufflinks, with my 85mm f/1.2.

One thing to note: Guys are usually more aware of you than the ladies are, so it sometimes takes a bit of talking to them without shooting to get them comfortable with you.

NO FEAR

Sometimes the guys aren't as comfortable being photographed getting ready as the women in the bridal party are. If that's the case, chat up the guys a bit. Talk to them like you would your buddies, and they'll usually loosen up within a few minutes.

Sometimes that means talking about a recent sports game, the hotel, that cool concert the other night, or even how lovely the bride and her brides- maids are looking. You can do this for a few min- utes, then go back to the bride, and then come back and shoot. It's all about building a comfort zone. Tense shots of the guys—or of anyone, for that matter—are no good, but once you get them to think of you as just another member of the family, then you can shoot without any hiccups.

The bride has her dress, jewelry, shoes, flowers, and veil, but the groom has some details that I look for, too. Sometimes it's a special suit, a tie, expensive shoes, a pocket watch, a flask, or maybe a patch. I had one wedding several years ago where the groom gave his best man the patch from the movie *You, Me and Dupree*. The best man wore this patch on his suit all day—it was really special to them, and it told me a lot about their relationship.

Although the bride and her bridal party are central to the day, don't make the mistake of *only* thinking about them. The men can have just as many details and stories; you just have to look for them.

This patch from the groom to his best man spoke volumes about their relationship. Details like this one can help you tell the story of the groomsmen, too.

If you're able to, shoot the groom's party getting ready, just as you do the bridal party. After all, the groom is a key part of the story, too!

On both sides, pay attention to every word being said. Listen for details that will tell you who these people are and that will help you shoot. They'll tell you what that pile of glasses on the desk represents, what that card on the table means, or what that special gift being sent over to the bride is. If you listen, you'll be prepared for what's happening and understand the meaning of it all. Knowing that a piece of jewelry was handed down from a grandmother is beneficial because you know that when the bride sees her grandmother, you can look for that extra connection between them. This doesn't always happen, but if it does, you'll be prepared.

Once in a while, you'll walk into the room and find people missing. "Where did they go?" I always ask. Sometimes people go off to write speeches or greet family members. These are important moments that you'll have to search for and listen for. The best man in the hotel lobby writing his speech is important to the wedding story. Not everything will happen in one room or even two rooms. You need to be a detective and use all your skills to find out who, what, when, where, and why.

Everyone's ready to go. Next up: the main event.

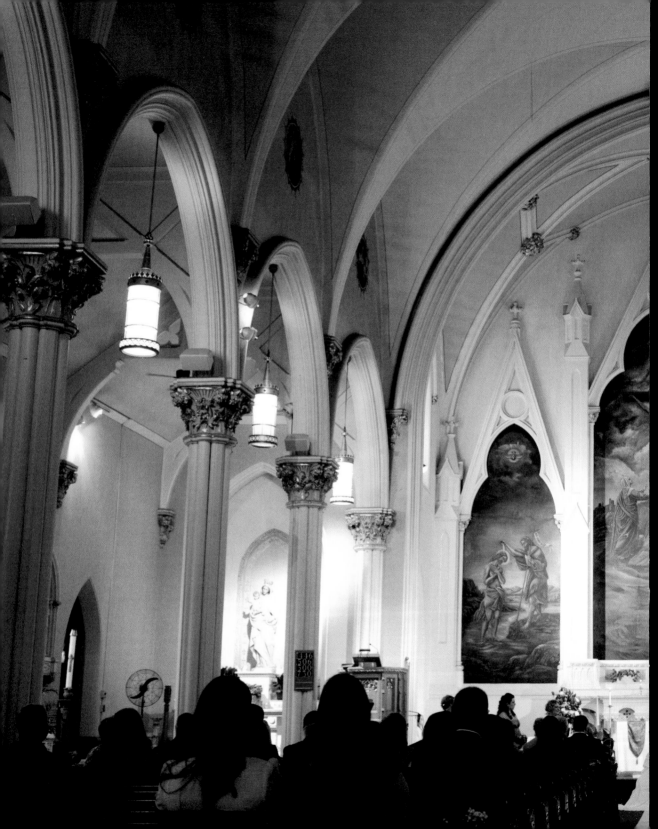

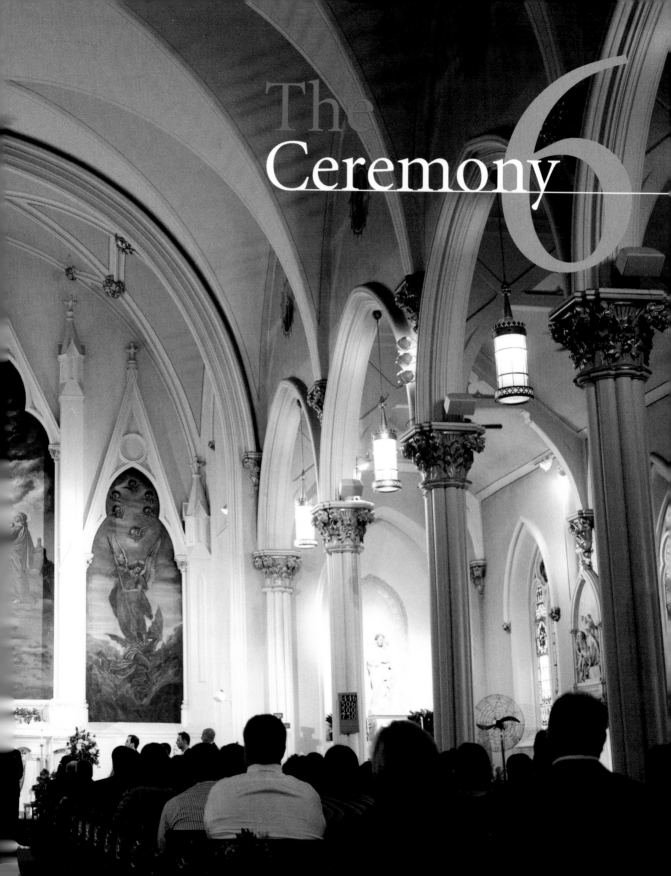

The
Ceremony 6

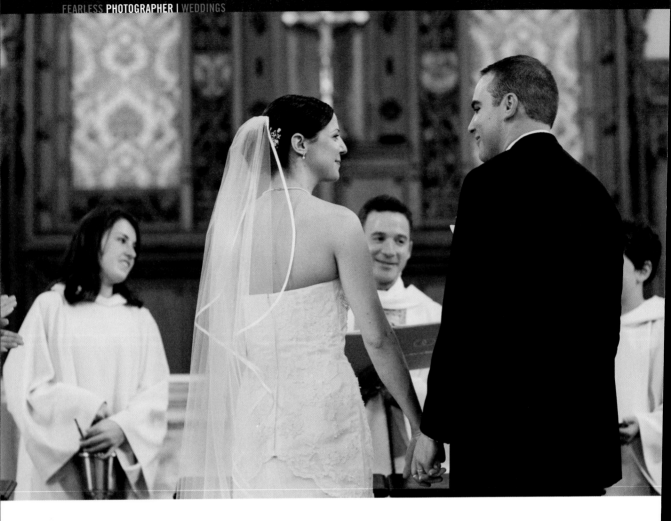

The ceremony is the most spiritual, connecting, and powerful part of the wedding day, and my approach to shooting it is pure documentation and photojournalism. I don't want to be connecting at all with the couple—I don't even want them to know I'm there. I do, however, want to get shots of the procession, the giving away of the bride, the vows, the exchange of the rings, the kiss, and any religious elements of the service.

Many Christian ceremonies take place just in the church, but for Judaism and some other religions, the ceremony can start many hours before and include elaborate elements. There can be very

serious and emotional moments, such as the groom coming to unveil the bride and make sure it's her, or the bride's parents smashing glasses in honor of the ceremony.

I can only speak for ceremonies I've seen, which include Catholic, Greek Orthodox, Christian (of many kinds), Jewish, and Orthodox Jewish. All of these religions have their own spiritual and meaningful traditions, and it's always a good thing to know what's going to happen during one of these ceremonies before you shoot one. I research religions and talk to my couples about what they plan on doing, and I always ask whether there's anything special being done that I should know about.

Jewish Weddings: Shooting the Moments Right before the Ceremony

"You just want to capture the pure and raw emotion of the moment."

Sometimes with Jewish weddings, the pre-ceremony starts with the groom being led by his groomsmen and the men in the family to check on and unveil the bride. The groom and bride may both be involved in special prayers and may not have seen each other in days. For these situations, you can go back and forth between the groom and the bride with their groups and document what's happening.

This isn't a time to include fashion or portraiture in your shots. It's just pure photojournalism. Don't even use flash if you think it will be distracting to what's happening. When the groom goes to unveil the bride, you don't want to be a distraction to anyone. You just want to capture the pure and raw emotion of the moment.

NOFEAR

Shoot like a photojournalist when you know the action is going to be fast and furious.

Case in point: I was shooting Melissa and Asher's wedding a few years ago. There were about 500 guests, and the bridal party was huge. When Asher was being led to unveil Melissa, there was a sea of people, and I had to decide very quickly how I was going to shoot. I had my gear on me—two bodies, two lenses, and my flashes—the room was huge, and everything was happening quickly. I decided to shoot this all super wide, because there was so much of a story to tell that tight shots would not do it justice.

I shot this scene with my 20mm and then used my 80–200mm for some tight shots of Asher and Melissa and of Asher being taken away on the shoulders of his friends and family. I moved like a madman during this shoot and was covered in sweat by the time it was over, but I captured the moments that mattered and the emotion that was shared between these two large groups of people. Had I not shot this like a photojournalist—had I not known this was going to happen—then I might've missed it and not gotten the shots that counted.

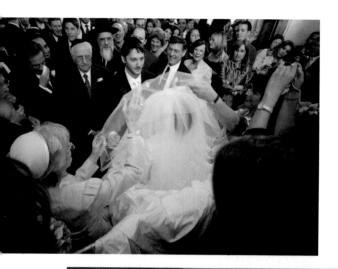

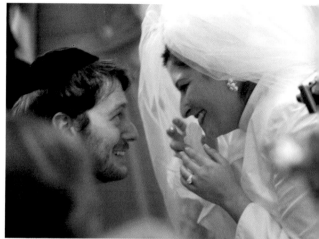

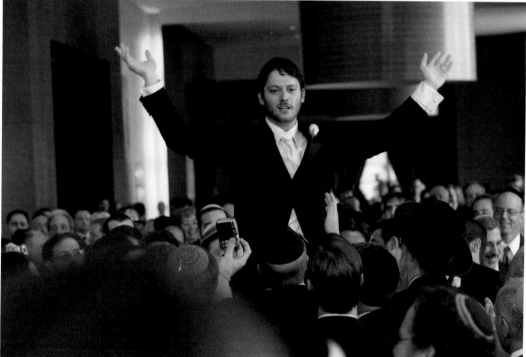

I didn't want to miss a moment of the emotion of this traditional Jewish unveiling of the bride.

Churches: Right before the Ceremony

For Christian and Catholic ceremonies, the moments right before the ceremony might include the bridal party lining up outside the church or hall, ushers seating guests, or a bride arriving or waiting in a limo or car with her father. The groom is at the altar with his best man, looking at a room full of friends and family, with everyone waiting for the bridal march or other special music that indicates the ceremony is about to begin. These are important moments, and they don't happen twice.

If the church is well lighted, I will use my 80–200mm on one body and my 35mm on another so that I can shoot moments happening close to me and moments from afar. You don't want to intrude on anyone's space during these moments, so you should use the highest ISO you need to capture the shots without flash. If this means shooting at 3200 ISO at f/1.2 or f/1.4, go for it.

Don't miss the important pre-ceremony moments!

I typically start with the groom inside the church, with his ushers greeting guests. Then I make my way outside to the limo with the bride in it or to wherever she may be waiting. I want to get shots of the bride in her final moments with her father before he walks her down the aisle.

You may sometimes find that everyone is rocking out to a radio song and drinking champagne in the limo. They may all be quite nervous, and the lighthearted atmosphere is a good way to ease the tension. Other times, you may find the limo outside and the bride peeking out the window to see what's going on. Every situation is different, but it still calls for you to shoot what's happening.

As the bride is escorted out of her limo or car to the church, I shoot quickly. I may be lying on the street somewhere shooting her being led out, or I may be up on the church stairs shooting down. I'm looking for a cool angle, not the safe shot that I'm having my assistant take, which is a rather straight-on, for-the-record shot.

I usually have fill flash on if I'm close to the bride and groom or if it's cloudy out and I want to add some pop. I run into the church as soon as the bride is settled in, and I head down to the end of the aisle, where the groom is waiting.

The Procession

Some churches are really well lit, and you can shoot the entire procession without any trouble. However, most churches in my area are very dimly lit, so in these cases (and only these cases), you may need to pull out the dreaded flash bracket and flash. You can use flash for the procession into the church. You'll want to have really clean shots of the bride walking in, as well as her bridesmaids and their flowers. Don't blast your flash, but you can set your camera to ISO 1600 to 3200 and shoot with your flash at 1/128 power or 1/64 power—or TTL with the power compensation set to −1/3 stop. TTL is very useful during the procession when the bride and bridesmaids are moving quickly down the aisle toward you.

Images of the procession captured with and without flash.

NOFEAR

If you must, you must. Some churches are just too dim to get clear shots without a flash. Don't use flash to light the room, though; just use it to freeze the motion of the bridal procession.

If you use a flash bracket, you can turn the camera vertically and still have your flash centered over the image. That way, you don't get flash shadow. You should only use the flash to freeze the motion of the bridal party walking toward you. Don't use it to light the room. You also don't want to bounce it, because it would kill the batteries very quickly and because you want to shoot quickly. As soon as the bride gets to the end of the aisle, drop the body with your telephoto lens, pick up your wide-angle body, and shoot her being given away.

The Vows and the Ceremony

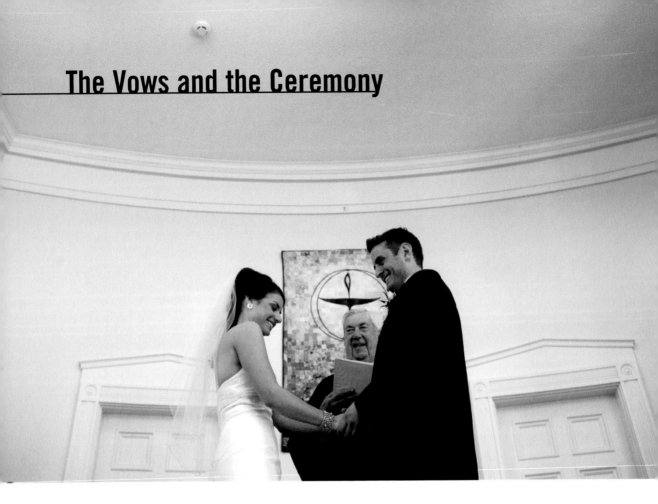

The vows and ring exchange are important parts of the ceremony, but you don't want to be obtrusive when you try to capture these moments.

For the vows and the ceremony, make your way to the end of the church and shut off your flash. For the rest of the ceremony, you don't even want to be heard breathing. Don't run around or make any scenes. Stick to the walls and the shadows and shoot as wide open as you can. Most altars are fairly well lit, so you can usually shoot at f/2.8 with an 80–200mm lens and get close-up shots of the ceremony. Some altars are not as well lit, and in these cases you'll need to move as close as you can while being discrete and shoot with something like an 85mm f/1.2.

Move up the aisle for the vows. Using both a wide-angle lens and a telephoto lens, you can take close-ups of the ring exchange and the kiss, but don't use flash or run around. Most the time I kneel or crouch in a very awkward position—wishing I did yoga to improve my flexibility!—to take these shots without being seen.

Try wide angle in churches, too. It's not all fun and games shooting tight all the time. I like to get up on the church balcony or lie down at the end of the aisle and shoot the church as a giant movie set with key characters all around. Shooting wide in a church is not appropriate for the ring exchange, but it works for the first kiss, and it can make a small church look larger than life.

NO FEAR

Shoot with a wide-angle lens to give a small church a larger-than-life look.

At the end of the ceremony, when it's time for the newlyweds to walk out together, toss your flash back on and put it to the setting you want, including TTL, and quickly shoot the couple coming toward you. They usually can't wait to get out of the place and into their getaway car. If you were shooting with manual flash, you'd have to adjust its power settings or your aperture as the couple moves closer to you, which takes time, but in TTL you can just set your camera to the exposure you want and shoot, knowing the flash will calculate the power needed as the couple moves toward you.

The first kiss, captured with a wide-angle lens.

I used flash in the color shot of the newlyweds exiting the church. I shot the black-and-white image without flash.

Family Reactions and Details

When I'm shooting a ceremony, I don't keep both of my eyes on the bride and groom—I keep one eye on them and the other on the family and guests at the wedding. I shoot the ceremony like a photojournalist, so not only do I want to shoot the action, I also want to shoot the reactions and the details.

I want to see the smile on grandma's face, the tears in the parents' eyes, and the joy of all the friends and family. I want to see that lineup of all the bridesmaids' flowers or the maid of honor fixing the bride's dress. I'm looking for the beauty of the ceremony and those magic moments that are so brief that they're over in the time it takes you to blink.

To do this, you're constantly scanning the room. When you see the bride and groom do or say something, immediately turn the camera to the family and friends to capture their reactions. You may not know the meaning behind some of the giggles and tears, but the bride and groom and many viewers of your images will know.

For the most part, the area where the guests are sitting is many stops of light lower than the altar or *hupa* area, so you should memorize the exposure for each zone and then set your camera(s) to the exposure for the bride and groom. Then set a second or third camera for shooting the guests. This way you can cover the altar area and the guest seating area without needing to reevaluate exposure.

"I'm looking for those magic moments that are over in the time it takes you to blink."

Just keep your eyes and ears open and your camera ready. These moments are the other half of the story, and they're still very important. Besides, remember that your bride and groom are so focused on each other that they won't get to see their guests' reactions, especially during the ceremony. When they see your pictures, it'll mean a lot to the couple to see the emotions their guests shared on the big day.

Don't forget the detail and expression shots. The bride and groom will likely be too preoccupied to pay much attention to such things during the ceremony, and they'll appreciate being able to experience these details in pictures!

Outdoor Ceremonies

When it comes to outdoor ceremonies, I'm always excited and scared. I'm excited for the great views and light I'll be able to work with. I'm scared of the pouring rain that we get so often here in Boston that will force the ceremony into a small room or tent.

With that said, I like to shoot ceremonies outside the same way I shoot them inside—very discretely. Use the longest lens you can and make sure to stay out of the way. What you do differently will depend only on the location. Look for every angle you can shoot from, and try to incorporate the location into the ceremony as much as you can. If that means making the sky the backdrop to the ceremony, you can use it and isolate the bride and groom in front of it.

If I can stand on a roof and shoot the ceremony from there, I will. It helps to preplan and know as much as possible about where and how long the ceremony will be before you do this. You don't want to run off to get a cool shot, only to realize that once you get back to where you were, the ceremony is over. So plan ahead or send your second shooter to get the shot you want.

In theory, shooting outdoor ceremonies is not much different from shooting indoor ceremonies. You're still looking for the best angle and shot—although this time, you're also hoping Mother Nature will cooperate!

Hotel Ceremonies

I used the bluish tint from the cloudy light to my advantage for this ceremony.

Sometimes ceremonies are not in a church or house of worship, on a field, at a beach, or in a temple, but in a hotel function room or hall. I actually enjoy hotel weddings because they break things up for me and put me in a place that can be tougher to shoot.

Most hotels' function rooms are well lit, but the light is usually flat unless the bride and groom decide to add some up-lighting or interior lighting to the room. This makes shooting a hotel ceremony a bit of a challenge, and I like challenges because they push me to try new things.

I once had to shoot a hotel ceremony that was facing windows overlooking Boston Harbor, but it was during sunset, and the sun was glaring straight into the room. To shoot the couple at this wedding meant shooting into the sun. What did I do? I positioned myself so I wasn't shooting directly into the sun and aimed to get the shadow

or room-lit side of the couple. I also hid the sun behind the couple and shot them with the background blown out around them. It was harsh but beautiful light. I may have used flash for a few shots, too, but not many.

NO FEAR

You can work with any type of light, no matter how unpleasant it appears. If you're faced with harsh light, try to hide the sun or get a different angle to shoot the couple.

On another occasion, there was no sunlight coming into the room, and the light was perfectly even everywhere—except for near the window where the bride and groom were. The cloudy daylight spilled into the room and created a blue tint to the overall gold and warm look of the rest of the room. I liked it and went with it. Had I used flash for this, I would have lost the golden glow created by the ornate light fixtures and cloudy light spilling in. I exposed for the couple's faces and shot. I worked from both the back of the room and the sides. Because this was not a church, I had a bit more freedom to move around and was able to move up and down the sides of the ceremony, since the room was so small.

For the ring shot, I moved to the center aisle and shot close-ups of the rings being exchanged. I never move farther forward than the second row of seated guests. That way, I'm never in the way or in the view of family members, but I'm in a prime position to get great reaction shots of guests during the ceremony.

So now that you've shot the ceremony, it's time to move on to family portraits—an entirely different type of shooting than what you do during the ceremony. Let's get ready to switch gears.

"I like challenges because they push me to try new things."

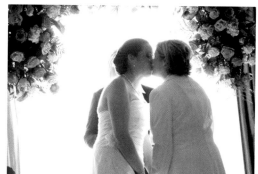

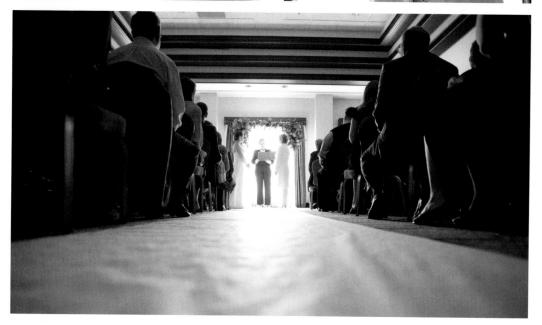

I couldn't avoid the harsh sunlight coming into the room for this ceremony, so I had to work with it to create beautiful images. Sometimes you just have to use a little creativity....

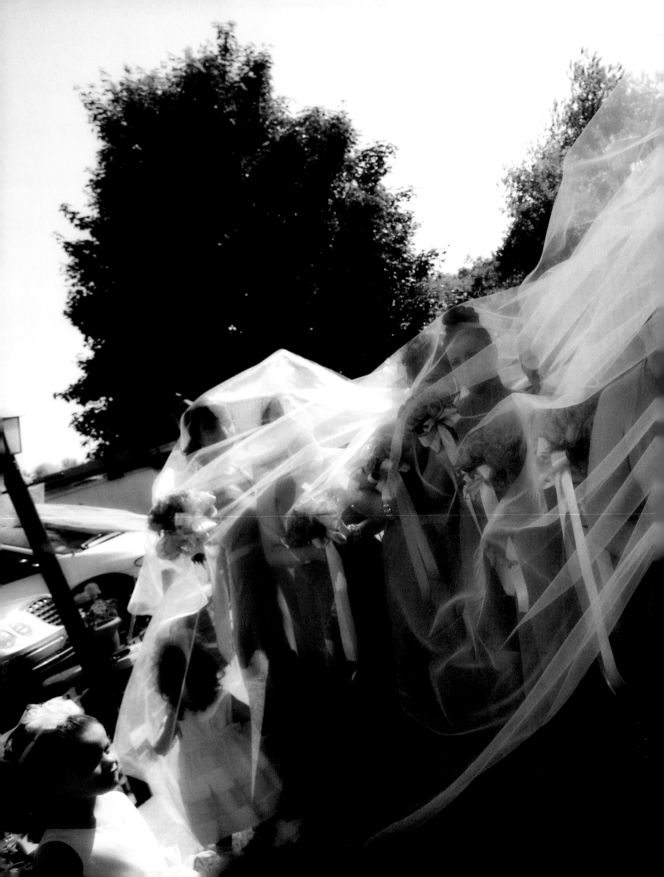

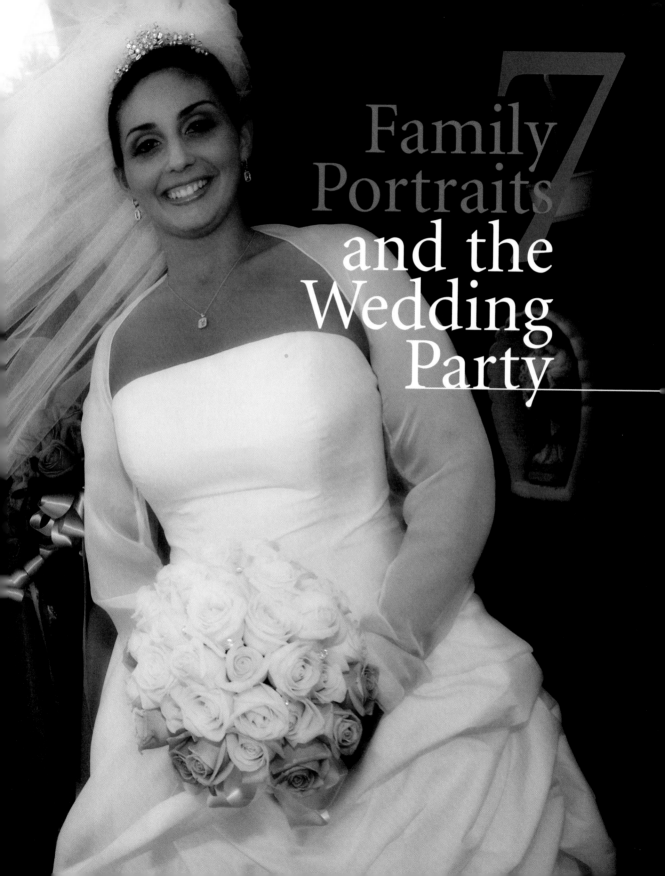

Family Portraits
and the Wedding Party

7

The Dreaded Family Shots

FEARLESS PHOTOGRAPHER: WEDDINGS

"Family shots are an important part of a wedding, and most likely they're the photos you'll actually sell and make a profit from."

You may be saying, "I hate family shots!" Well, too bad! They aren't the most exciting things to shoot, but they are an important part of a wedding, and most likely they're the photos you'll actually sell and make a profit from. Shooting family portraits doesn't have to be a long and painful process, but you should make sure the shots are well posed and well lighted. If your coverage of the day and portraits of the bride and groom are awesome, you don't want to ruin the trend by providing lesser family images.

I can't stress enough how important these photos are as a record of who the people you're photographing are. When you look back in history-type books, it's family portraits that tell the story of a family. I know one of the most important photos to me is one of me and 50 of my relatives. It was taken in the 1980s, and it shows most of my family, many of whom have since passed away, so I cherish the photo. I had it blown up and gave it as a gift a few Christmases ago when I stumbled upon it going through old photos.

Family photos can be powerful, so let's talk about how you're going to take them.

First, you need to be prepared. Get a list from the bride and groom of whom they want family formals with and how many people they will include. Have the couple write out a list with names and group combos. You don't want to show up the day of the wedding and say, "So, who do you want shots with?" It's far better to be prepared. Besides, the bride and groom already have enough on their mind that day—having them write the list ahead of time gives them one less thing to worry about on their big day.

Also, you can't assume that the bride and groom want parents in the shots with them—they might not get along. Don't assume anything; just do as the bride and groom have told you to do. Of course, they can always add more groups, and they usually do.

NOFEAR

Don't ever assume that the couple will want specific people in their family shots. The last thing you want to do is step into the middle of a family feud. Ask before you shoot!

You may hate taking family shots, but keep in mind how important they are to the people in them. For some, this may be the only record they have of their entire family.

Planning for the Family Shots

Now that you know who you need to photograph, make sure you let the couple know how much time you'll need to photograph that number of people. That time is relative to how you work with groups and how quickly you shoot. I like to get all my family formals finished within half an hour, and I find that most couples appreciate this. They just got married—they and everyone else involved are eager to get to the reception, not to spend time posing for an endless set of pictures!

Second, you need to know where you're going to take these photos—outside, indoors, or in a photo room? It all depends on what the couple wants, and I always ask them. Sometimes, even though you are on the beach and have a beautiful vista, the couple may still want formal indoor, lighted shots. If that's the case, you need to be ready with your lighting and know where you're going to take the shots.

If you're outdoors and you do have a vista background, make sure you know what you're doing. This is where your knowledge of lighting and flash comes in. No mother wants a photo of her and her daughter with them squinting or with the background blown out. This is not the time to get crazy high-contrast shots. This is when I want well-balanced, clean exposures that make everyone look great.

"If you're outdoors and you have a vista background, make sure you know what you're doing."

Look for a non-distracting background and ensure even lighting when you shoot family portraits indoors.

If you're outdoors and the lighting does not suit the photo, tell the couple and recommend that they move somewhere else or even indoors. Of course, you should explain all this to the couple when you meet before the wedding, so you can make sure they're okay with this. If you just tell them you want to get the best family photos you can for them, they'll usually agree. Sometimes they're dead set on outdoor shots at noon, though. If this happens, just take the shots and do your best to make everyone look recognizable as they squint. You've warned them of the risks, but in the end it's their decision.

When you do have control and the lighting is really bad outside, you might opt for indoor umbrella-lit family portraits. Find an area, a wall, or a nice room where you have good ceiling height and non-distracting backgrounds. You can set up a couple studio strobes, both at the same power and bounced into large umbrellas. If the room has white or off-white walls, you can sometimes just bounce off of them instead, for a more diffused look. You want everyone to be lighted evenly. Try to get them at f/8 across the image, so everyone is sharp, and at ISO 100. If you need to, go up to ISO 800, but no further. Beyond that, noise can be an issue.

When you're shooting an outdoor summer wedding and there is no place to shoot inside, try to find really good bounced light from a building or trees, or even shade. Use fill flash on your on-camera speedlight to fill in any shadows, but also to make the family members pop from the background. I usually meter off of the bride's face and then add some flash to get one-third to a half stop more of f-stop with my flash. You don't want the family to be exposed and the background to be black, but you want just enough flash to make the family members pop.

"Make them laugh, make them cheer—just get some emotion from them."

Creativity in Family Shots

Just because these aren't exciting, dramatic shots, that doesn't mean you can't be different with them. I always try to make my family shots stand out. If this means lying on the ground, climbing a ladder, or hanging out a window, I'll do it.

Everyone in the shot does not have to be standing there looking at their drinks behind you, either. Make them laugh, make them cheer—just get some emotion from them. Be sure to pose them, too. I like to look at old Kennedy wedding photos

and other photos from that era and see how high-end portraits were done. Is everyone looking at the camera? Is someone's hand just hanging there when he could be holding someone or placing it in his pocket? Give life to the people in the photo. An extra moment spent posing everyone to look unposed will make the photo a lot better and more exciting in the end.

NOFEAR

Get a little crazy if you need to in order to get creative, interesting family shots. Try shooting from a ladder, lying on the ground, or even hanging out a window. Unusual angles can really liven up a family portrait.

There's nothing wrong with traditional family portraits, but try some creative angles, too. You may be pleasantly surprised by the results. A unique angle can add a lot of interest to a family portrait.

I don't recommend trying to make these images over the top or goofy. Shoot for elegance, fun, and style. Out of all the incredible photos you take at a wedding, these are likely the ones that'll be hanging on someone's wall, displayed in their wallet, or even set as their computer background.

One final thing about family shots: Be sure to take multiple shots. You have them there, so you don't want to take only one shot and then realize you later have to Photoshop eyes on the person who blinked. Get the shot right the first time.

"I'm a big fan of negative space and movie art.... I want the background to be as much a part of the photo as my clients are."

The Wedding Party

Everything I said about family photos goes for the wedding party as well. Except now you're dealing with a smaller group of people who are most likely close friends of the bride and groom.

Let's start with knowing who the wedding party is. The wedding party is made up of the groomsmen, bridesmaids, flower girls, ring bearers, and sometimes parents. Most of my clients want shots of this group together and then smaller group shots with just the bridesmaids, groomsmen, and any of the kids.

Traditional versus More Creative Wedding-Party Shots

As I said before, your photos are a record of this day, of who these people are and where they were at this time in their life. So before you try anything edgy or different, always make sure to get a really clean and formal portrait of everyone. Take, for example, a wedding I shot at a Boston hotel in the fall. It was pouring on and off, so I had to do the family formals in the cocktail room, where I set up lights and chairs for everyone. These were my safe shots. I knew that no matter what, I had taken shots that showed everyone.

When I had those shots, I took the ushers outside, since they weren't worried about being cold for a minute, and I got a flying V shot of them with the hotel behind them. For the bride and her bridesmaids, I took advantage of the hotel's interior and found a nice couch for her and friends to be photographed on. I wanted the photo to be modern, because this was a super-contemporary hotel, but also very friendly. I placed the ladies as I imagined a Renaissance painting from Rome, where the ladies in their dresses looked elegant, at ease, and perfect. *Click*—I got the shot. If the shot didn't come out, I still had the umbrella-lit shots to fall back on.

If you're outdoors, you probably want to take a few shots that are full dress and very traditional, but then you can get creative and use what you see. I'm a big fan of negative space and movie art. So with that in mind, I shift my focus from full body and dress to just shoulders or waist up and fill the bottom of the frame with the wedding party and the rest with the sky or background. I want the background to be as much a part of the photo as my clients are.

This isn't one of my favorite shots, but it allowed me to get everyone in when it was pouring rain, and this was the only space large enough to fit everyone. It also allowed me to light them all at once. It's not an artsy shot, but a shot for the record.

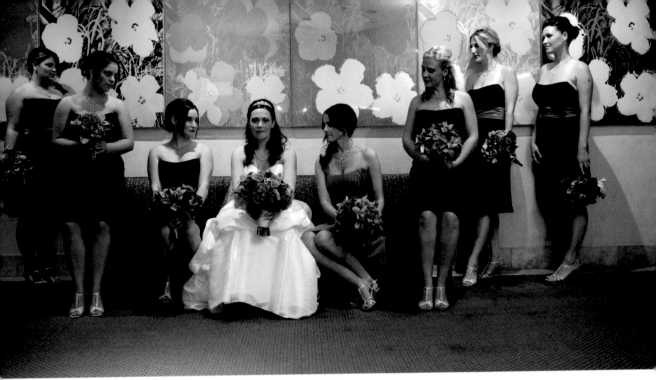

After I had the traditional portrait "safe" shot, I was able to get more creative with the small-group shots.

Sometimes this is obvious. If you were shooting in London, for example, Big Ben might be important. But if you're in a park or at a mansion, then the trees or house would be your Big Ben. Remember, these location details help tell the story of the wedding, so don't ignore them when you're shooting. If you're just getting a shot of the wedding party and not showing anything else, then your photo won't say anything about the wedding—where it was, when it was, or how it was.

If you treat the background as a subject and not just as a background, then new ideas will open to you. The location, your background, is a subject or member of the wedding party, so if you can lay out the background with the wedding party as you might lay out a movie poster, where the wedding party is your team of superheroes and the background is the scene in the movie, then you've created a really cool image.

NOFEAR

Treat the background as a subject, and new ideas will open up to you.

Posing the Wedding Party

Posing the wedding party doesn't have to result in something that looks like a police lineup. You can have lots of fun with wedding-party shots. I usually have fairly large groups here in Boston—sometimes 18 or more people. When I get a large group like that, I line them up in the friendliest way possible, and I shoot really low and fill the frame with them. I also try to create rows—on a stairway if I have to—and then I can stack the party together with the bride and groom front and center. Stacking requires more depth of field, so when it comes to shooting really large groups of people, keep it simple and just line everyone up and create rows if you have to—no complicated or super-creative poses for large groups.

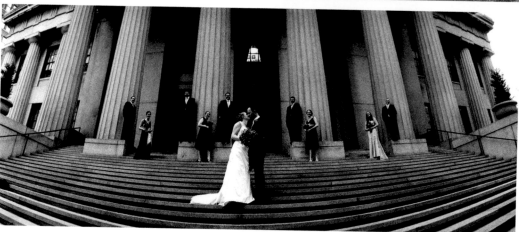

Fill the frame in unexpected ways or shoot at unique angles to get some really memorable wedding-party shots.

Case in point: I was shooting a wedding that had a wedding party of 20+ people, and the only time I had to do this shot was right after the wedding ceremony. This was a large Italian wedding with well over a hundred guests at the church, and all these guests were itching to get outside and meet the newlyweds. I had little time. As soon as the ceremony was over, I bolted out the church doors and told an usher to shut the doors after the last member of the wedding party walked out. As each member walked out, I placed him or her quickly on the steps of the church. When the last one stepped out, I started yelling to get everyone's attention; I was like a movie director. Then a woman who did not want to wait inside opened the door to the church, and I quickly yelled, "Hey, lady in the blue dress! Get out the way!" Everyone in the wedding party started laughing, and I clicked the shutter and got the shot. Seconds later, people poured out of the church doors, and the wedding party dispersed. Had I not turned into a director and worked quickly, that shot would never have happened.

NOFEAR

Assume the role of movie director if you have to. When you're dealing with large groups of people, you need to take charge to get your shots.

At the same wedding, I took photos of the bride and her bridesmaids right before they jumped into the limo to head to the church. They were all waiting for the limo outside, and the bride's extremely long veil was blowing over everyone, so I did a little persuading and got the ladies to get under the veil. I took a few shots and then bolted to my car to get to the church to meet the groom and his groomsmen. I had only minutes before the bride was to arrive, so I set the gentlemen up on the church steps (after gathering them all) and took a few shots. That was it.

I was able to get creative and fun with these bridal-party shots.

"Posing the wedding party doesn't have to result in something that looks like a police lineup."

Some Final Tips for Shooting the Wedding Party

Not every wedding will allow you hours of photography with the wedding party; sometimes you just have few moments to take advantage of. Seeing these moments is key, and good planning in terms of knowing the schedule of the day will help you. There's rarely time to say, "Oh, let's do that again. Can we try this? Maybe if you look here…" There is rarely time to experiment, just time to get the shot

and move on. You need to be confident with your gear, trust your exposure, and more or less feel the group and control them by talking to them to get the right reactions from them to get the shot.

Know your clients and interact with them. Let them know you're totally cool with them. Don't try to be "the photographer"—be their friend, but be direct. Make sure they are paying attention to you, and do what you have to do to get them to pay attention. There are no redos, so be the movie director if you have to.

 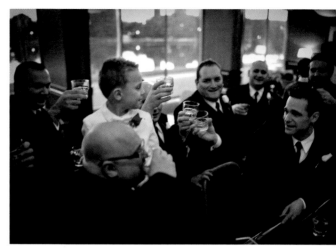

These wedding-party images shot in a bar have an old-world feel despite the contemporary wedding.

When you have a smaller wedding party—say, 10 people or fewer—you can have a field day setting up wedding-party shots. I like to look at fashion magazine ads and see how they group people and then re-create or re-imagine those shots with my own twist.

When I was shooting a wedding party in a vineyard this past summer, I envisioned some Prada ads I had seen earlier that year. I didn't take the ads with me, but more the feeling of the ads. I thought to myself, "If I was at a fashion shoot for a clothing line, what would I be doing?" And then I did it. Don't hold yourself to the "wedding box"—get those safe shots and then move on to being creative. If you want to have the wedding party lie on the ground and then shoot them from a ladder, do it!

You may be saying to yourself, "Not every couple looks like a fashion ad!" Well, you're right, but that doesn't mean you can't have fun with their wedding-party shots. Every group of friends—in other words, every wedding party—has personality, and it's up to you to find out what will make them spark.

What about that bar in the hotel lobby or across the street? How about placing the wedding party at the bar corner and letting them toast each other like in a Mafia movie? Or how about just lining up the ushers on the steps of the church and shooting up at them so that they look like a rock band? See what your wedding party is into—listen to them as they are talking all day and find out what they like. The bride and groom already like your style and what you can do, so just do it.

"Don't hold yourself to the "wedding box"—get those safe shots and then move on to being creative."

NOFEAR

Find out what your wedding party is into, and use that information to come up with some new ideas for wedding-party shots.

Approach every wedding inspired and ready to try new things. Try to set one goal or test for every wedding you shoot. That way, you're always pushing yourself to do your best. Sometimes my goal is to shoot more with my 20mm lens; other times it's to shoot more film or even to try out a new pose that's been in my head. I write down my ideas and plans for a wedding when I meet with the bride and groom. I even tell them some of my ideas to make sure they're cool with them. I don't want to plan a big location shoot during a wedding, only to find out the day of the wedding that the bride is vehemently opposed to the idea.

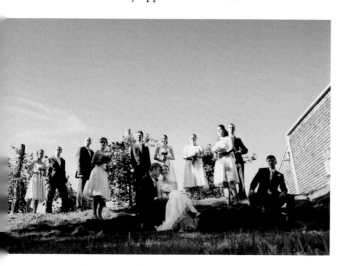

Not a traditional wedding-party shot, but an interesting one.

"Every wedding party has personality, and it's up to you to find out what will make them spark."

Case in point: I was shooting a wedding near a railroad yard last year, and the groom and I were planning to go to the yard during cocktail hour to do wedding-party shots with boxcars in the background. At the meeting everything was a go, but just a few days before the wedding, the bride changed her mind. So, I planned out everything again, but this time without the railroad yard. Had I not planned and had I just assumed the couple would go where I wanted, I would have been in trouble!

Get to your location early if you can. Run around it, lie on the ground, and look everywhere. Doing this will set you free to take pictures when the time comes to shoot. If you can, try to explore the location before the wedding day—take snapshots and notes. If you can get to a location before a wedding, you can visualize the wedding there and run it through your head so that when the wedding happens, you know where you want to be and how you want to shoot it.

The more you plan, the better. And the more you know your gear, the quicker you can work to get the shots you need.

So now that you've shot the bridal party, it's time to move on to the real stars of the day: the bride and groom. We'll cover their shots in the next chapter.

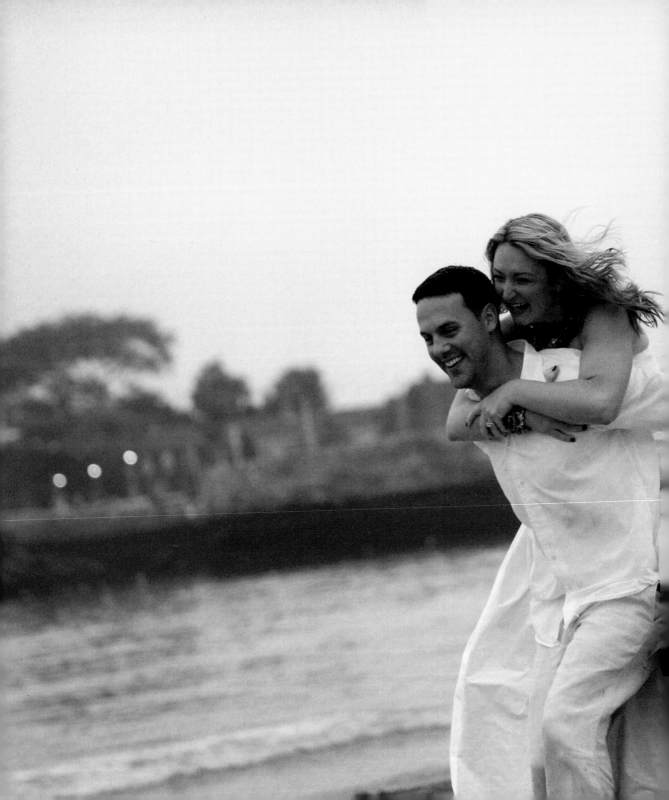

Bride and
Groom

Whether you're shooting the bride and groom before the ceremony or after, their portrait time with you is a huge part of what they hired you for. Forgetting everything else about the day, they hired you because they, above all, want pictures that show them as a couple and how beautiful they are together.

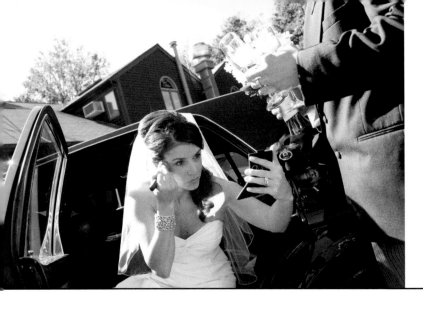

Make Your Bride and Groom Feel Comfortable

Never start a shoot by just clicking your camera. You need your clients to be totally at ease and enjoying themselves. Even on a strict timetable, don't just turn into a director and start shooting. Talk to the couple and see how they're feeling. Ask them how happy they are and congratulate them. You might even break off into some small talk about something you know they like (which you learned from the engagement shoot) to set them more at ease. Once you have them feeling calm and happy—maybe after some champagne, too—you can talk to them about what you want to do, and you can start shooting.

While you're doing this, you might have the bride retouch her makeup or have the groom just relax with her for a few minutes while you prep your gear. You may not actually need to prep your gear—it's probably ready to go, but you want them to be at ease and never feel rushed.

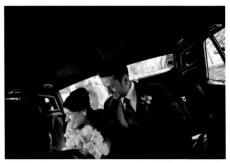

Taking a few minutes for the bride and groom to relax before you start the "official" shooting can yield some excellent shots.

Use Simple Poses

Once the couple is at ease, tell them your ideas, and you can start shooting. Always try to start with some simple poses so that if all else fails, if it starts to rain, or if you have to leave for some reason, they'll have shots that are good—not incredible, but timeless. A simple "grip and grin," as we call it.

I do these shots really quickly, and sometimes I probably rush them (because I hate them), but they are a safety. I'd rather have them than not have them.

Simply having the couple hold each other with the groom's hands on the bride's waist and her flowers over his hands produces that classic clichéd bride and groom shot. Full body, then three-quarters, and done. Let's move on!

NOFEAR

Get through the obligatory "grip and grin" shots quickly so you can move on to poses that are more natural and fun.

These poses are simple but still natural-looking.

Then you can move on to poses that are more fun and natural for everyone. Have the couple turn and face each other; then take a few shots and have them clasp their hands at chest height and look into each other's eyes. Moving on, you might have the bride turn around and have the groom hold her from behind and kiss her on the shoulder. Keep close and just move them little by little to get new shots and poses quickly and effortlessly.

You can do all this in one place, without anyone having to move; it can be done inside or outside. Sometimes I don't do many of these simple poses if I have other things in mind or if a few are all the couple wants. Not every couple wants to do fashion poses or walking-around types of shots—every wedding and couple is different. But I'll do some of this, even if it's just one shot for every couple.

"Keep the bride and groom close and just move them little by little to get new shots and poses quickly and effortlessly."

Capture Real Emotion

Not a traditional "happy couple" shot, but one that shows true emotion.

I don't ask my couples to smile and laugh. Well, okay, I do—but I do it in a way that lets them really show how they're feeling, so it's not set-up and fake. You want your shots to express how the bride and groom really feel—how they feel about each other and how they express that. To accomplish this, you can do a couple of things. One, stay out of their faces—keep some distance. And two, create situations that allow them to really express how they feel.

This may seem unimportant, but it is crucial. Let's say you have the bride and groom holding hands and looking into each other's eyes. They might be laughing and giggling, thinking it's weird, which is fine—you can take those shots. But if you keep quiet for a moment and then ask the groom to tell the bride what he felt when he saw her walking down the aisle or the emotion that he felt when he proposed to her…then there is quiet for a moment, and the bride and groom may be serious and show real emotion—fear and vulnerability. They are showing real joy, happiness, and emotion. That's what you want to capture.

NOFEAR

To capture real emotion from the bride and groom, encourage them to tell each other something specific about their feelings. Ask the groom to tell his bride what he felt as she approached the altar. Ask the bride to tell her groom how she felt when he proposed. Then be ready to capture the emotion on their faces as they drop the posed, sometimes stiff smiles and let what they really feel show.

"Create situations that allow the couple to really express how they feel."

At one wedding I shot, the ceremony had just ended, and the receiving line had lasted about 15 minutes. The couple sat down on a sofa, and I could see the bride was a little overwhelmed by everything, so I asked the groom to go sit down next to her, maybe kiss her hand and tell her how much he loved her. I followed, stayed low and a few feet away, and took the shot. My assistant held a second flash for me, and I was able to capture real emotion by simply listening to what was happening and letting the couple be themselves.

Use Fashion Poses

Typically, I don't look at wedding magazines or every photographer's wedding blog. I like to read *Vogue Italia* and other European and American fashion and style magazines. I do this to be inspired by what's happening in the fashion world, so that I can introduce new ideas and styles into my wedding portrait shots.

Not every couple is looking for me to try fashion poses on them—some just want the simple, elegant poses I described earlier. But the couples who want fashion in their shots make me so, so happy! This means we get to experiment and make a commercial shoot out of their wedding.

For a recent wedding, I had scouted an alley before the wedding, and we went there for some fashion shots. Granted, the couple told me they wanted to do this with the elegant shots, so they had given me three hours for fashion, simple, and family photos—more than enough time. So we headed to the alley, and our shoot began. I looked at the lighting, gauged it, and started placing the couple how I wanted, which was like a Calvin Klein ad I'd seen. I did some fun shots, too, but I tried to get really serious shots of the couple in the alley, leaning back on the walls and just looking awesome.

NOFEAR

For an edgy, fashion-type shot, consider combining the glamour of the bride and groom's attire with a gritty location, such as an alley or an industrial area. When you frame your shots, just keep the "cool factor" of the location, but crop out any undesirable elements, such as dumpsters.

At another wedding, I was thinking of Guess and Gucci ads, and I thought the couple would work perfectly for it. We were in a state park in Rhode Island shooting on a path that was surrounded by forest. This made for some really magical woods shots with the bridal party. However, I knew I could do better, so I looked into the woods and saw some areas deep in shadow and pools of light. I persuaded the couple to follow me into the woods, promising no poison ivy or ticks, and proceeded to set up the shot. I had the groom hold the bride's dress up and look down at her while the bride looked ahead with her hands on her hips, almost as though they were trying to get through the forest together.

We then moved out of the woods and back to the edge of the forested area, where I placed the bride leaning on a tree, with one arm out on the tree and another grabbing the groom as he was looking away, almost as if to say, "Hey, pay attention to me!" As I was shooting, the flower girl and ring bearer were walking by, and I clicked the shutter and got the shot.

This alley was a perfect location for this couple's portraits.

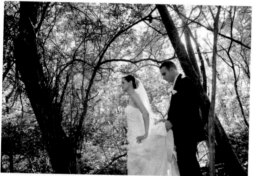

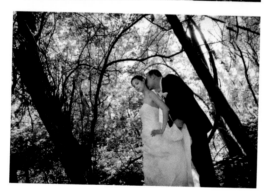

By stepping off the path at this park, we were able to get some beautiful shots—much more interesting than if the couple had simply posed on a park bench, for example.

Work Quickly

Not every wedding allows you three hours (or even an hour) to do the shots you have to do. So you need to work with dedication, purpose, and speed. I don't work carelessly fast, but rather efficiently to get the job done in the time allotted.

To do this right, you need to be like a director. But if you start telling a bride and groom to do this or move her hand here and then there, it could take a while to create the look or shot you want—plus that becomes a totally posed shot, which is usually not what clients want. So instead, you can use yourself or your assistant as a model and ask them to do something like what you're demonstrating. Then ask them to share how they feel or give them an idea: "You just saw him looking at another girl—get him to look at you!" And work with it.... Make up things as you go to get them to show real feelings and be comfortable.

NO FEAR

Try some light role-playing suggestions to get fun, unposed shots of the couple.

Planning ahead and knowing where you want to be shooting and what you'll be shooting will also help you get through the shoot in the time allotted. But most of all, treating the shoot like a movie production and acting more like a movie director than a photojournalist lets you create the shots you want and keep the couple comfortable and looking good.

Time	Description		Timeline
Sat 21-Jul-2007			
8:30 AM-9:00 AM	Shower, eat breakfast		Groom's timeline
9:00 AM-10:00 AM	Wake up-eat breakfast-shower		Wedding Day
9:00 AM-1:00 PM	Free time		Groom's timeline
10:30 AM-11:00 AM	Bridal party arrives		Wedding Day
10:30 AM-11:00 AM	Hairstylist arrives		Wedding Day
12:00 PM-12:30 PM	Photographer arrives	Joseph Prezioso	Wedding Day
12:00 PM-12:30 PM	Make-up arrives		Wedding Day
12:00 PM-12:30 PM	Joseph Prezioso arrives		Groom's timeline
12:00 PM-12:30 PM	Ceremony musicians arrive		Wedding Day
1:00 PM-1:30 PM	Get dressed		Wedding Day
1:00 PM-1:30 PM	Get dressed	Photography	Groom's timeline
1:30 PM-2:00 PM	Gather with groomsmen outside	Photography	Groom's timeline
2:00 PM	Ceremony begins		Wedding Day
2:00 PM-2:30 PM	Ceremony		Groom's timeline
2:30 PM	Ceremony Ends	Additional Photos	Wedding Day
2:30 PM-3:30 PM	Cocktail hour		Wedding Day
2:30 PM-3:30 PM	Cocktail hour		Groom's timeline
3:30 PM-5:30 PM	Guests invited to take seating/Guests enter dining room	OPEN SEATING	Groom's timeline
3:30 PM-5:30 PM	Guests invited to take seating/Guests enter dining room	OPEN SEATING	Wedding Day
3:40 PM	Introduction of bridal party		Wedding Day
3:40 PM	Introduction of bridal party		Groom's timeline
3:45 PM-5:45 PM	Dinner		Wedding Day
3:45 PM-5:45 PM	Dinner		Groom's timeline
5:00 PM	Dessert table offerings set		Wedding Day
5:00 PM	Dessert table offerings set		Groom's timeline
5:45 PM-6:15 PM	Dances begin		Wedding Day
5:45 PM-6:15 PM	Dances begin		Groom's timeline
6:15 PM-10:00 PM	Reception continues		Groom's timeline
6:15 PM-10:00 PM	Reception continues		Wedding Day

A timeline of events will help you budget the time you have for shooting.

Practice your direction of models and setting up shoots. I find that working on personal projects and learning to direct models for fashion and portrait shoots really helps out with bride and groom shoots. If you can direct a model and work well with people, you'll be fine. If you're not comfortable directing, practice on models beforehand to build up your skills. Don't practice on friends—work with professional or amateur models so that you have no emotional ties to them. That way, you'll feel freer to express what you want to do. Plus, if you make a mistake, no one will know, and you won't be embarrassed.

NOFEAR

Practice on professional or amateur models to get comfortable acting as a director for your shoots.

"Acting more like a movie director than a photojournalist lets you create the shots you want and keep the couple comfortable and looking good."

Everyone Is Sexy, and It's Your Job to Make Them Look Good

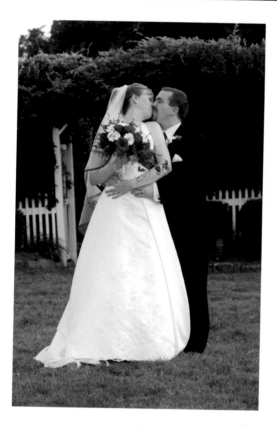

"Everyone deserves to be photographed with beauty."

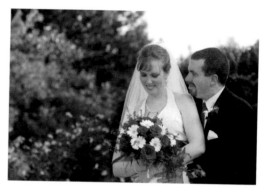

I posed this couple in ways that wouldn't draw attention to the fact that the bride is taller than the groom. Every couple is beautiful—it's your job to bring that out in their pictures!

I've been doing weddings for about 10 years now, and I can tell you that most people don't look like models. But that doesn't mean you can't take beautiful shots of everyday people. People come in all shapes and sizes, and everyone deserves to be photographed with beauty.

Once thing that is key when photographing people is making them feel great. Getting someone to smile or feel good about herself will set her at ease and make her more amenable to being photographed and shown in a great light.

This probably goes without saying, but you should never focus on anyone's negative features. Find something that is beautiful about the person and feature that. Posing someone of a larger size is no different from posing someone who is slender—just pay attention to how you position them and how you're showing them on camera. Don't pose a heavyset person so that she ends up having multiple chins in the picture. And don't shoot a very thin person from an angle that makes her look positively emaciated.

You can always go into Photoshop and manipulate the person's image after the fact, but I'd rather do most of my work in-camera with my client, so that I have less work later.

Just approach everyone with the same creative energy and know your limits and your gear. Positioning people is all about making them look great, so learn what is great about your clients and use those features to their fullest.

For the most part, you can make anyone sexy or—for lack of a better word—cool. Finding out who your client is and using that for your shots is what will make your images work. If your clients are avid bicyclists, get their bikes to the wedding and in the shots. Or if your clients like shoes, use shoes in your shots. Be mindful of what your client thinks and not just what you envision.

Make the Most of What's around You

There's no better way to make your shots work in your favor than by knowing where you're shooting and what you have to work with. For every wedding you can, scout out the locations you'll be shooting with your iPhone/smartphone and take images of things you like and things that stand out to you. Pre-plan your shoot according to what you think your clients will like.

You don't have to go out and look for green pastures, gazebos, and flower gardens, but you can use them when appropriate. Look at everything—walls, streets, buildings, fire escapes, parking lots, signs, alleys (I love alleys), trees, parks, bridges, hotel lobbies, and everything else. Look for contrast, color, and character. You want to place your clients in locations that will work with them and not against them.

NOFEAR

Look beyond the obvious. Green fields and flower gardens are the perfect backdrop for some shots—but they're not the *only* perfect backdrop. Check out parking lots, fire escapes, alleys, and everything else around you. Sometimes the least likely backdrop can make the most compelling shot.

There will be times when you can't get to a location before the wedding, and in those cases you can use tools such as Google Earth and the Internet to get a feel for where you're shooting. Then get to the location early and run around and check out everything before the shoot. Envision the wedding and where you'll place the bride and groom. Use your imagination.

In a hotel, I want to know that there is an awesome sofa in the side lobby where I can have the bride lie down, or that there's a little alley with a streetlight where I can place my couple and light them romantically. Just like a movie director would storyboard a film, I storyboard my weddings.

For example, last season I had a wedding in western Massachusetts, about three hours from my home. I was not able to get out to scout the wedding in person, but I researched all the locations I was going to be at—the ceremony at the museum, the reception at the old train station—and then I looked for what else was around the wedding site. The wedding was happening in a really cool and artsy town with a great downtown scene that looked like something out of a Norman Rockwell painting, and the reception location was at an old train station where the old underground railways had been turned into cool film noir–era bars.

"Just like a movie director would storyboard a film, I storyboard my weddings."

Look for anything interesting—no matter how out of the ordinary it might seem—when you're scouting locations for a wedding shoot.

So the wedding day was approaching, and the plan was to walk around the downtown area and shoot with all the cool old buildings, shops, and lights for a really vintage look. That was the plan. The wedding day came, and guess what? It was pouring out, nonstop, so then my researching of locations came into play. We could shoot in both the museum gallery rooms and the underground railway bars. If I hadn't taken the time to research what my possible locations were, I wouldn't have been able to get to these locations, because no one would've known about them.

Another wedding I did last season took me to some fantastic places for location scouting. My couple wanted something different and fun. I was scouting the area near the church and en route to the reception venue when I decided to get lunch. I stumbled upon a cool little vintage diner, like something out of *Dick Tracy*. While eating, I thought about shooting in there, and one thing led to another.… Soon, I was talking to the owner and setting up a shoot with my clients for the wedding day. I called the bride and groom and got them excited about the location, and then I called the owner back. He then told me they were closed the day of the wedding, but that he would come and open up the diner for us. It was perfect. Had I not gone and looked for something different, this couple's images would've been like everyone else's and not unique.

After the diner, we hit the downtown area and then headed to the reception venue to meet up with the bridal party and family.

Rain required us to change plans for the shoot, but this underground railway bar provided a perfect venue.

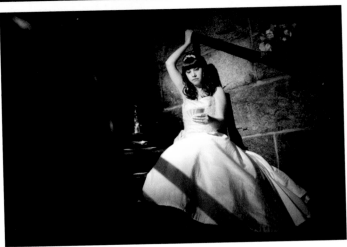

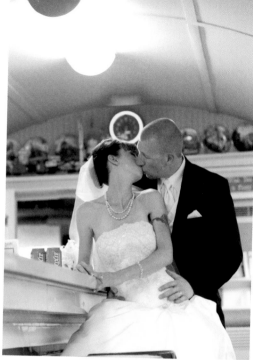

"Had I not gone and looked for something different, the couple's images would've been like everyone else's and not unique."

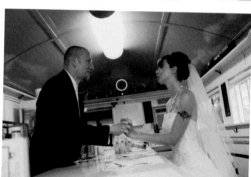

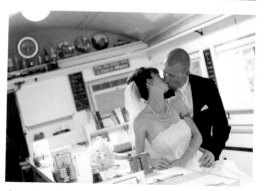

A random lunch stop turned up the perfect shooting location for this couple's portraits.

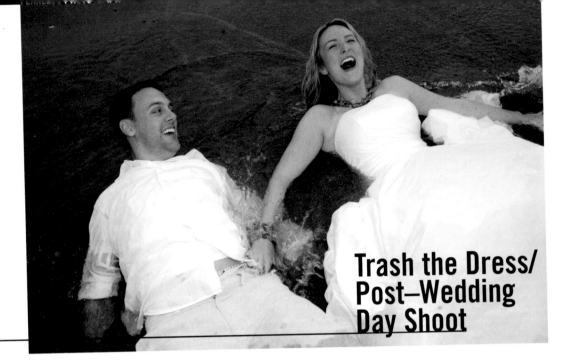

Trash the Dress/ Post–Wedding Day Shoot

Sometimes the bride and groom will love working with you so much that they want another day of shooting. And so comes the post–wedding day shoot. Some people call this a "trash the dress" shoot, but I prefer to treat it as just another shooting session with my couple, as if it were the wedding day itself. I'm not an advocate of ruining dresses just for the sake of doing so.

Post–wedding day shoots are awesome because you can control much more of the shoot, and you're not restricted by time or location. You and the couple can find the perfect place and shoot to your heart's content. Find a location that works well with the couple—something they couldn't get on their wedding day. If their wedding was in the city, then maybe you'll shoot at the beach. If they had a country wedding, then maybe you can shoot in the city. It's about providing a location that not only fits what the couple wants, but also fits their personality and can add to their wedding story.

NOFEAR

For a post–wedding day shoot, find a location that fits the couple's personality but that also is something they couldn't get on their wedding day.

Shooting the couple post–wedding day is no different from shooting them at the wedding. I work the same way, although a bit less rushed. Time is always somewhat of a stressor—if not for you, then sometimes for the couple. Most couples are totally stress-free on post–wedding day shoots and are willing to be more creative. To this end, try to shoot with a theme in mind. Having a central theme or idea in your head of what you want to gain from this shoot will help you achieve stronger images that will flow together well.

Case in point: Amanda and Tanner had a hotel wedding on a cool May day in Boston. They had a great time shooting with me and wanted to do something

"It's about providing a location that not only fits what the couple wants, but also fits their personality and can add to their wedding story."

a little longer that could let them express themselves more. They wanted to shoot in Rockport, a little fishing village on the coast in northern Massachusetts that is very much vintage and timeless. With that in mind, and knowing what the couple was wearing, I decided to go with a vintage post-war look to the shoot, meaning I wanted happy looks, mostly full-body shots, and images that told a story.

I wanted the shoot to feel like a storybook movie wedding from the 1950s, with the couple running around and having fun. To do this, we simply walked around the little town, and I let Amanda and Tanner have fun. I posed myself a few times to show them what I had in mind, and I let them go with it. I would say things like, "Amanda, fluff up your dress at Tanner and tell him how good he looks in that linen." She would laugh and fluff the dress, and I would click the shutter and get the shot.

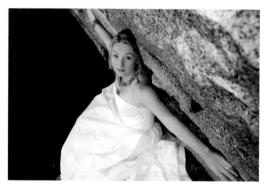

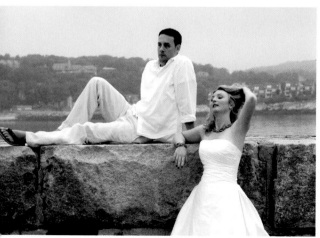

"I gave them motives, like actors on a movie set—that way, they could be themselves without being 100-percent posed."

I also had in mind some images I'd seen in magazines growing up—pictures of soldiers in Europe getting married and just being so casual and cool. So I had Tanner sit on some concrete blocks, and I told him to just look out at the sky while I had Amanda lean back on the wall. I told her to toss her hair back as if she was bored and waiting for something. What I did was give them motives, like actors on a movie set—that way, they could be themselves without being 100-percent posed.

After that, we strolled down to the beach and did a race scene where Amanda ran with Tanner down the beach and finally jumped on his back, with the great little village as the backdrop. They were having a blast, and I just used my 80–200mm to track them as they ran around and laughed.

When they finally got back to me, they told me they wanted to get wet. I strolled out into the ocean until I was about two feet deep and proceeded to click my shutter as Amanda and Tanner began to realize how cold the water really was. I told them, "Grab each other; look into each other's eyes" and other things to get them to look sexy and pinup.

I had them lie there in the surf for a few moments longer while I got back onto the beach. I directed them to be bored and unamused so I could get some fashion-like shots of them at the beach at sunset—very Miami Vice–like.

Then the sun set, and the shoot was over. We had a great time, and Amanda and Tanner got some really creative shots that we never could've captured on their wedding day.

But we're not finished with the wedding day yet. Turn to the next chapter to learn about shooting the reception.

9 The Reception

Weddings are an event when families get together. Sometimes these people have not seen each other for years and this is the only time they will all be together for a while. This is an important reason to make the reception an incredible and tasteful event. Many brides and grooms spend a lot of money on the details of their wedding day, and nowhere is this more apparent than in the effort and design of a reception. Not everyone goes to the ceremony, but everyone wants to go to the reception. Why? Well, it's magical—there's dancing, food, music, and tons of fun.

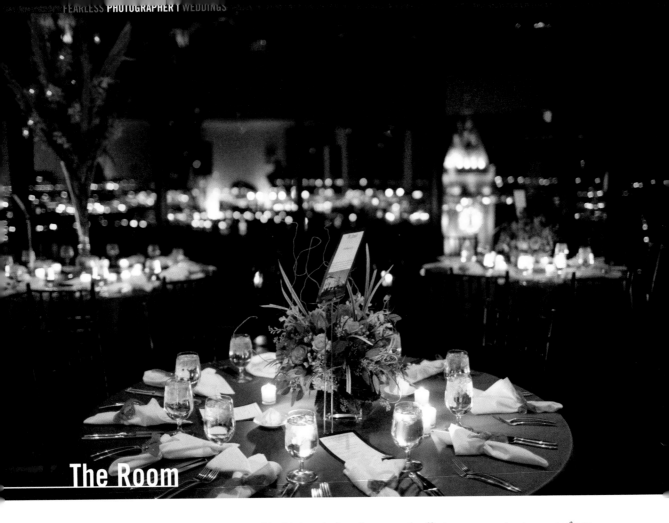

The Room

If possible, I always try to get room shots before the guests enter and disturb the careful arrangement of the details.

With this in mind, make as much effort as you can to step away from the newlyweds and get detail and overall shots of the reception venue. Take images of the table setups and flower arrangements before guests pour into the room and disturb them. You want to have photos that show the bride and groom the room they created.

If the bride and groom are doing something important or asking you to take photos of them, or if time otherwise won't allow, you have to weigh the importance of the room shots. Room shots lose out when weighed against the bride and groom. However, if you can't break away from the bride and groom, sometimes you can send your assistant to take these photos for you.

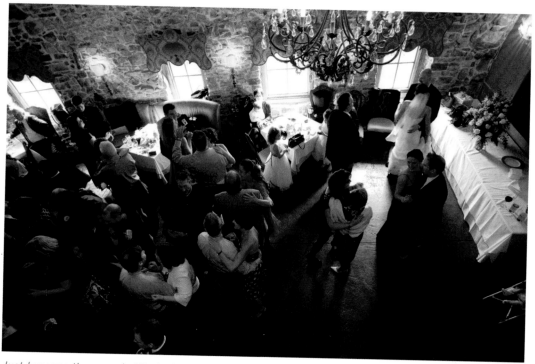

Just because the room is filled with people, that doesn't mean you can't get a great shot. Sometimes people in the shot can add life to a room.

In cases where you're away from the reception with the bride and groom, and when you arrive the venue is already filled with guests, just do what you can to photograph the room as it's alive and filled with people. Don't get upset or feel frustrated. You can still make killer shots of the room.

NOFEAR

Try doing detail shots of the reception without using a flash. Use a long exposure and don't worry about blurred guests in the shot. The room detail is the focal point of the image, and the blurred people will merely show that there is life in the room.

You can usually do these giant room shots without flash and try to take as long a handheld exposure as possible to maximize the ambient light in the room. You don't necessarily have to worry about people looking blurry here, because you're shooting the room as the subject, and blurred people just add to the feeling of the shot and show that the room has life.

Detail shots are fun, but be sure you don't spend so much time on them that you neglect the bride and groom or their guests!

The cake and centerpieces are room details that can be captured almost anytime and don't have to be rushed. You do need to shoot the seating cards before people are seated, though. It's fun to photograph all these details, but try not to take long doing so, because you'll want to get back to the wedding and the bride and groom. Details are important, but not as important as the people looking at them or the people who created them.

First Dance

The first dance is magic.

The first dance, a magical, emotional, joyful, musical experience…I love to photograph it. I used to go crazy lighting the first dance, setting up multiple flashes and studio strobes to light the room, and even having my assistant hold a second flash for me at 90 degrees from where I was standing, but I usually don't do that anymore.

Today I shoot the first dance with mostly the available light. If it's super dark, I'll have my assistant hold a video light on the couple, but not up close—from behind the circle of guests watching the couple. You don't want to disturb the intimacy of the couple's dance. You can bounce flash if you need to, but it's preferable to shoot really wide open and at high ISO.

NO FEAR

During the first dance, stand on a chair to get a clear shot of the couple without having to crowd them. Or lie on the floor to get a unique perspective of the room with the dancing couple as the centerpiece.

Don't run around; don't circle the couple on the dance floor. Stay on the edge of the dance floor, behind or between guests if you must. You can stand on chairs to shoot over everyone, and in some really big rooms you can lie on the floor to show the room as a cool location as the bride and groom are dancing in it.

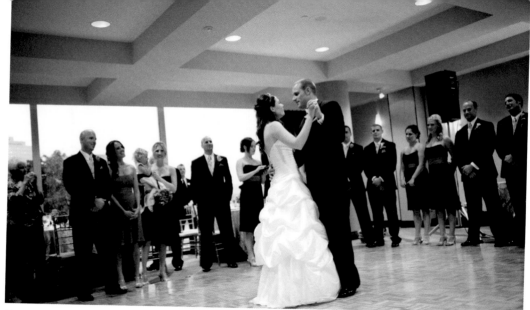

You can shoot a first dance as if you were up close without actually setting foot on the dance floor. Choose a spot near the edge and do what you need to in order to get the shots—even if that means climbing on a nearby chair.

Some reception venues are downright boring, and it's your job to make sure that these photos look amazing. Whether the room has a view of the city, a great chandelier, or a drop ceiling, look for the composition that will best portray the story of what is happening—a magical first dance between two people in love. It's one more moment in the story of the day that you want to capture. Don't ever say, "Hey, look over here!" You don't want the couple to be aware of you. This is their time.

NOFEAR

For a creative rule-breaker shot, try shooting the first dance through the wedding guests who surround the dance floor. The guests can actually serve to frame the shot if you use this technique.

"You don't want the couple to be aware of you. This is their time."

The impressive chandelier at this venue added an elegant touch to this couple's first-dance shots.

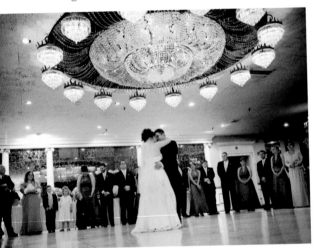

One of my favorite shots for the first dance—which is kind of a traditional-method rule breaker—is shooting through the wedding guests who are around the dance floor. I like this look because it frames the couple between their guests and also provides an image that represents the view of the guests at the wedding. This method works best when the bride and groom are spot lit so that the foreground guests go silhouette or dark, and the viewer's eye will immediately focus on the bride and groom dancing. I try this shot a lot, and it doesn't always work, but often it does.

Shooting through the guests doesn't always work for a first-dance shot, but when it does, the results can be amazing.

As I mentioned briefly earlier in this chapter, another way of photographing the first dance is to get a new angle. Try to get away from the dance floor—get really high or really low. I've shot a few barn weddings, and I really like to get up in the loft and shoot down at the couple dancing. I get very dirty doing this, and it's not always a safe climb, but I'm a little nuts. When I do this climbing to shoot from a different view, I leave my assistant to shoot on the ground level so that we can still get those regular shots that I know will work and that the couple will want to see. But if what I'm doing works, it will knock the couple's socks off, and that's what I want.

With Jewish weddings, the first dance is a little different. They do the Hora. If you have never shot a Hora, it's a really cool experience. You have traditional klezmer music from a band or DJ, and everyone dances in circles. Sometimes all the men are on one side of the room and the women are on the other side (as in orthodox Jewish weddings), or you have everyone together holding hands and making circles, putting people on chairs and parading around the room.

I have photographed Horas that were almost an hour long, and the band just kept going and people kept dancing. Old, young…everyone is dancing. Sometimes you will see guests do crazy things, such as put on outfits and masks or run around with flags. This is all to entertain the bride and groom. It's part of their culture, so be prepared, like I always say.

With Horas, you need to be really careful that you don't get knocked over, because everyone can be rotating in different directions. One circle could be going clockwise, and the other counterclockwise, and at the same time people could be up in chairs. Because this isn't a slow dance, you should use multiple flashes for it. Use one on your camera

and the other on your assistant's monopod, held up to shoot or bounce the flash either beside you or 90 degrees from you. Use flash here to freeze the action. You don't want blurry people in chairs or circles. This is their first dance, but instead of just being contained to the bride and groom, everyone is involved.

My approach to the Hora is simple: Photograph everyone dancing who's family, focus on the bride and groom when they're up in the chairs, and try not to get knocked over by anyone.

Try a high angle for some fun first-dance shots.

The Hora is an exciting dance to shoot.

"If what I'm doing works, it will
knock the couple's socks off,
and that's what I want."

Parent Dances

"Shoot the parent dances in the same manner that you shoot the first dance—discretely."

A father dancing with his daughter or a mother dancing with her son—these are moments that parents dream of from the day their child is born. It's your job to capture this moment and not intervene in their shared emotion.

Shoot the parent dances in the same manner that you shoot the first dance—discretely. Work the sides of the dance floor and work around the room to get the best shots you can of the parent and his or her now-married child. Use both wide and tele lenses to achieve different perspectives, and try to shoot with ambient light only. You can bounce flash from behind you or have your assistant shine video light on the dancing pair if the room is too dark.

There are no tricks or approaches to do differently for these dances. Just try to watch the parents' faces for emotion, as well as those of their spouses or siblings. I sometimes find that a bride's sisters will be crying, holding their mom, or the groom's sister will be with her dad. Keep open eyes and ears for these little stories happening around the room.

I also don't mind shooting the parent dance at f/1.2 or f/1.4. I don't mind having everything blurry except for the dancing pair, as long as their emotions and stories stay true.

Parent dances can be very emotional.

Speeches

Epic tales of life and shared stories make up most speeches worth listening to at a wedding. At most weddings I cover, speeches are given by the best man, the maid of honor, a sister or brother, and sometimes the fathers of the bride and groom. On rare occasions I see aunts, uncles, and sometimes even grandparents speak, but most the time it's just two to three 10-minute speeches.

You can approach shooting speeches the same way you do the formal dances at the reception—you want to get the shots and stay out of the way. The main goals for shooting speeches are to get the speaker (of course!), the bride's and groom's reactions, and then, if possible, the reactions of family members and guests toasting at the tables.

Positioning yourself between the couple and the speaker is usually the best option, but only do it off to the side. Don't stand and block views; you should never be directly in between unless there is no other option.

I generally take some wide shots but mostly tight shots during these moments. I like the tight shots of faces crying, glasses toasting, and people laughing. In the case of really long speeches, get your

During the speeches, some of your best images will be tight shots showing people's emotions.

safe shots and then move around to experiment, sometimes shooting from the back of the speaker and into the bride and groom, or vice versa. You can even go to the windows outside or a balcony if there is one—but again, only if there's time.

NOFEAR

If a speech runs long, take advantage of the opportunity to try some different shots and angles after you've gotten your safe shots.

When a person has completed his or her speech, always be ready for a hug with the bride and groom, tears in people's eyes, or a big cheer from everyone. Never put down the camera.

Guest Reactions

This is not a big thing for me, but I do like to go around the room and get a feel for the guests and the wedding. Some guests are very happy to be at the wedding, and others are just there, to put it nicely. Naturally, I prefer the ones who are excited to be there, but I have worked with both, as I'm sure you have.

You should constantly scan the room, listening for laughter, toasts, clapping, and anything that could signify happy people (or drunk people—ha!). You might not walk over right away and disturb them, but you can aim your tele lens at them and take some shots of whatever they're doing. Sometimes you need to move in close, and of course you should get right into the scene if you have to. However, it's preferable to shoot the action from afar and not disturb what's happening.

Unposed, unscripted reactions from guests make excellent photo opportunities during the reception.

It's also important to note that even though I don't personally think guest reactions are a big part of the reception, the bride and groom might think differently. Remember, the bride and groom are usually so busy on their big day that they rarely even get the chance to *talk* to everyone at the wedding, much less see their reactions to parts of the reception. Guest reaction shots give the couple a peek at what their guests were feeling during the event. So don't focus on guest reaction shots at the expense of the all-important first dance, parents dance, and cake cutting shots…but where you can, try to capture some candid moments.

Cake Cutting

Mmmmm, time to cut the cake! This is one of my least favorite things to shoot, but of course I do shoot it. Why don't I like it? I guess I just don't enjoy it because I can't eat the cake, as I'm allergic to tree nuts and I'm lactose intolerant!

Don't assume that shooting the cake cutting from the front is the only option. Shooting from behind the couple can create some unique images, especially when you capture the guests' camera flashes in the background.

However, personal feelings aside, that doesn't mean I can't get awesome shots of the bride and groom cutting the cake. I'm never one to pose the bride and groom in front of the cake and tell them to look a certain place. I never do that, and I usually have to tell the DJ or band that I don't do that. I just let the couple go up and do their thing.

Try to position yourself in the line of everyone shooting the couple with their cameras, so that you don't block anyone's view. Have your flash on-camera and your assistant off to the side of the bride and groom with a second flash on slave. Make sure to evenly light the couple; sometimes having the off-camera flash more powerful than yours lets you get farther back from the couple. That way, you can use a longer lens, such as an 85mm, to shoot them instead of being right on top of them with the 35mm.

Shoot the couple cutting from one side and then move around—90 degrees or sometimes 180—and get right behind the couple (with good distance) and shoot them with all their friends and family watching and taking photos from up front.

To pull this off, use a slow shutter speed, knowing that your flashes have frozen the bride and groom on frame. With the shutter open, you can capture the flashes from all the guests' cameras firing. Shutter speeds at 1/15, 1/10, or sometimes 1/20 work well for this.

Party Time

When all the formalities of the day are finished, the band or DJ usually takes over, and people start to dance. This is a fun time, and I say that with truth. You can put down some of your gear and just put on one body with a 20mm lens. You can explore the room, move on and off the dance floor, and try new things and old things. There is usually about two to three hours of people jumping, dancing, and getting down. This is a time when you can experiment.

NOFEAR

Get right into the thick of the dance floor to get some of your best party shots.

My normal procedure is to have my flash with the Sto-Fen on it to about 1/16 power and my camera set to 1/30 or 1/25 at f/2.8. My ISO is 1600, and I'm shooting JPEG. I have my assistant hold her flash 90 degrees from me and have her flash set to 1/8 or 1/16, depending on how many people are dancing and the distance she is from me. Because I'm shooting at 20mm, I like to get really close to everyone and shoot. I like to engage the party people, and I'll even dance a bit if I like the song. Ever jump with your camera and take images? I have, and it works. If you can feel the music and the crowd, and you have worked with these people all day and built trust, you can totally capture them being a little nuts and uninhibited on the dance floor.

"If you can feel the music and the crowd, you can capture guests being a little nuts and uninhibited on the dance floor."

Open dancing is party time…and a great time to get some crazy, uninhibited shots of guests.

If you want to try different things, pull people out of the crowd and use them as models. Or, point your flashes in different directions or even directly to see what effects you can achieve.

If people start to slow dance, switch back to an 85mm or 200mm and shoot the dancing from up on a chair to capture the important couples without being in the way. If you have studio strobes in the room, use them for these formals but not for the party dancing. The party dancing should be more dramatic with up-close lighting.

"Just keep exploring and looking."

If there's a band, make sure to get great shots of the instruments and the guests through the band, in an effort to show the power of the music and the feedback from the guests in one shot. A close-up here and there of drums, guitars, and saxophones with dramatic stage lighting can really help tell the story of the dancing in an album.

You can break away from the main action on the dance floor and work around the room and the lobby as well, to see what the guests and the bride and groom are doing. If people are toasting, sitting outside, or watching the sunset or fireworks, you want to get it.

Just keep exploring and looking.

Step off the dance floor to capture slow dances without being in the way.

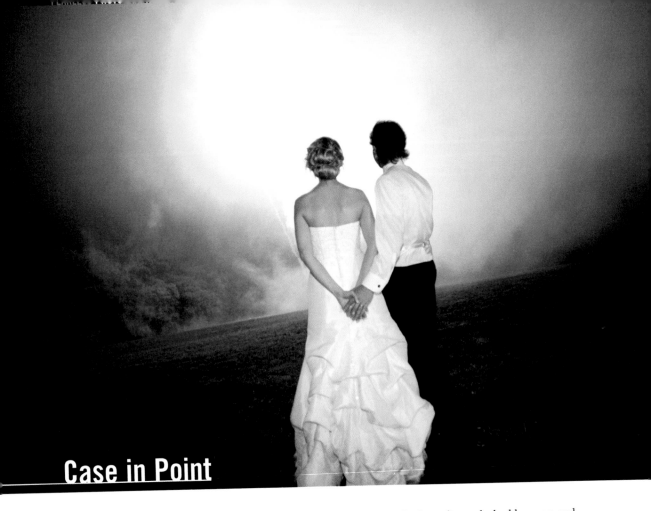

Case in Point

"I knew how to use my gear to get the shot."

At a wedding in Vermont, the talk about fireworks had been on and off all day, and then I was told that they weren't going to happen. Everyone was inside dancing, when…*swoosh, boom!* Fireworks! I immediately got behind the bride and groom and got ready to switch my camera from party dance shots to capturing fireworks on a mountain, in the rain, with no light other than the light from the fireworks. I pointed my flash right at the couple, set the camera for a 1/30 at f/2.8, at ISO 1600 or 3200, and bracketed. Flash was at about 1/8. I was shooting in the dark, and the rain made focusing the bride and groom impossible. I just set the lens to manual, estimated their distance from me, and shot. I got the shots—the bride and groom were slightly out of focus, but it was nothing they would care about or even know.

The bride and groom are slightly out of focus due to the rain, but the important thing is that I got the shots of the fireworks.

The point is, I ran out there and knew how to use my gear to get the shot. If I hadn't changed my settings quickly, or if I hadn't tried to use a slow shutter speed to capture the fireworks, I might've had a great shot of the bride and groom, but not what they were looking at.

Of course, I turned around and got the reactions from the bride and groom as well, but I made sure to get the fireworks exploding with the couple in the shot, too. If I did that same shot today, would it be different? Of course, but I would use the same method I did two years ago in the rain.

So the dancing is finished, the fireworks have gone off…what's left to talk about? A lot, starting with location. Read on…

10
Locations,
Locations,

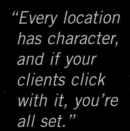

"Every location has character, and if your clients click with it, you're all set."

Real estate isn't the only area where it's all about location. The location can make or break a wedding. A lot depends on the bride and groom, too. Some couples feel right at home in a glamorous ballroom or at an exquisitely landscaped estate. Others prefer a more unusual location—perhaps an old railroad station or dance hall, or maybe a venue with old-world charm and character. Still others prefer a very simple venue. And then there are those who opt for a destination wedding on a tropical island....

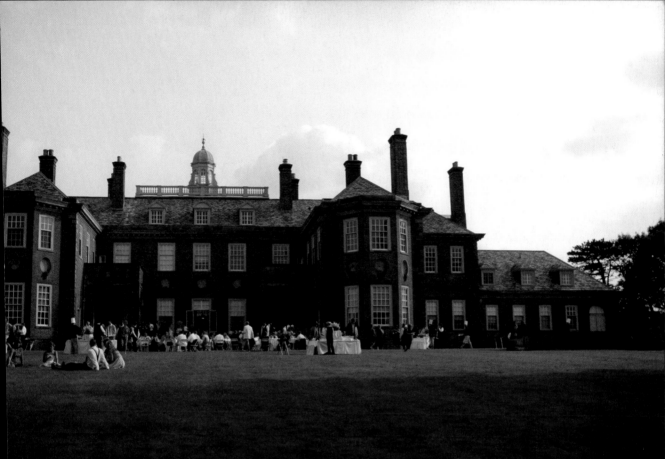

Locations

Hopefully, your clients have chosen a venue that fits their personality and the style of their wedding. And even if it's not *your* preferred location for shooting, it's up to you to make incredible images of their big day by using the best features of the location to your advantage. A small town-hall wedding can yield great shots just as well as a wedding at a mansion. Every location has character, and if your clients click with it, you're all set. If they don't…well, you'll have to work extra hard to minimize or hide that fact. Just do your best.

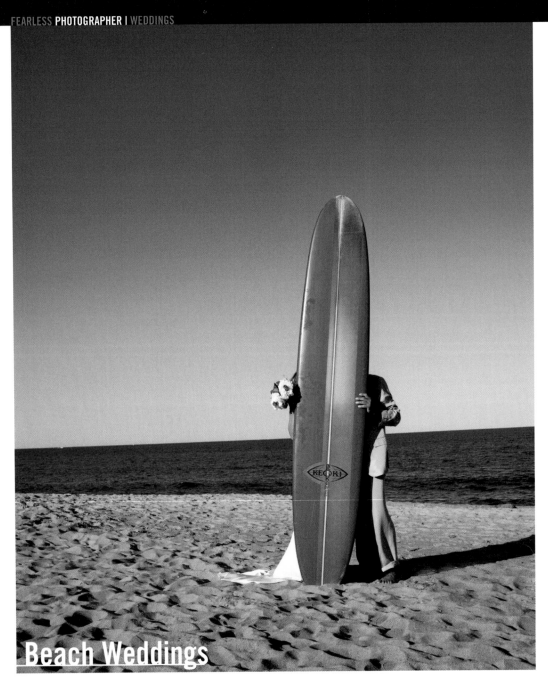

Beach Weddings

Sun, heat, sand, and saltwater are the elements of a beach wedding. Here in Massachusetts, I have shot plenty of beach weddings. And although they may not be Caribbean weddings or southern beach weddings, New England beach weddings are still pretty cool. Think of Amity Island in *Jaws*, and you'll have an idea of what coastal Massachusetts is like—very traditional and vintage (but hopefully without the menacing great white shark!).

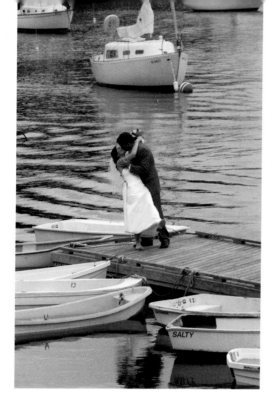

With that said, shooting beach weddings can be a little tricky. Factors you'll deal with range from sand blowing into your gear and fouling it up, to glaring sunlight causing everyone to squint or have raccoon eyes. In some locations, you might even have one side of the ceremony or reception in sunlight and the other in total shade.

Beaches have sand, moisture, and salt—all elements that aren't your camera's friends. Saltwater is corrosive to some elements of the camera, and sand can scratch your lens or jam the inner workings of the camera. Try to use cameras that have weather seals so that your camera doesn't have a heart attack. Also, if you see sand on your gear, blow or wipe it off (being extremely careful not to scratch your lens, viewfinder, LCD screen in the process). And don't drop your gear in the sand or water!

The best solution to shooting beach weddings is to first check out the area and find out where the sun will be at the time you'll be there. Scout out the

location a couple days before so you can assess where the sun and shade will likely fall during the wedding and/or reception.

A beach is always an amazing location for a wedding, but it does present some unique challenges in terms of lighting and gear.

Second, bring your flash and batteries to the event. You don't want your clients to have raccoon eyes or be in shadow, so you should use flash at beach weddings to balance everyone out. If you're worried about not having enough flash power, increase your ISO so that you can use a lower flash setting to get the desired results without eating too much of your batteries.

Depending on the time of day and the location of the sun, the water can create a lot of glare. Let's say the water is f/11 and your clients' faces are f/4 at the given shutter speed. The water will appear hot, overexposed, or possibly blown out in the shot. Using flash to balance your subjects to the exposure of the ocean can help, but it's better to just try to minimize glare and blowouts by doing some careful framing. Drop down low and shoot your clients to the sky or get up high and shoot them to the sand. Or, if you need to show the ocean in a wide shot, try silhouetting the couple against the backdrop or shooting it at a middle or average exposure that will allow you to dodge and burn the image to perfection in post-production. I try not to do a lot in post, though; I prefer to work more with what I have.

NOFEAR

Beach weddings are another place where trying some different shooting angles can be a real benefit. Shoot from down low or up high to minimize the amount of ocean shown in the shot, thus reducing the almost inevitable glare that comes from it.

Beaches can be a lot of fun at sunset. Of course, any location is fun at sunset, but at the beach you can watch for the color separations in the sky, the clouds, and the stillness of the water. If I have the choice, this is when I do the portraits—just as the sun is setting.

Because beach elements can be so hard on cameras, your choice of gear is a factor in the shoot. I like to use my 80–200mm lens at the beach so that I don't have to worry about changing lenses and getting sand in my gear. It gives a good range and a lot of versatility, and I don't have to worry about blowing sand damaging my camera body.

In general, try to work light. Bring a towel, too, in case you get wet or want to lie down in the sand to shoot.

Don't be afraid to use props, either. At a recent beach/boat wedding, my clients were into surfing, so we brought the surfboard out to the beach and made the photos rock. Doing these shots, I was thinking one thing: Beach Boys album covers! That was my inspiration—just thinking of the '60s and that entire "surf's up" lifestyle.

Mountains of Fun

Mountain weddings are pretty cool. You're up high, usually with great views all around. Because the Boston area isn't particularly mountainous, I have only shot a couple mountain weddings. However, they're worth talking about, because you may be shooting in a hilly region where such weddings are the norm!

Shooting a mountain wedding is no different from shooting any other wedding, except this time you'll want to pull out that wide-angle lens and play up the views.

One mountain wedding I shot took place on a very cloudy day, so I used flash to make people pop a little. However, for the most part I just shot wide open and kept my distance to get a really good sense of what was going on. One thing to keep in mind is that on a mountain there may not be any outlets for you to charge your batteries or run your strobes from. You have little choice but to leave the strobes home and bring plenty of batteries to power your gear. Remember, when the sun sets, it will be very dark on the mountain, except for the light from whatever lights your clients are using.

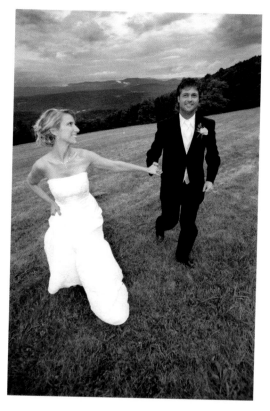

"For a mountain wedding, you'll want to pull out that wide-angle lens and play up the views."

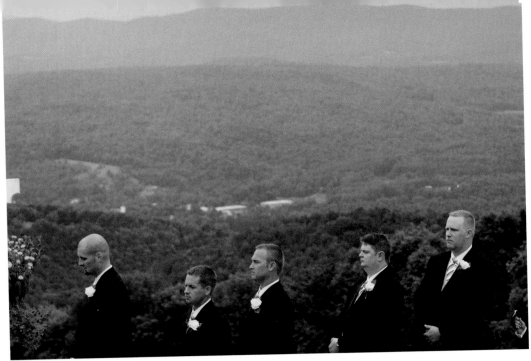

Scenic vistas can be your best friend during a mountain shoot—but be careful not to overuse them.

Although I suggested you use your wide-angle lens to play up the vistas, don't be afraid to use your telephoto lenses, too. Just work with everything you have to get the best shots you can. Don't put yourself in a box where you think you must have the mountains and vistas in every shot, because then it will become a gimmick or cliché.

NOFEAR

Be sure to take your telephoto lens with you to a mountain wedding. Those wide vistas are fantastic, but they're not the *only* types of shots you'll want to get.

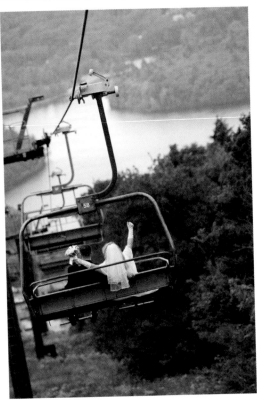

On a side note, check yourself often for ticks if the mountain is in a region known for them. Also check your bride and groom if you're placing them in a grassy area. Nobody wants to contract Lyme disease....

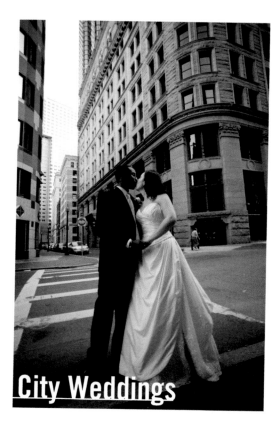

City Weddings

parades, festivals, or anything like that scheduled—check a calendar of events to make sure your shoot won't be overrun by a parade.

With that said, try to find really cool walls, structural parts of buildings, and that really cool light emitted from city streetlights and neon signs. Nothing says city like a city lamp-lit street with a dark sky and glowing buildings all around.

NOFEAR

Look for unusual light sources and structures when you're shooting in the city. That neon light against a cool old-style brick wall could make a fun backdrop. The possibilities are endless in the city.

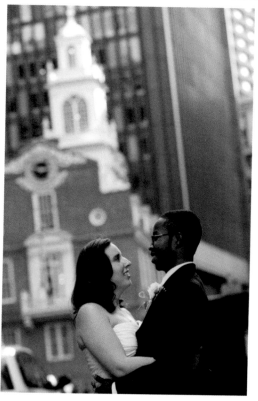

There's always something interesting to use as a backdrop when you're shooting in the city.

Probably my favorite place to shoot is the city. Why? Because it has so much going on that you can never get bored. There are parks with trees, waterfront areas, vintage ethnic areas, skyscrapers, brownstones, incredible architecture, modern and vintage lounges, subways, taxis, and above all, tons of available light at night.

Cities never sleep, so there's always something to shoot at a wedding or at a location with the bride and groom. Day, night—it doesn't matter.

Like anywhere else, it's up to you to scout, scout, scout! Walk around in person if you can, or use Google Earth's street view. Find out what's around where you'll be shooting. Plan ahead of time where you're going to shoot everything so that you're prepared. Make sure there are no city

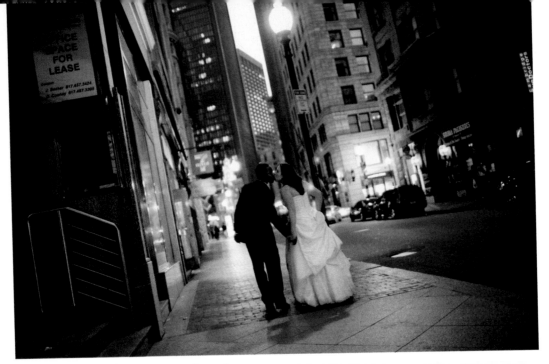

"Cities never sleep, so there's always something for me to shoot at a city wedding."

For shooting in the city, use the fastest lenses you have so that you can shoot in the low light after sunset. You'll likely have light from streetlights and neon signs around you, but you'll still need to use a fast lens to get the best possible images.

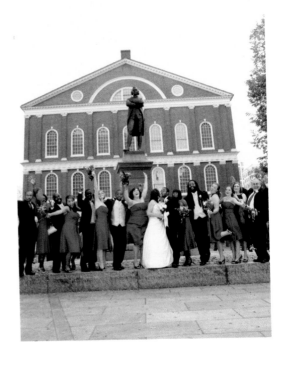

Another cool thing about big cities is that there's always shade to shoot in. It makes shooting large bridal parties in the middle of the day easier when you can find some even shade to put them in. I do find that I sometimes have to yell to be heard over all the noise the city creates, but to me it's worth it. The city is a magical place at any time of the day.

A final tip about shooting in the city: Be aware of everything that's going on around you. Don't ever just put gear down and walk away—you don't want to have your gear stolen!

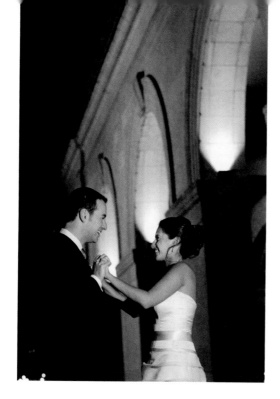

"Nothing says city to me like a city lamp-lit street with a dark sky and glowing buildings all around."

Night Weddings

Here in Boston, the sun can set pretty early in the spring, fall, and winter. Sometimes the sun sets as early as 4 p.m. Because of this, I've shot a great number of weddings that took place after sunset.

So what's to be done? Don't fret! Working night weddings may not seem like an easy task, but you can still achieve excellent coverage without the sun. There are three solutions to shooting night weddings: high ISO, fast lenses, and a lighting source.

The ISO in today's cameras is so much better than the super-grainy high-ISO films I once used. You can get great images at 1600 ISO and above, and I regularly use 3200 and sometimes 6400. Some new cameras from both Nikon and Canon push the limits even farther and make photography work in almost any low-light situation.

If you're shooting in low light, you also want to get as much light as you can to the sensor or film plane, so try to use f/2.8 lenses or faster. I like to use f/2, f/1.8, f/1.4, or as fast as I can. I do a lot of shooting at f/2, but I always like to know I can open to f/1.4 or f/1.2 if needed.

If high ISO and a fast lens aren't quite enough, flashes and video lights can provide extra light to help capture and shape an image. You can shoot to your flashes or use them to add light to the current exposure; the same goes for video light.

NOFEAR

Never fear night weddings. High ISO, fast lenses, and additional light sources will be your best friends in these situations.

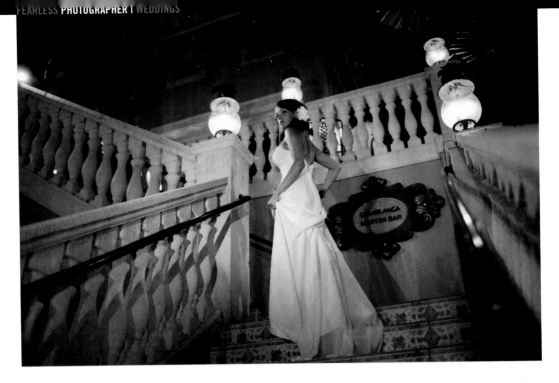

I can have an exposure for a scene—let's say like this image of a bride on a stairway, where the main lights are the lanterns on the stairway. But I want to have more of a focus on my bride, so for this shot I used flash (gelled to tungsten) with a Sto-Fen and pointed up so that just a little flash fired forward. I had two members of the bridal party holding video lights on the bride—one behind me and another to the top left of the image. I used this in conjunction with high ISO and my 35mm f/1.4 lens to take the shot.

For this image I combined all three of my solutions for night shooting: high ISO, a fast lens, and a lighting source.

Using all these elements together helps me capture images at night weddings when the sun isn't out to light up the world.

Last season I shot a wedding on a boat. The ceremony wasn't set to start until the sun had set completely, so imagine this: We're out on the ocean, with darkness all around except for the lights on the shore and the few spot lights on the boat. It's dark. So what did I do? I shot with and without

my flash. When there was a good spot light or fluorescent light being used, I shot to that; and when there wasn't, I shot with flash. I used both direct and bounced flash depending on where I was on the boat. I also had to use the flash's infrared beam to help focus, as it was very dark!

Don't be afraid to lug your strobes with you to help light an outdoor scene if you have to. Many clients request a shot of themselves at a certain location—a shot that is fine to take during the day but is fairly impossible to get without strobes at night. A key example is a bridge that's surrounded by fountains at a local country club. The fountains are lit, and there's some available light from the building, but not enough to capture the huge depth of field to get the bridge, the fountain, and the couple in focus. Every wedding reception I've done there has been after sunset, so to get this shot that the couples consider a "must have," I put out all my lights. To light this shot, I use two 750-watt strobes, a video light, and my on-camera flash.

So grab your strobes, video lights, and speed lights and light things up.

> *"High ISO, fast lenses, and a lighting source help me capture images at night weddings when the sun isn't out to light up the world."*

A night wedding on a boat posed an interesting challenge for lighting.

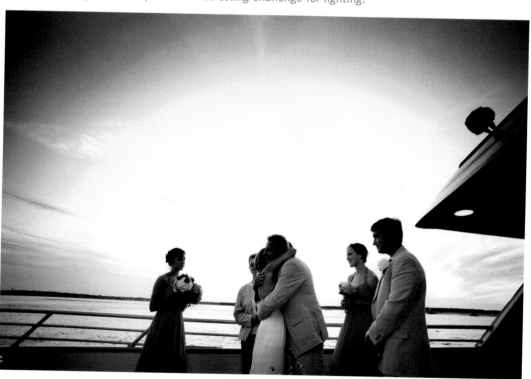

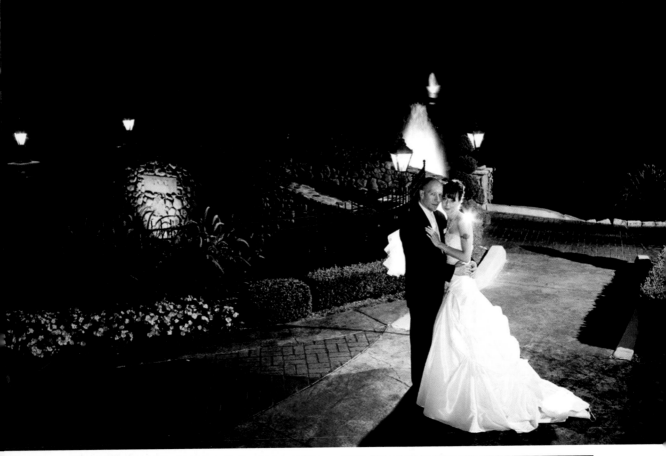

Night weddings don't have to be a frightening proposition. Use whatever available light you can find and supplement with strobes, video lights, and speed lights where you need to.

Function Hall Weddings

Not every wedding will take place at an ultra-cool location. Some will just be down the street at the local function hall. Some of these halls can be great, some are really old and outdated, some are cheesy, and some are just plain *ahhh*!

So what do you do? The first thing is to scout the location, of course. Second, find out where most photographers shoot at this hall and avoid that area like the plague. You want to take shots that will make people rethink where to take photos at that location.

This isn't always easy. Two years ago, I pulled a couple and their bridal party away from the "photo room" and brought them down the street to the town center and then into the parking lot of the function hall. I got great images using the urban/city theme of the vintage town, but boy did the function manager get mad. She yelled at me, asking whether I knew anything about photography. It happens, but as long as you produce good work, no one will care about what the function-hall people say about you. (I know that function manager doesn't recommend me, but I know my clients loved me!)

"Look around and always scout, even while you're shooting. You never know what you may find."

There's nearly always a good backdrop for shots, no matter how simple or plain the location seems. Just keep scouting, and you'll usually find something brilliant.

When shooting the reception in the hall, the location should fall second to what you're there for—to shoot the people there. If the hall truly offers nothing, then treat it as nothing. Shoot tight or find ways to eliminate it from your shots. Thankfully, I've never shot at a location that was dreadful. I've shot at some that I haven't particularly liked or that I didn't think matched the wedding, but you know what? It's okay. The clients picked the location because they liked it, and that's what really matters.

NOFEAR

Truly awful locations are few and far between, but if you find yourself faced with one, just treat it as a nonentity. Shoot tight and find ways to eliminate the venue from your shots.

Remember, you can always drop down low or get really high and find different angles that can help your shots. As I've said throughout this book, look around and always scout—even continue scouting while you're there shooting. You never know what you may find, such as a cool side hallway or a funky couch.

Destination Weddings

"Be yourself and do what you always do—rock it!"

So your clients are getting married somewhere far, far away from you, but they want you to shoot their wedding. They want you out of all the photographers in the country, or at least over and above the ones who live where they're getting married. Why? Because they love your work, or they really click with you.

For a couple to be willing to fly you across the country or even out of the country, they obviously must feel strongly about you, because they could easily have hired a local photographer at the location where they're getting married. So what does this mean to you? It means that you'd better be yourself and do what you always do— rock it!

When you do destination weddings, try to find a local photographer you can use as an assistant. That way, your clients don't have to pay for another flight and room, and you still get to have someone working with you whom you can (hopefully!) trust.

You want an assistant for a few reasons. First, if something happens to you at the wedding, the assistant can keep shooting. Second, because the assistant is local, he or she likely knows some spots to shoot that you don't know about. And finally, it's always nice to have someone to help with your gear, so you can keep shooting and not have to worry about it.

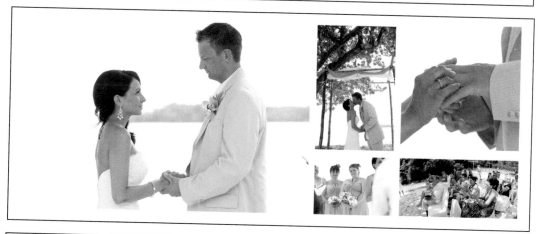

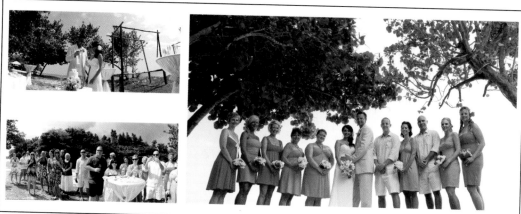

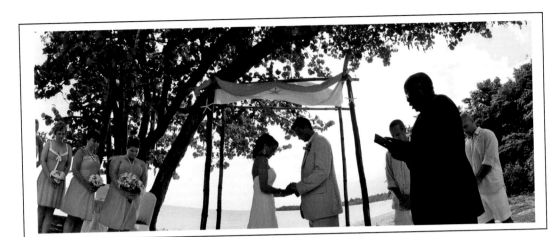

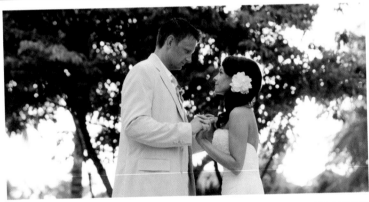

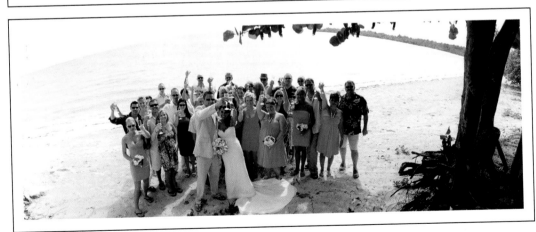

NOFEAR

Consider hiring a local photographer as an assistant for the day. Besides being your backup, the photographer can also clue you in on the best shooting locations in the area.

With that said, you really need to be prepared to shoot destination weddings. Here are some tips that will help you.

- Make sure your passport is up to date. It would be *extremely unprofessional* to book a wedding out of the country and find out when you get to the airport that you can't board the plane. The solution is simple: Make sure your passport is up to date. If you *do* need to renew your passport, be sure to do it well ahead of time to avoid having to pay rush fees for it. The passport renewal/issuance process can be a slow one.

- Use an airline carry-on sized gear bag. I use an airport security bag from Think Tank Photo and have never had an issue yet. I never want to check my gear unless I am bringing studio lights. Rather, I want to pack as light as I can and bring only what I will need plus necessary backup. I take two digital bodies, my panoramic film camera, four lenses, and three flashes, plus my cleaning kit, batteries, and video lights. You've undoubtedly seen what baggage handlers do to checked baggage, and of course there's the unfortunate issue of possible theft of your gear. Be smart and carry your gear on the plane with you. Not only can it be very expensive to replace, you're also unlikely to have the time to replace it before the destination wedding you're headed for. Avoid these problems and carry on your gear.

- Research where you'll be shooting or get there early to check it out if possible.

- Insure your camera gear, if you haven't already done so. It's always good to be prepared for the possibility of loss, damage, or theft, just in case.

- Double-check your gear and make a checklist. You don't want to leave something at home or something at the location where you're shooting. Make sure to keep track of your gear.

- Check everything again. Safe is always better than sorry.

Every location has its challenges, but each one also has its strong points. So find the best parts about the location and make amazing images for the couple. You're creative, so put that talent to use. And if you're not feeling particularly inventive…well, just take a look at the next chapter, which is all about staying creative.

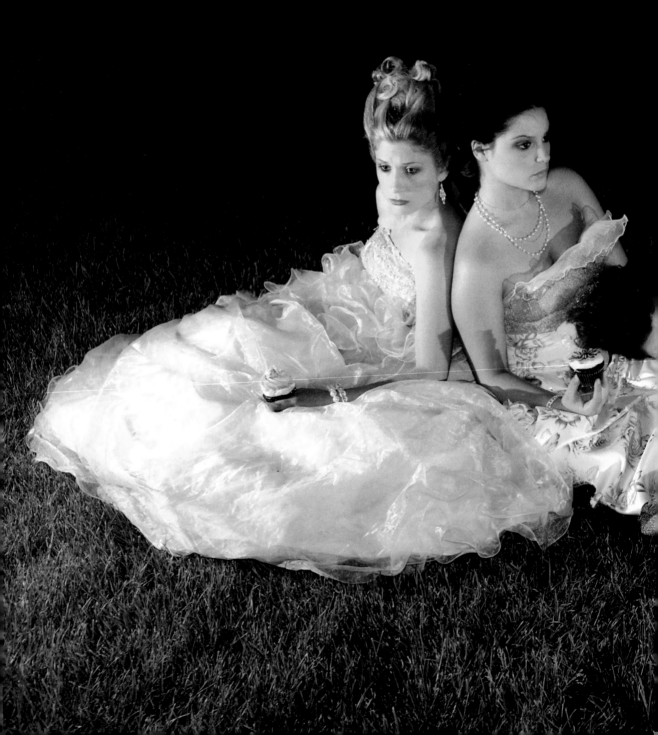

Staying Creative

So how do I stay fresh and not go insane aftershooting weddings weekend after weekend? How do I find new things to try and work with? I need inspiration; I need to have that crazy feeling inside me telling me to try this or do that. I need to be new (and old, too).

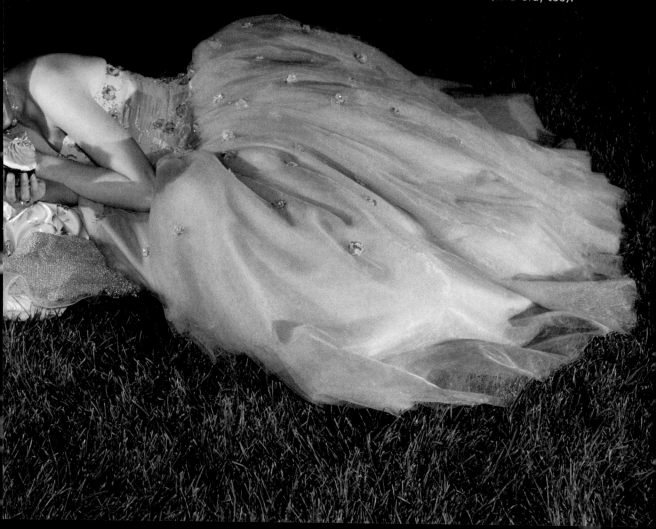

Go Find Inspiration

Go looking for inspiration. Don't expect it to just fall into your lap at a wedding; that's not going to happen. You need to search for it, and you'll find it.

You won't see me looking at wedding magazines for inspiration, though. I don't want to just copy what other wedding photographers are doing. So I look at fashion magazines, art magazines, and even newspapers. I go to art museums and look at oil paintings to see how life was being captured before photography. I also like to look at vintage photos from the past—they can be inspiring in their own right. Old family photos and black-and-white snapshots from yesteryear can be cool and can provide you with ideas.

NOFEAR

Try looking beyond wedding magazines for inspiration. Branch out into fashion, art, and even the news to see what inspires you.

Old family photos may not seem like great inspiration, but they can be. As I write this, I am looking at a wall with images of my family from the '50s through the '80s. Simple, great black-and-white images, group shots, and a shot of my brother and me in bathing suits as kids. Why are these shots inspiring? Well, think about what they have in common. They all capture moments, tell a story, and show emotion. That's what makes a photo—at least a family photo—important. Thanksgiving dinner, turkey on the table, drinks, people holding each other, and everyone happy. By looking at the image, you can imagine being at the table. Now go take an image like that at a wedding. Show people as they are—show what they're doing and the moment they're living in.

Look back through old family photos for some timeless ideas for images.

"Show people as they are—show what they're doing and the moment they're living in."

A Trip to the MFA

Recently, I shot an engagement session at the Museum of Fine Arts in Boston, and as usual, I found some great paintings that inspired me. Whether they will affect my overall shooting or make me take more classic shots…well, that's unknown at the moment. I *do* know that I'll be looking at these images before my next couple of weddings and perhaps trying to re-create with my brides and grooms the magic in the paintings.

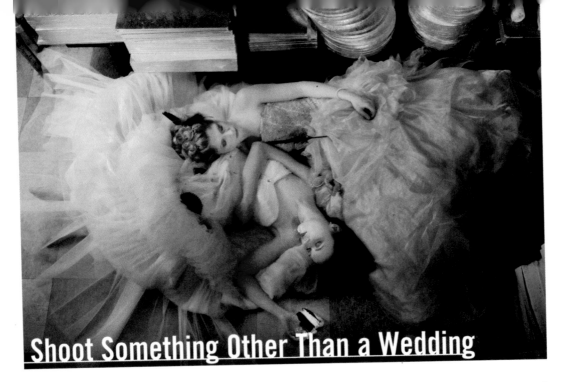

Shoot Something Other Than a Wedding

*"Keep trying new
things. If you stop,
you'll be left
behind."*

Another important practice I use to stay fresh is to do many personal projects that aren't wedding-related. These projects include fashion shoots, photojournalism projects, and just crazy art projects. Working on these side projects that have nothing to do with weddings lets me use my gear in a different way and allows me to think about taking photos in another way.

This is a great exercise, because it lets you explore things you would never do at a wedding. By the same token, it allows you to learn new ways of doing things that you *can* do at a wedding, such as using new lighting methods or posing people in a different way.

If you were to shoot nothing but weddings, your brain might just stop being creative, and your work wouldn't change. As I work on personal projects, I find my brain full of excitement, so that when I *do* get to my next wedding, I'm really excited to shoot it and maybe try some new things.

One personal project that's currently important to me is shooting Super 8mm and 16mm film at a wedding. I recently purchased these old movie cameras and can't wait to shoot some 100-foot reels of film at upcoming weddings. The 16mm and 8mm films have a unique look, and shooting at 24 frames per second (fps) or 19 fps also allows my mind to operate at a different state. It's entirely different from me taking single frames here and there with my still camera.

You may say that this isn't wedding photography, but I beg to differ—it's wedding photography at 24 frames per second versus one or two frames per second. Everything from exposure, to ISO, to focus is exactly the same, but when I press the shutter, many frames will be exposed instead of one. I don't know what to expect out of this project yet, but I'm hoping to make some cool vintage reels of film that I can mix in with my wedding stills to create a sort of slideshow.

Shooting vintage film may not be your area of interest, but find something that is. If you want to be creative, you must endeavor to be—keep trying new things, and never, ever just be content. If you stop, you'll be left behind.

Shoot something (anything!) other than weddings in your spare time, to keep your creative self charged.

Chenin Boutwell, on Being Creative and What Inspires Her

I am inspired by the challenge of capturing people in their most natural, vulnerable state. While some photographers study colleagues' blogs or websites for inspiration, I study how people naturally interact with their loved ones. I am constantly observing how two people hold hands, kiss, or simply talk with each other. And if I see something that strikes me, I file it away in my brain to use during a shoot. I guess I am just trying to record the tender, effortless way people show affection when they think no one is looking.

Chenin Boutwell.

When I think about what it means to be creative or what it means to be a good photographer, I don't feel the need to be different. I think too many people favor "different" over "genuine." I am not a photographer so that I can play with the latest camera gear or engage in some sort of camera gymnastics. I am a photographer because I love the simplicity and genuine honesty of a photograph. Being a creative wedding photographer, to me, means always bringing your "A" game and always aiming for that one true image that is a perfect representation of a couple's connection.

To stay fresh at weddings, I remind myself that although I have photographed many weddings, this is a special, once-in-a-lifetime day for the client. I feed off clients' energy, excitement, and anticipation, and I remind myself how blessed I am that people invite me to share such an incredible day with them and their families.

Neil van Niekerk on Style

Spontaneity, genuine expressions and gestures, the things that make each bride and groom individual—these are things I continually hone in on when photographing a wedding or engagement session. Even when I'm working with the couple, perhaps even directing them a little, I'm still looking for something real—something uniquely "them"—as we collaborate in getting wonderful images of their wedding.

There is a strong sense of storytelling in my photography. However, I'm not particularly a purist about the idea of "photojournalism" in wedding photography. I do interact with people, and especially during the portrait session I might direct the bride and groom—all in an effort to give my couples the best wedding photographs I can. In that way, the portrait session with the bride and groom becomes a collaborative experience. I really want to stay far away from cheesy grins for the camera and static posed images. We really want that spontaneity and expressions: the real thing.

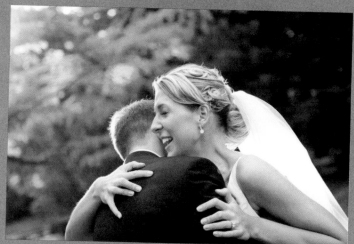

What I find are those genuine moments where the bride and groom interact with each other, and that's what I give back to them in the photographs I show them. Whether it is a found moment, a gesture, or an action that just works...really works.

During the portrait sessions, I try for a natural approach. I do want my couples to appear relaxed and look like themselves. To this end, I "take myself out of the picture" by using a longer lens and having them talk to each other, cuddle, walk, and just be together. This definitely helps with any nervousness in front of the camera and results in portraits that appear casual and relaxed.

My website was originally named "One Perfect Moment," and that encapsulated the ideal that I strive for with photography—capturing essential and distinctive moments. It derives from the idea of the "decisive moment" in photography where everything just falls perfectly into place. Hence, One Perfect Moment.

Let me say this outright: I hate gazebos. I hate gazebos and fountains, and I especially hate having to photograph a couple at whatever landmark/feature that a reception venue has, where every other couple from the last five years has been photographed. There, I've said it. I feel better now, with that weight off of my shoulders.

(continued)

Neil van Niekerk on Style (continued)

Wedding portraits should be about capturing the romance and capturing the relationship between the couple. I would much rather work with the couple and with the light available. I want to show how much they are in love with each other, rather than the wooden structure that the reception venue bought from Home Depot.

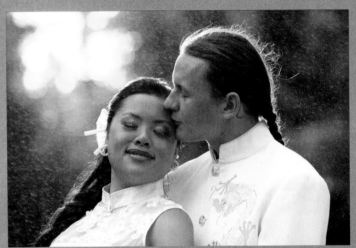

The portrait above from Simone and Damien's wedding was taken in the late afternoon. The maître d' of the venue suggested I use the fountain as a backdrop for the couple—the same fountain that every other photographer uses as a backdrop for every other couple who gets married there. Instead, I looked at where the light was coming from...and it was stunningly beautiful glowing light. And the best was, the spray from the fountain was lit up by the glow from the late-afternoon sun. This created that ethereal-looking golden mist behind them. Looking for and using great light and looking for a beautiful backdrop to place the couple in context is so much better than photographing them against unconnected objects in the landscape.

Wedding portraits should be about romance, and not the gazebo or fountain. Indeed, we need more cowbell, less gazebo!

Get Inspired by Famous Weddings

Another source of inspiration is famous weddings of yesteryear. I really like to look at Lisa Larsen's photos of JFK's 1953 wedding in Newport, Rhode Island. This wedding is just timeless, and the moments that Larsen captured were incredible. In an era when many were still shooting with a Speed Graphic, the 35mm coverage that Larsen provided made the way for much of the photojournalistic coverage of today. Unposed moments, real emotion, and real events as they happened—that inspires me.

So you've shot the wedding, and along the way you've managed to stay inspired. Now it's time for a little post-production—editing all those amazing shots you took. Read on…

12 The Edit

So the wedding is shot, the images are downloaded, and now it's time to view them, sort through them, and pick the shots that count. At an average wedding, my assistant/ second shooter and I can shoot about 2,000 to 3,000 images; at smaller weddings, it's sometimes 1,200 or so. Either way, there are a lot of images to go through. But let me back up for just a moment....

Time Sync Multiple Cameras

Because we are shooting on multiple cameras, the first thing we do (before we even shoot) is to make sure they're all synced to the same time. Sometimes this involves me connecting them to my laptop and using the camera's software to sync the camera clock to my computer clock. More often, though, I just match the clocks by dialing in the time myself. This can result in slightly imperfect alignment, but it's close enough.

NOFEAR

As a wedding photographer, I fear little…except image chaos. If you don't time sync your cameras before you shoot a wedding, you'll find yourself in image chaos when you try to organize the shots in post-production. Do yourself a favor and time sync.

If you don't sync your cameras, you'll have a really fun time (I say with sarcasm) moving all the images in the timeline to the order in which they're supposed to be. Images from cameras that weren't time synced will be all over the place, so if you choose to view your images by date in a program such as Photo Mechanic, Bridge, Lightroom, or Aperture, the images might be all over the place, with last-dance photos intermixed with getting-dressed photos. You would have to manually move everything! Save yourself the hassle and time sync your cameras before the event.

Sort and Edit

I am an Apple guy, so I use Apple's Aperture to edit and sort my photos. However, Aperture is not the only option out there. What I do in Aperture can be done in Adobe's Lightroom and probably even in other software packages. I use Aperture because I like its operating system and layout. The software makes it very easy for me to edit a wedding. But as I said, what I do in Aperture should work in most other software editing suites, too.

Sorting

My computer setup consists of a Power Mac with 1- to 2-terabyte drives loaded in the drive bays, and then I have one 20-inch and one 23-inch monitor attached to the video card so that my desktop spans two screens. I need two screens—one would never be enough for all the applications I have open or the way I like to edit.

full-screen preview of the image I've selected, I have the ability to see everything I shot on one screen and images in detail on my second screen.

I use Aperture for sorting and editing images, but there are other programs available that offer many of the same features.

Editing

Starting with the first image, I go through each image, starring the ones I like and also adjusting them with the Exposure control if needed as I go along. Because I shoot mostly RAW and with neutral settings in Adobe RGB (1998) color, I like to adjust the images as I go. For some I boost the saturation, and for others I just do a simple levels adjustment, but mostly I'm just adjusting for color, brightness, contrast, and sharpness. Working with

I start my editing by organizing all the photos into one folder and viewing them in order by date. This allows me to see all the images from the wedding in chronological order. With one monitor set to view all the thumbnails and another set to show a

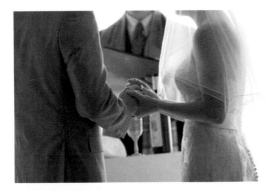

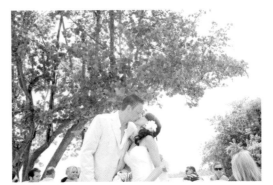

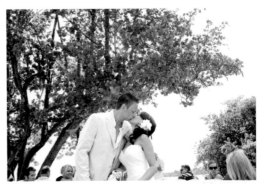

Before-and-after pictures after adjustment in Aperture. I didn't Photoshop these images; I simply made some quick adjustments in Aperture.

images that go together, I can simply copy my adjustments from one image and paste them onto the next (or any image I want). This saves me the time of having to adjust each image individually. I move from image to image until I'm at the last image. As I go along, I send photos to and from Photoshop when I want to do special effects or more processing than I can do in Aperture.

My most common adjustments are:

- Brightness and contrast

- Highlight details

- Luminance levels

- Sharpness

- Saturation/colors

I rate the images as I go along—you could call them picks or selects. In Aperture, you can rate your images from one to five stars. I just stick to giving five stars to the images I want. The others I skip and don't rate or edit.

When I'm at the last image, I change the view/sort mode to sort by rating (which sorts them by rating and date). That way, all the images I have selected are in order by capture time, and I can select them and move them into their own folder that I call "Pics." Now I can export the photos to the web for a gallery, design an album, export and scale images to any size I want, and send images to a lab.

Typically, I can edit a 2,300-image wedding in about six hours, with a final image selection of about 600.

Tell the Story

"When I edit the images from a wedding, I'm editing to tell a story."

It's important to remember that when you're doing post-production on wedding photos, you're not just editing from a technical perspective. Of course you're editing to clean up exposure, color, and sharpness issues. But there's more to it than that. When I edit the images from a wedding, I'm editing to tell a story, and I'm only using images that flow together and work well. Rarely would I ever discard an image based on exposure. Instead, what I'm editing for is people—the way they look and what the image says about them. I am editing for a wedding-day story. Just because I take a shot does not mean I have to use it, though. I just want to show the best and the most concise image sequence to tell the story. And yes, I clean up any technical details as I go.

As I said, I do most of my work in Aperture. But for you Photoshop junkies, I've included a chapter on some of the various ways you can work on your images in Photoshop. Doug Boutwell of GetTotallyRad.com was kind enough to contribute this chapter to the book. Enjoy!

These images, sorted by rating and date in Aperture, tell the story of the bride getting ready.

Snazzing Up Your Images in Photoshop

13

Finding the right groove for your post-production is probably the toughest but perhaps most important step in running an efficient wedding photography business. In a recent survey by *Rangefinder* magazine, wedding photographers topped the charts for the most images shot per job. What's more, today's clients expect even more retouching and Photoshop magic than ever before. An increasing awareness of digital photography and of the amazing tools available to today's photographers sets the bar higher for your post-production.

Fortunately, the quality and variety of tools is also increasing. Industry powerhouses such as Adobe and Apple have created immensely powerful cataloging and processing tools with Lightroom and Aperture, respectively. Photoshop keeps getting better. Third-party Raw processors keep improving. Furthermore, the number of products that extend Photoshop's functionality grows by the day. Arguably the best bang for your buck is in Photoshop actions (and Lightroom presets, but we'll touch on those later).

A Photoshop action is like a little mini program that runs inside Photoshop, automatically performing several tasks for you. Like an army of little elves inside your computer, actions take care of all the details for you. Want to add a watermark to your image to prepare it for your blog? Press a button, and an action can do that for you. What about giving your image a faded, vintage look? There are actions for that, too. Have a photo that needs some skin retouching? An action can do all the hard work for you, and all you need to do is some quick painting with the Brush tool. Literally every successful working wedding photographer I know uses actions in his or her workflow. You get better images in less time, which allows you to spend your limited, valuable time doing something besides sitting in front of a computer.

Let's delve a little further into what an action is. Photoshop actions have their own palette in the program. (Palette is Adobe's fancy word for all those boxes on the right side of the screen.) If the palette is not visible for some reason, you can click on Window > Actions to display it. The Actions palette lets you run, modify, organize, and create actions.

When you're tweaking your actions or reorganizing them, you'll want to have your Actions palette in the default view. In the default Actions palette view, you'll have several buttons at the bottom of the palette that let you create new actions, create a folder to organize your actions, play actions, and record actions. To run an action, click the action name and click the Play button at the bottom of the palette.

If you're just running actions (which is most of the time), you should probably put your Actions palette into Button mode. Click on the Actions palette menu button (at the top right of the Actions palette) and select Button Mode.

The Photoshop Actions palette appears in both Standard and Button Mode views. You can switch between the two modes by accessing the Actions Palette menu on the top right of the palette.

Button mode has several benefits. First, you can run an action with a single click. Just click the action name, and it runs. Second, if you have lots of actions, you can widen the palette by resizing it, and the palette will automatically split into several columns as you widen it. More columns means less scrolling up and down the list to find the action you're looking for. Third, you can assign colors to your actions so that they're a bit more organized, and indeed some commercially available action sets already do this for you. Button mode is pretty. Button mode is fast. Button mode rocks.

Why Actions Are the Bee's Knees

Why do I think actions are so awesome? Well, for several reasons…

Actions Save You Time

Photoshop is immensely powerful. It can do nearly anything you want to do within the realm of pushing pixels. It also forces you to do things one small step at a time. Doing anything remotely useful to an image requires probably half a dozen different commands, and you have to enter the right values at each step of the way. For control freaks with lots of time on their hands, that works fine. For a wedding photographer who has to get through retouching 80 images in the next seven hours, it's a death sentence. Actions can reduce 30 or 40 clicks of the mouse into one click. They can save minutes per image at least, and those minutes add up quickly.

You also can apply Photoshop actions to hundreds or even thousands of images automatically with batch processing (which I'll cover in more depth later in this chapter). Whether you're preparing images for client proofs or getting images ready for the web, batch processing is an invaluable tool, and you'd be pretty sunk without it.

Actions Make Complex Tasks Repeatable

As I mentioned, doing anything non-trivial in Photoshop requires several commands, and each command requires several specific parameters to be input. The more complex the thing you're trying to accomplish, the more numbers and settings you're inputting. That's all fine and dandy if you're only working on one image, but what if you want to do the same thing to a different image? Can you remember exactly what you did? Could you do it again? Chances are, unless you're a Photoshop guru with a freakish memory, you'll spend more time trying to replicate what you did than the time you spent creating your masterpiece to begin with.

Actions can make at least some of those steps repeatable. It's hard to build a visual style when every image you produce looks different from the last. Photoshop actions allow you to condense all those complicated steps into one command, which frees up space in your brain for important stuff.

Boutwell Magic Glasses
▶ Make layer
▶ Merge Visible
▶ Set Selection
Copy
▶ Make
▶ Paste
▶ Convert Mode
▶ Gaussian Blur
Find Edges
▶ Levels
▶ Convert Mode
Select RGB channel
▶ Set Selection
▶ Unsharp Mask
▶ Set Selection
Delete channel "Alpha 1"

Many tasks in Photoshop are complex, consisting of several steps that each have their own particular parameters. Actions make repeating those tasks easy. For instance, the Boutwell Magic Glasses action performs 16 different steps, requiring dozens of mouse clicks, with a single command.

Actions Let You Hijack the Brains of Smart People

Actions are fairly simple to create. You don't have to be a programming whiz to make one. That's pretty good news, considering there aren't many people in the world who can write complex computer programs *and* who are post-production gurus. Many of the world's best photographers have written actions that condense their processing styles into the click of a button (well, as close as possible, anyway). Commercially available actions (and many free ones as well) can give you access to complex techniques that would take years to master on your own.

There's no shame in that, despite what many Internet forum trolls would have you believe. In fact, you can think of many commercial actions as a relatively cheap way to bring an expert or two into your business. Movie directors have cinematographers, set designers, editors, and a whole army of other experts to bring their vision to life. Musicians recording an album typically have different experts for recording, mixing, and mastering the music. You should take all the help you can get, too. Besides, you can learn a lot from seeing how other people's actions work. It's like getting a peek inside an expert's head.

How to Record an Action

If you're using Photoshop, knowing how to make your own actions is a great skill to have, and it's easy, too. Here's how to do it:

1. Head over to the Actions palette and click on the Folder icon. This will make a new folder to contain your new action. You can call it "My Folder" or something more clever if you're feeling up to it.

2. Click the New Action button. (If your palette is in Button mode, now's the time to switch back to the regular palette.)

Create a new action.

3. Give your action a name. Descriptive names are best, but hey, they're your actions—you could name it "monkeys on motorcycles" if that tickled your fancy.

4. Once you've typed a name, you'll notice that the Record button in the Actions palette turns red. This is just like the little recording light on a camcorder: When it's red, everything you do is being recorded.

5. Do some stuff! Photoshop will record almost anything you do while that Record button is highlighted. Just for illustration purposes, we'll make a quick and dirty web-prep action in the next few steps.

 a. Select Flatten Image from the Layer menu. This collapses all the layers in your document into the background layer, and it's a good first step for "finishing" actions like this one.

b. Go to File > Automate > Fit Image. Type in the maximum height and width that you'd like your web images to be. The actual values will depend on what your web designer has specified, but let's assume the biggest image can be 900 pixels wide by 600 pixels high. Type those values into Fit Image, and Photoshop will automatically resize your photo to fit within an imaginary 900 pixel by 600 pixel box.

c. Head to Filter > Sharpen > Sharpen to select the plain ol' Sharpen filter. This is generally a pretty useless filter for most images, but it works well in a pinch on web-sized photos. This will add a bit of snap to the web-sized image.

d. From the Edit menu, select Fade Sharpen. Set the Mode to Luminosity and set the Opacity to 65% or so. (Have a look at your photo and choose a value that looks good to you.) This will make sure that you're not sharpening any color noise in the image (generally a good step) and will also reduce the strength of the Sharpen filter.

6. Now that you've completed all of your web resize steps, click the Stop button on the Actions palette. The Record button will change back to its usual grayed-out appearance, indicating that you're no longer recording.

That's it! You've recorded an action, and a pretty useful one at that. Now, instead of having to remember a bunch of steps and values every time you prep an image for the web, you only have to press that button, and all the hard work is done for you. All that's left is to save your image (but remember to save it as a copy, or else you'll overwrite your original with a web-sized image, and that's never a good thing!)

You'll notice that all the steps you just took were dutifully recorded in the Actions palette under your new action. You can show and hide the steps in an action by clicking on the triangle next to the action name. You can also use that triangle to show/hide the values in each step of the action (such as the radius you used in the Gaussian Blur filter, for example). Finally, the same triangle will show and hide the actions in a folder of actions. The detailed information available to you in this view disappears in Button mode, but it's handy to have when you're making and tweaking actions.

Modifying and Adding to Actions

Suppose you messed up, and you need to fix a step you recorded in an action. Suppose you want to tweak someone else's action to be more to your taste. No problem. Actions are as easy to modify as they are to make.

Let's expand on our previous Resize for Web example. We can also add a thin keyline border around the image to spice it up. Adding steps to an action is as simple as selecting the step before the place where you want the new step inserted and hitting Record. So, to add a keyline border, we can modify the action we just created.

1. Select the Resize for Web action you just created in the Actions palette (and make sure you're not in Button mode).

2. From the Actions Palette menu, select Duplicate. This gives you a copy to work on, so you don't inadvertently mess up a perfectly good, working action.

3. Once again, head to the Actions Palette menu and select Action Options. Here you can rename your action to something more useful than the

default. You can also, incidentally, assign a color to the action for Button mode and a shortcut key combination for quick access. If you find yourself using the same action over and over, then assigning a shortcut key combination here can save you even *more* time.

4. Expand the new action so all the steps are visible (if they aren't already) by clicking the triangle next to the action name.

5. Select the last step in the action—the Fade Sharpen step.

6. Hit the Record button. Now anything you do in Photoshop will be inserted into this action right below the Fade Sharpen step.

7. From the Select menu, choose All.

8. From the Edit menu, choose Stroke. Set the location to Inside, the color to Black, and the Mode to Normal. Set the width to 1 pixel (or more if you like beefier keylines—I like mine thin).

9. Press the Stop button on the Actions palette.

Now we have two actions—one that resizes and sharpens an image to prep it for the web, and another that does all of that *plus* adds a thin keyline.

What if you messed up and needed to change something? There are two ways to do that. First, you could select the action step in the Actions palette and drag it to the little trash-can icon at the bottom of the palette to delete it. Then you could insert a different step in its place.

There's an easier way, however, that works for most steps. Just double-click the step in the action you want to change. In most cases, Photoshop will bring up the dialog box for the step you clicked and allow you to change the parameters for that step, saving the new values into the action. Suppose you decided later that you liked a thicker keyline. You could just double-click the Stroke step and enter a different width. When you click OK, the action will store the new values for that step. Simple.

Making a Super Action (an Action of Actions)

You can also record an action that plays other actions. If you have several actions that you commonly run together, why not make *that* an action and save even more time? That's a Super Action. It's simple to do.

1. Create a new action.

2. While the new action is recording, play a couple other actions.

3. Hit the Stop button.

Some actions also create separate layers each time an action is run. This allows you to quickly adjust the "strength" of the effect by altering the opacity of the layer the action created. Although a great feature on its own, the "one action equals one layer" concept becomes even handier when you're writing a Super Action. If you change a layer's opacity while an action is recording, the action will remember that opacity change as well. That means that not only can you create a Super Action that runs several other actions, but you can also change the mix of effects by varying the opacity of the actions you're running. The possibilities are endless.

Batch Processing

Making a Super Action comes in handy for batch processing. Suppose you had 20 images all retouched and looking beautiful, and you wanted to post them to your blog. You could open up each of those images one by one and monkey around with them, or you could just run your new web-resize action on *all* of them at once with some batch-processing tricks. Unless you're a masochist, you'll choose the faster method.

Recent versions of Photoshop have two ways to process a batch of images. The old way, using the Batch command (File > Automate > Batch) is simple and effective. Just place all the images you want to process in a folder, select the action you want to run on those images, and the Batch Process feature does the rest. However, it's a somewhat fickle, picky command, and it can get picky if things aren't set up just right.

The better option is to use Image Processor. You'll find Image Processor under the File > Scripts menu. When you open Image Processor, you'll see a dialog box.

To run your newly created web-resize action on a bunch of images at once:

1. Open Image Processor from the File > Scripts menu.

2. Select the folder containing the images you want to process and the place you want to save them to.

3. Because we're saving these for the web, check the Save as JPEG box and enter a quality of 8 or so. (That's a nice setting for a high-quality web JPEG. For print stuff I like to go a bit higher and usually use 10.)

The Image Processor dialog box.

a. You should also check Convert to sRGB, so that your images display something approximating the correct colors when viewed in a web browser. If you work in Adobe RGB or another color space and don't check that box, you're likely to get funky colors when you view the resulting JPEG on the web.

b. Make sure the Resize to Fit box is unchecked (since our action already does the resizing for us).

4. In the last section, check Run Action and select your web-resize action. Enter any copyright info you'd like and uncheck Include ICC Profile. For the web, browsers just ignore any profiles an image has, and since they add to the file size, I recommend leaving profiles out of web images. For anything other than the web, though, you'll want to include an ICC profile.

5. Hit the Run button, and Photoshop will automatically open each of the images in your input folder, run your action, and save them to your output folder. Neat!

A couple other words about Image Processor… Notice that there's an option to resize images right in Image Processor. That's a fast and handy way to shrink your images down without writing a custom action. It also means, in our case, that you can simply do the resizing in Image Processor and run a simple sharpening action instead of your custom resize+sharpen action. The choice is yours.

Also note that you can load and save the settings used in Image Processor. If you have commonly used settings (such as the ones we just entered), but you don't want to remember all the specifics, you can save the settings to disk and load them when you want to do the same thing in the future.

Commercial and Premade Actions

Knowing how to create your own action is essential, but actions can still take a while to master, and creating complex actions is something that requires finesse, experience, and some experimentation. That's why, for working pros especially, buying premade actions can be a relative bargain. When you consider that dozens, if not hundreds, of hours were spent to create a good action set, and that the person creating the set usually has years and years of Photoshop experience, the value of premade actions becomes clear. There are also plenty of free actions available online, although like many free things, you often get what you pay for (or don't pay for, as the case may be).

You can find, for free download or for purchase, both individual actions and groups of actions sold in sets. A good commercial action set usually includes at least several actions, and sometimes several dozen. They can concentrate on a specific task (speeding workflow, adding image textures, and so on), or they can be a mixed bag of different tools. The upsides to a commercial set versus many free ones are:

- **Documentation.** At the bare minimum, there will be some usage guidelines to help you figure out how to use the actions in the way the author intended. Some sets come with elaborate online manuals and video tutorials that walk you through using the actions and break down in detail what each one does.

- **Support.** If you have any issues with the more reputable commercial action sets, you can usually get help from an actual live person.

- **More robust tools.** Because commercial action sets usually come with support, they tend to work better.

Although the quality does vary a bit from set to set, you can usually find good feedback from other users by searching for information about a particular set online. A quick Google search will tell you a whole lot. Searching for information about Photoshop actions in general will also reveal many places to purchase and download Photoshop actions. It's definitely worth some keyboard tapping to investigate.

Tips for Using Actions in Your Workflow

So how can you use actions in your workflow? Let me give you a few tips.

Pick a Few Favorites and Stick with Them

There's a dizzying array of actions available, both free and commercial, that can do nearly everything under the sun. Nearly any effect you could want to re-create in Photoshop has an action that does the work for you. It's a natural temptation to want to use them all. If variety is the spice of life, then more actions is better, right?

Unfortunately, this isn't really the case. Having a portfolio with a jillion different actions and effects, where every photo looks tweaked and no two photos look alike, is the mark of an amateur. All of the best photographers tend to gravitate toward a small number of tools that they use over and over again to bring their vision to different subjects. Although most leading wedding photographers use actions in some form, most of them only use a select few, and they recombine and tweak them in subtle ways to make the actions serve their vision. You don't want your vision to be dictated by your tools. In many ways, the best thing you can do for your post-production and your overall visual style is to pick a few actions or techniques that you like and stick to them.

This isn't to say that you can't ever change. You should always be evolving and looking for new, exciting ways to create beautiful images. But the grab-bag approach to actions and effects almost always looks like a gimmick. Remember, you're using Photoshop to make your photos more beautiful, not to show off how many features you used in Photoshop. The best post-production doesn't draw attention to itself.

Take Them Apart and Learn from Them

Commercial and premade actions are not only useful by themselves, they're also great learning tools. Remember, some of the best, most experienced Photoshop users around put a lot of time into them. You can learn a lot by investigating how they work.

Remember those little triangles next to the action names? Use them! Dig deep into the actions you have and try to figure out why they work. Look at your favorites. What are they doing to an image? Why does the action use *that* filter?

Try repeating the same steps yourself, just for fun, and see whether you can get similar results. If not, what did you do differently? If you *did* get the look just right, what happens if you start removing a step here or tweaking a step there? Trying to break down how actions—even simple ones—work can teach you a lot about the different tools in Photoshop, and that can only make you a better retoucher.

Don't Be Afraid to Tweak and Experiment

If you have some concept of how an action works from playing and experimenting with it, then why not tweak it a bit and make it your own? You can make a duplicate of an action that you like and then edit and experiment to your heart's content. This is how many of the best photographers get looks that are uniquely their own. By taking an action that you like and changing some things around a bit, you can add your own signature to it.

A Few Words about Lightroom Presets

For many photographers, Adobe Lightroom is replacing Photoshop as their bread-and-butter post-production tool. Lightroom combines flexible image cataloging with a powerful Raw processor and several different output options. Unless you're painting on a photo or retouching blemishes or flaws, Lightroom can often do everything you need. Lightroom isn't as powerful as Photoshop as a general image-editing program, but you can do a lot with its Raw processor to create cool effects, and it's certainly a robust tool for basic image corrections. Photoshop actions won't work directly inside of Lightroom, but you can utilize presets, built specifically for Lightroom, to get some of the same benefits.

Like Photoshop actions, Lightroom presets can condense several different steps into a single button-click. There are also a wide variety of free and commercial Lightroom presets available online (though Photoshop still has many, many more add-on tools). Lightroom presets can create neat effects on your images and help speed some basic image-correction tasks. They are also very easy to create and fairly easy to dissect and learn from.

Unlike Photoshop actions, Lightroom presets can be tricky to customize or tweak. They also can't be mixed together the way some Photoshop actions can, due to the way Lightroom works. Finally, Lightroom presets are limited by having to fit within Lightroom's five modules, and their abilities have to fit neatly within one of those categories.

If you're a Lightroom convert, it's worth checking out the plethora of different preset options available online. You can definitely save time and learn more about how to get the most from Lightroom.

14 Presenting
Your Work

I eagerly wait to hear what clients think of the work
I produce for them, and I'm always really excited to
share my images with them. I used to share images
by presenting the couple with a print set, but once I
went digital, I was able to showcase their photos
online via web galleries. I also maintain a blog
where I display some of my favorite shots. The
advent of digital photography and the information
age has opened up a wealth of possibilities for how
you present your work.

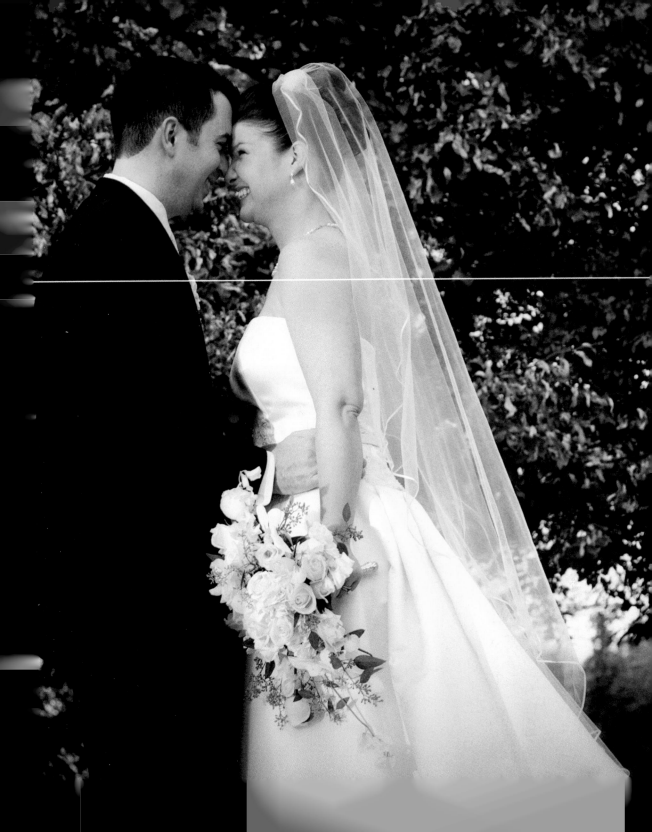

Blogging

*"I consider my blog
one of my greatest
advertising and
promotional tools."*

Today, I post my favorite images on my blog and usually write a small story about the wedding, too. I guess the journalist in me wants to treat a wedding like a news event and share it with the public! I take pride in blogging about my work, and I consider my blog one of my greatest advertising and promotional tools.

A blog not only showcases your latest work, but it's a place where couples can send friends and family to see their wedding pictures. The blog also serves as an archive or journal of your work—a living portfolio, always updated and showcasing what you believe is your latest and greatest.

My blog lets me showcase some of my favorite images from weddings I've shot. I enjoy writing a bit about the weddings, and the blog serves as an excellent form of promotion.

Digital Slideshows

At my studio, I showcase the best 100 or so wedding images in a slideshow that I present to the couple via a projector and movie screen. This allows them to see the images I captured on a large scale and in detail. Seeing images on a small computer screen is nothing like seeing them up on a big movie screen.

However, I don't recommend showing a couple the *entire* gallery from their wedding in this manner. More than 100 or so images can get rather tiring to see on the big screen.

NOFEAR

There's something to be said for leaving them wanting more. If you showcase on the big screen only the best 100 or so images from a couple's wedding, you leave them excited about seeing the rest and feeling positive about the results you've produced for them.

Prints and Albums

I also offer prints for the couple. I really like 4×6 photo print sets. They allow clients to see all their images in a tangible format that doesn't require a computer or a projector. Prints can be taken anywhere and are timeless. Prints are also archival quality and will last for decades. Many couples getting married today only want a disc with their images, and I'm afraid that they'll have nothing left of their wedding images in the years to come. Most CD and DVD recordable media are not suitable for archival and will start rotting after a few years— sometimes called *laser rot*. They're also usually fragile and can be scratched and damaged easily. If the couples don't back up the images on a regular basis, if they scratch their discs, or even if they just misplace their files, they could lose everything.

If the couple has a print set or an album, they have a real, tangible memory of their wedding. It's pretty hard to lose a wedding album or misplace 600 wedding photos in a box. And albums don't require electricity or require certain programs to view them. They are timeless and fully compatible with the future.

The only real threat to an album or prints is fire, flooding, or theft. But in the case of fire or flooding, a CD or DVD would be lost just as easily as an album or prints would. And as for theft…well, unless you're a celebrity whose wedding photos will fetch a sum from the tabloids, you probably don't have much to worry about.

With that said, it's very important that you work with a professional lab to print your work. It's not a good idea to bring your photos to be printed by a 16-year-old at the local drugstore one-hour photo. You need your work to be printed by people who know color, know that you color-correct your work, and know how you want your images to look. Professional labs will cost more than the one-hour photo, but your prints will look better and more consistent. If you spend thousands on your camera gear and editing software and time touching up or toning your images, do you want to cheap out on printing them? I don't. I want my prints and albums to be the best way to view my images and to show off all the time I put into them.

NOFEAR

Spend the money on a professional lab to print your photos. The local one-hour photo can't do justice to the beautiful images you captured and processed.

Find a lab and album company you like and use them. Get to know them, and you'll find that the partnership you can form with them will serve you much better than any drugstore could.

"Prints and albums are timeless and fully compatible with the future."

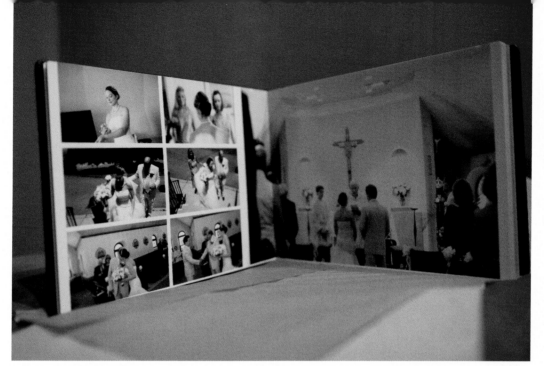

A quality album can be the best showpiece of your images.

Goodbye, Farewell, Toodle-oo!

"I never want to stop learning or trying new things."

I hope this book has inspired you to try some new things at the next wedding you shoot and to look at the world and photography in a new and fun way. At the time of this writing, I have been a photographer for about 10 years, and I know there is still so much for me to learn and to try. I never want to stop learning or trying new things.

No matter what new camera technology is available to us—lenses, bodies, flashes, or even post-production techniques—I truly believe that the most important skills for this business are learning about people and understanding them. Love is forever; life is not. But if we can capture moments—capture the way people feel and who they are—then our photos will be able to show who they were to their descendants. No one wants to be forgotten, and, if taken properly, a photo can say more than a thousand words about a person.

If people can look at your images and feel emotion—maybe laugh, smile, or have a tear come to their eye—then I think you have a great photo. We can talk about style, skill, and technique forever, but if your photo can share an emotion or make someone remember a time or a person in his or her life who is no longer around, then you've done a good job.

What else are photos but memories of life?

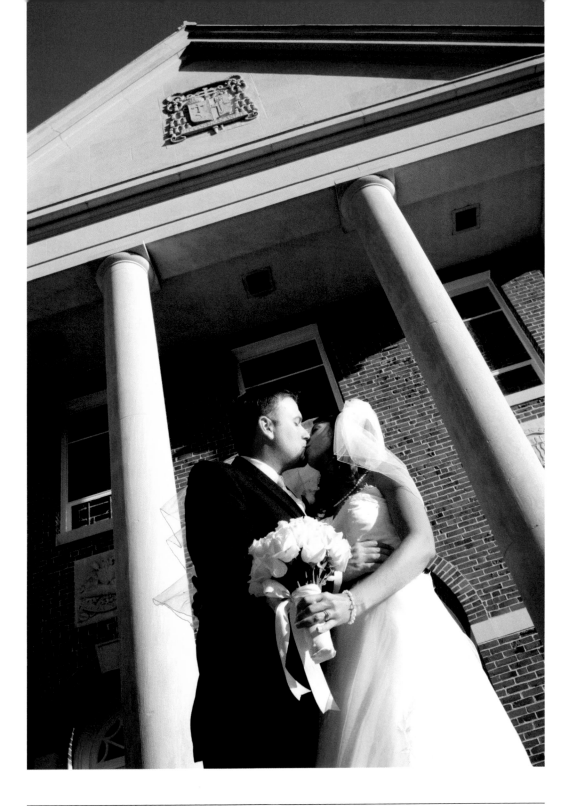

Index

V-Z